Swatch

A Guide for Connoisseurs and Collectors

Swatch

A Guide for Connoisseurs and Collectors

FRANK EDWARDS

FIREFLY BOOKS

A FIREFLY BOOK

Published in Canada in 1998
by Firefly Books Ltd.
3680 Victoria Park Avenue
Willowdale, Ontario, Canada
M2H 3K1

Published in the United States in 1998
by Firefly Books (U.S.) Inc.
P.O. Box 1338, Ellicott Station
Buffalo, New York, USA
14205

Cataloguing in Publication Data

Edwards, Frank
Swatch
A guide for collectors and connoisseurs
Includes Index
ISBN 1-55209-119-8

Creative Director: Richard Dewing
Art Director: Clare Reynolds
Design: deep creative ltd
Senior Editor: Anna Briffa
Editor: Sean Connolly

This book was designed and produced by
Quintet Publishing Limited
Typeset in Great Britain
Manufactured in Singapore
Printed in China

All pictures in this book were supplied by SMH-Swatch, Swiss
Corporation for Microelectronics and Watchmaking Industries Ltd.,
and have been reproduced with their kind permission.

Contents

Foreword 6

Part I Origins 7

Part II Collecting Swatch 27

Part III The Swatch Directory 35

Part IV Other Swatch Products 149

Part V Swatch Activities 155
 Appendix 158
 Swatch the Club Addresses 159
 Index 160

Foreword

In its comparatively short life in terms of horological history, Swatch has become more than just a watch—it is an institution.

What started out as a cheap and cheerful plastic watch was given, in the word of Nicolas G. Hayek, Chairman and NCO of SMH-Swatch, its producers, "a generous helping of creativity. Brash colors . . . clean cut images with no fancy padding" and a very carefully calculated price.

Swatch is unique, but it is universal. It is at home with both sexes and all nations; with the rich and the not so rich; with the young and the not so young. It revived the spirit of the Swiss watch industry at a time when it was at a very low ebb. It has been honored by international organizations and is collected by hundreds of thousands of fans.

It was not created overnight, nor was it the work of one man. It took years of patient toil by a devoted team of watchmakers and technicians, engineers, designers, and marketing people.

To that team this book is dedicated.

I

Origins

Origins

> **It is probably fair to say that the creation of Swatch has had a greater impact on the Swiss watch industry than any other horological development this century.**

When the industry was reeling under the onslaught of millions of cheap electronic watches from the United States and the Far East, Swatch provided both a rallying point and a signpost to the way ahead.

The first major producers of electronic watches were the giant U.S. calculator companies, which had been working on miniaturized counting devices for the space program. It was a small step to convert them to measuring time. These companies—Texas Instruments, Hughes Aircraft, etc.—marketed their watches as extensively as they did their calculators and through the same outlets.

Switzerland, which a few years earlier had a virtual monopoly of the world market for watches—it produced around 91 million watches and movements in 1974, the majority of which were low-priced pin pallet or Roskopf type—saw its overseas markets disappear almost overnight. By the end of the decade its output had dropped to barely 60 million, a figure by then equaled not only by Japan but by the newcomer Hong Kong (the United States had virtually dropped out of the running). By 1983, it had fallen to just over 43 million units.

Now, the Swiss had known about electronic watches for some time and in fact the world's first genuinely electronic watch incorporating a transistorized circuit was designed by Swiss engineer Max Hetzel who, finding no enthusiasm for it in his own country, had offered it to Bulova, which marketed it as the Accutron—the "tuning fork" watch. But the industry wanted a quartz oscillator and a number of top manufacturers joined forces to set up a research and development venture, called the Center for Electronic Horology (CEH) in Neuchâtel, to be collectively financed and managed.

In 1967 it presented its supporting companies with the first quartz movement for a wristwatch. Its electronic circuits were specially designed for low power consumption and it used the oscillation of a quartz rod, vibrating at 8192Hz or vph. It was called Beta 2I and did not look particularly like a quartz movement as we know it today, but it matched the project's technical requirements. But the Swiss failed to capitalize on their invention and allowed the Japanese and Hong Kong manufacturers to forge ahead with developing and marketing quartz watches. The Swiss watch industry was forced to recognize a very real threat to its existence.

Of the 2,000 or more watch houses making watches or components in the 1950s only 632 were left by 1984. A work force of close on 90,000 people had plummeted to around 30,000 and many firms had to amalgamate to survive. Among the mergers forced through by the Swiss banks was that between ASUAG (Allgemeine Schweizerische Uhrenindustrie AG), which owned Longines, Eterna, Certina and Rado, and SSIH (Société Suisse pour l'Industrie Horlogère), which manufactured Omega, Tissot, and Hamilton; the capital reconstruction took until 1983 to complete and the Group did not acquire its final name SMH (Société Suisse de Microélétronique et d'horlogerie) until 1985. It now accounts for about one third of Switzerland's output of watches and movements.

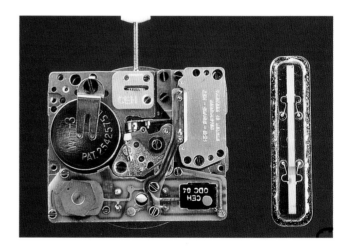

Early Days

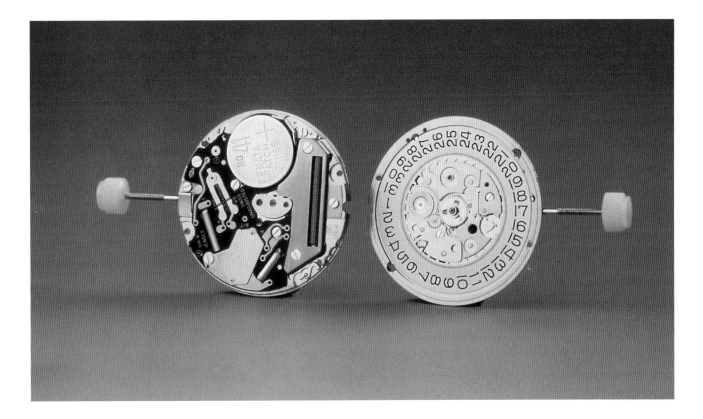

> **Among the constituent companies of ASUAG was Ebauches SA, Switzerland's largest manufacturer of components and movements. Ebauches SA had been developing its own quartz movements for some time and in 1976 had already produced the world's thinnest quartz analog caliber which they called "Flatline." The movement, including seconds hand and date indicator, was just 3.7mm thick—a year later, they improved this to 3.10mm which made it possible to produce a cased up watch of 6mm overall thickness.**

In 1978 the Japanese firm Seiko came out with a complete watch only 4.10mm thick. Later in the same year they reduced it to 2.5mm—now Japan held the record for the world's thinnest quartz watch!

The story goes that ASUAG, put on its mettle by this challenge, decided to take the Japanese producers on at their own game and gave a team of ETA engineers the task of producing a watch

movement that would be as efficient as the competition but better made, as accurate but no more expensive, above all it had to be thinner. One of the team, on learning that the movement had to fit into a case just 2mm high, said it was "un delirium très mince"–a pun on the expression "Delerium Tremens" which is a special sort of madness! So it became known as the Delerium project.

Six months later, the technicians reported back. They had devised a movement whose major innovation was that it required no separate back plate—all the components were to be assembled unilaterally and directly on to the case back. As a result it was incredibly thin—just 0.98mm. It was unveiled on January 12, 1979. Once again Switzerland had produced the world's flattest watch and ASAUAG had achieved its aim!

The movement was put into a Concorde case—one of Switzerland's more expensive brands and it received a qualified success, largely in the United States where it sold for $10,000.

A Watch for the Mass Market

> **After the amalgamation of ASUAG and SSIH the new management came under the control of Nicolas G. Hayek, the consultant whose firm Hayek Engineering had advised the board during the reconstruction and who now led a consortium of investors in the group. He saw that the Swiss could not continue to sell only watches in the luxury class and determined to capitalize on the success of the Delerium project to produce an inexpensive mass-market watch.**

ASUAG awarded ETA, a subsidiary of Ebauches SA, a contract to make "Delerium Vulgare," a popular version of the project, the brief being to develop a low-price, high-quality quartz analog watch which would have to satisfy certain criteria. These were:

1 *The retail price must be low enough to compete with the competition from the Far East.*

2 *The high standards of quality associated with Swiss manufacture must not be compromised.*

3 *It must be possible to manufacture the watch with an acceptable profit margin.*

4 *The basic model must be adaptable to a wide range of products.*

5 *The watch must have features that make it suitable for everyday wear—it must be tough, water-resistant, and able to keep going for three years without a battery change.*

Hayek knew that these criteria made it impossible to solve the problem by conventional watch-making methods—only a completely new solution would have any chance of success.

The project was officially given the go-ahead in October 1979. Following the submission of preliminary design blueprints and technical studies—all of which took a year—ETA was ready, by January 1981, to produce the first actual models which by midyear had acquired a shape very similar to the one finally adopted. The name was changed to "Popularis," a production budget was agreed, and provisional approval for a lady's version was received.

By the middle of 1982, a draft collection had been designed and preparations made for an initial production run of 300,000 watches. ASUAG approved the budget for the launch of the watch which was provisionally to be in the United States. Toward the end of the year the strategy for the launch and the part the project was to play in the development of the ASUAG Group was agreed. The final recommendations to the board suggested that an international marketing concept be agreed and that the watch should be launched immediately in Switzerland.

Overcoming Production Problems

> **The secret of the Delerium Tremens was its extreme simplification. The conventional construction of mounting plate, case, and bottom plate was abandoned. The case itself was made to serve as the main plate. The movement is mounted from above and the very thin (0.24mm) sapphire crystal glued into place. Every part of the watch was now scrutinized to see if improvements could be made. The synthetic material of the case and the injection molding process was new and required development work on the dies. The watch gearing system was simplified and the number of components reduced from 91 to 51 with no loss of accuracy (a conventional quartz watch can have 150 parts).**

The planning of a coherent assembly pattern produced a real headache. On the first pilot runs the reject rate was as high as 70 percent. Initially ETA would not risk giving a guarantee of more than six months. One of the biggest problems was automation of the manufacturing and assembly processes and it became necessary to assemble the first production runs by hand.

In the end, however, perseverence, know-how, intelligence, and above all teamwork triumphed over the obstacles that continued to turn up. In the end there was a crew of some 30–40 people involved in bringing Delerium Popularis, as it was now called, to the starting line.

Three years after the initial decision had been taken, a waterproof, shock-resistant accurate watch, cased in a synthetic material that could be mass produced in an attractive range of colors, was ready for delivery. It was time for the management, which in this case meant the ASUAG/SSIH Steering Committee, to decide on the next step.

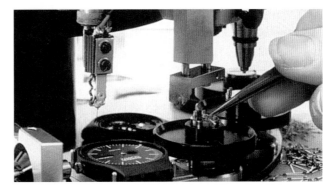

The First Collections

> **It has to be said that the first prototypes did not have a particularly attractive image—not helped by the names Vulgaris and Populis. But the project leaders realized that they needed something more to enable their baby to ride the tides of fashion. And the first thing they needed was a name.**

The name "Swatch" was the inspiration of a New York advertising agency which even at that stage—the summer of 1981—was working on some basic marketing guidelines. Developed from the idea of a "second watch" and a Swiss watch at that, the credit for the solution is given to Franz Xaver Sprecher, one of the marketing consultants on the project.

As soon as practicable, the name was protected legally worldwide, and in early 1982 the steering committee endeavored to set up a joint venture in the United States with a Texas businessman with a wealth of experience in this segment of the market. But although production was stepped up to supply some 3,000 units a week, over 25 different models, it became apparent after three months that the venture had failed—largely, it is said, through lack of any real organizational support. For a while the whole project looked to be in jeopardy, but the direct intervention of Hayek himself, whose company Hayek Engineering was now the project consultant, stopped the group selling the Swatch project and calling it a day.

It was at this stage that the steering committee was advised strongly by Hayek to create an "in house" marketing team—this was to be yet another innovation.

Up to that time, ETA SA had been a producer of movements for both quartz and mechanical watches. Their customers assembled the movements, cased them up, put their own brand on the finished product and handled their own marketing. But management took the view that leaving the marketing of a revolutionary watch like Swatch to the mercy of traditional distribution channels was too risky and not likely to produce the dynamic energy and imagination needed to make it work.

So an advertising agency was brought in and a launch campaign organized around a specially prepared spring collection. The launch was heralded by a press conference at which the virtues of Swatch were trumpeted to the world. Its four aces were:

- *a quartz-powered analog watch at a price never before seen in Switzerland;*
- *a quality normally associated with more expensive watches—an accuracy of +/– one sec/day;*
- *new technology destined to become a byword, a new wave of Swiss watches for the young, and a symbol of a new lifestyle; and*
- *a product that can adapt quickly to any style and is therefore ideally suited as a fashion accessory*

The Swatch message

> **It was said at the time that Swatch could well play a part in helping the Swiss make up for the losses suffered in the mass market and for the immediate post-launch years it certainly appeared to have done so.**

Swatch was launched in Switzerland, Germany, and Great Britain on March 1, 1983. The collection consisted of 12 models priced from SF39.90 to SF49.90 and the target for 1983 was set at one million pieces. Shortly afterwards a standard price was established for all models, of both sexes, at SF50—a price that was to be maintained for many years. By the end of that year the target of one million pieces had already been reached.

The crucial year for Swatch was 1984. An upbeat advertising campaign targeted to fashion conscious young people had helped to achieve the task target. But would it last?

The sales budget for 1984 was set for 2.4 million pieces. New models were introduced—each part of a collection. They were given names instead of dreary old code numbers. "Swatch is always changing, which is the only unchanging thing about it," said Max Imgruth, sales director for the U.S. market in the early years of the company.

The policy settled down to two new collections a year. From about 200–250 designs, a final choice of 70 models would be made, each selected for its specific contribution in terms of originality, controversy, or interpretation of fashion.

"Swatch means provocation, color, throwing conventions overboard. Swatch cocks a snook at the pretentious and the snobbish. Swatch is there for the rich and poor; men and women, young, and old."

"Swatch has demonstrated that it is possible to make a top-quality product at a very low price in a place as expensive as Europe; not only that, we have done it in Switzerland, the most expensive country in the world."

"Swatch has managed to create an awareness of the potentially disastrous ecological consequences of present day developments and show that there is an alternative."

Nicolas G. Hayek Chairman and NCO of SMH
Swatch World journal

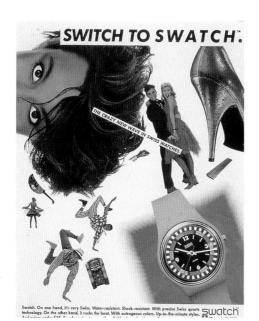

SWITCH TO SWATCH.

THE CRAZY NEW WAVE IN SWISS WATCHES

Swatch. On one hand, it's very Swiss. Water-resistant. Shock-resistant. With precise Swiss quartz technology. On the other hand, it rocks the boat. With outrageous colors. Up-to-the-minute styles. swatch

On Course for Success

> **Swatch was spoken of originally as a second watch. Soon it became a third, and then a fourth watch even a wardrobe accessory. Ultimately it was to become a collector's watch.**

It soon became clear that the concept of a high-quality watch at a low price was, thanks to its high-tech materials and innovative production, a distinct possibility. What was less clear was its future direction. What shape should it be? What size? Would uniformity reinforce its individual brand identity?

Well aware of the current dictum "Form follows function," the Swatch team finally decided that the best solution was to keep the case perfectly round. Other items—dial, hands, strap, buckle—all could be as variable as imagination dictated. Only the shape was to remain immutable. And every one of each year's

500 designs scrutinized by the Swatch teams selection crew is discussed and debated in detail—for they must bear in mind that what they select today will not be launched until a further nine months' time.

In fact the whole creative process starts about a year in advance with group discussions about basic ideas from which creative guidelines are drawn up. Swatch designers draw their inspiration from all horizons and the singularity of Swatch derives from its plurality of styles—all contained within that unwavering circle. A Swatch is for a season, not for all seasons, is the driving force. Swatch was well christened "Fashion that ticks."

It was a natural transition from artistic designs to Art itself. World-famous artists were commissioned to design a Swatch or a collection of Swatches: Valerio Adami, Pierre Alechinsky, Pol

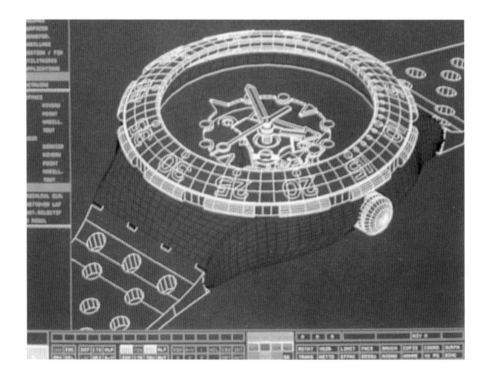

> Bury, Jean Michel Folon, Sam Francis, Massimo Giacon, Keith Haring, Alfred Hofkunst, Alessandro Mendini, Mimmo Paladino, Kiki Picasso, Matteo Thun, Niklaus Troxler, Felice Varini, Not Vital, and Tadanori Yokoo are just some of the artists and designers who have put their stamp on a Swatch. Many designs had only small production runs. But their individuality helped to bring Swatch Art into everyday life. And to reinforce the feeling of being part of life, since 1984 each Swatch has been given a name. These have included Graffiti (1984), Granita di Frutta (1985), Calypso Beach (1986), Journey to Samoa (1987), Spades (1993), and Lolita (1995). Each name also belongs to a generic theme—Vasily or Street Smart—although it is not always easy to see the connection. In 1989 the Creative lab was established in Milan to ensure Swatch designs maintain their freshness and topicality.

In 1989 the Swatch Design Lab was created in Milan with the task of making sure that Swatch designs were ever more daring.

The Design Lab is in the center of Milan. Everything takes place on the same floor—from the computer screen design to the actual weaving of colors, materials, and patterns. Designers work in-house and the Lab has access to roughly the same number outside. Two collections, each of approximately 80 models, are produced every year and twice as many are rejected. From initial discussion to final package takes about 12 months (Haute Couture has a similar time span).

Swatch World Journal

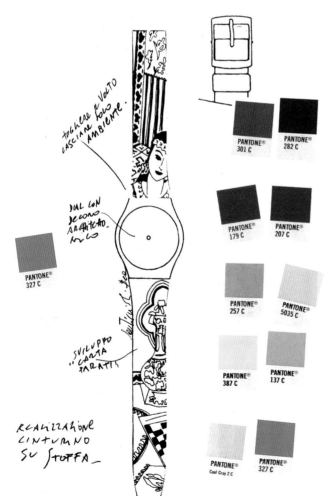

Swatch Developments

> **The inventiveness of the Swatch team did not stop at creating two new colorful collections a year. The first step in the evolution of the Swatch was the Maxi—a giant timepiece to hang on a wall (it was 6.9 feet long "ten times the size of a regular Swatch").**

Another, if more modest step, was the 1986 introduction of the POP Swatch, with its oversized colorful strap designed to fit over overalls or denim jackets or boiler suits.

In the spring of 1990 came the Scuba 200—the diver's friend and waterproof to 656 feet with a rotating bezel to check the time of the dive.

At the same time Swatch launched its first multifunctional model, the Chrono, with a facility to time individual laps, intermediate times and periods of up to 12 hours. Out of 5,000 submitted to Switzerland's official Chronometer Testing Institute (COSC) 4,843 were awarded chronometer certificates—a unique tribute to their timekeeping qualities.

It is a sign of the Swatch team's confidence that they did not send any more Chronos to COSC—it was costly and took two weeks. Five thousand was a good batch test so the Swatch team decided that they had gotten it right and had no need for further official testing. After all, they had their own 24-hour test on a vibrating machine at 90 percent humidity and a temperature test from freezing to 50°C (122°F) apart from the numerous routine production tests along the way.

Both the Chrono and the Scuba, incidentally, far outstripped their sales targets and caused headaches in the marketing department in spite of increased production capacity.

In September 1991 Swatch launched "Swatch Collectors of Swatch." Members received regular mailings about Swatch activities, invitations to exclusive events, and a free members-only Swatch once a year.

With the next year came a surprising development. Swatch had made its name as a highly accurate, low-priced analog quartz watch. The Automatic, launched in 1991 was a classical *mechanical* self-winding watch, waterproof, shockproof, and reasonably priced. It showed that for all its revolutionary techniques, Swatch was capable of producing a traditional watch for those people who believe there are more things in life than split-second accuracy. In fact the Automatic is accurate to a respectable +/– 15 seconds a day, a range that is acceptable in all but the most exclusive hand-built masterpieces of the watchmaker's art.

For those whose requirements were less than the Chrono offered, in 1992 Swatch produced the Stopwatch, which, without any additional hands or pushpieces, offered a stop function with a range of six hours—a simple push of the button zeroes both hands at 12 o'clock.

In 1993 Swatch launched the MusiCall—an alarm watch with a difference. Instead of the customary rather metallic electronic beep it had a catchy little tune by Jean Michel Jarre taken from

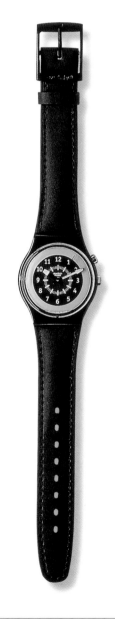
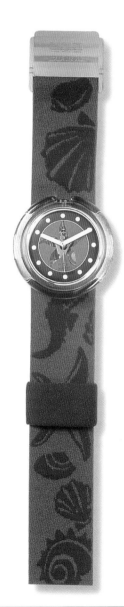

> his Suite "Chronographie" composed for the "Swatch and Europe in Concert" tour in 1993.

Beep-up was the first Swatch with a telephone line all of its own. It is the first analog wristwatch to feature an integrated pager. The Beep-up has four different tone sequences to identify specific callers. Introduced in 1993, it was soon followed by Beep Numeric. It gives a discreet beep when someone is trying to get in touch—and even that can be turned off—and the

number to call back appears on the dial. The Beep can store up to 20 calls and can even receive messages in code provided that the owner and the caller have previously agreed in advance what the numbers mean.

Right from the start Swatch had introduced "Specials"—models with a specific theme like the Olympics, or Christmas—or for special occasions like the Breakdance event in the States. Perhaps the most notable was the Swatch Automatic Special

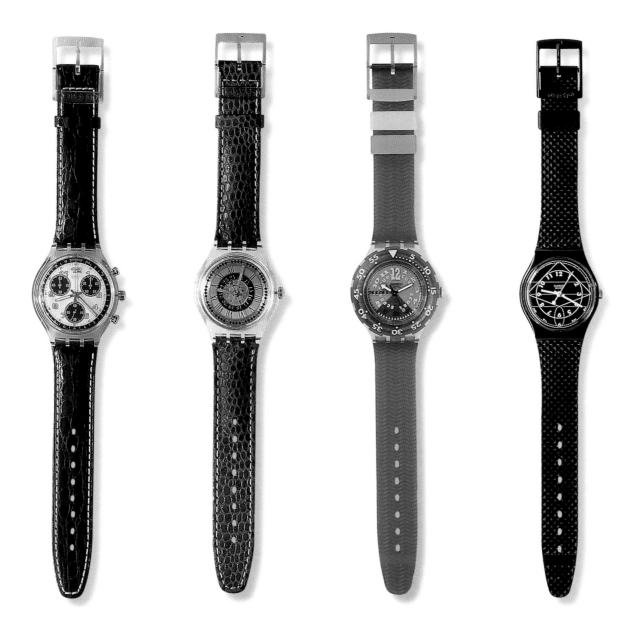

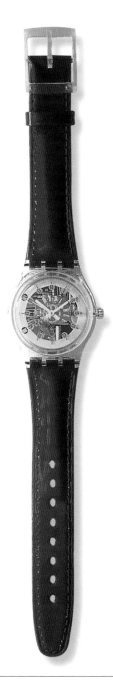

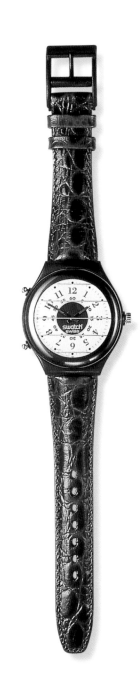

> called Time to Move, created to coincide with the Earth Summit in Rio de Janiero in 1992. A "Special," according to Swatch, is an extraordinary kind of Swatch made for an extraordinary occasion or for an extraordinary personality. Or, it might be, for an ordinary occasion for extraordinary reasons.

A Swatch Special for 1994 had been the first one designed for Easter. Called Eggsdream, it was egg-colored and came in an Easter Egg yellow pack. It was inspired, they said (in a gentle spirit of poking fun) by the diamond-studded and enameled Fabergé eggs that the Russian Czar used to present to his family at Easter. Swatch just thought their followers might like to follow suit . . . and produced 33,333 just to be ready to meet the demand.

POP Swatches, too, had their Specials for Christmas with highly original "add-ons" and special presentation boxes.

By now, just ten years after its creation, sales of Swatch stood at more than 165 million pieces and it appeared to be as popular as ever. Its creators still insist that the prime reason for its existence is to ensure a state of permanent revolution on the wrist, a secondary purpose being to document the spirit of the times we live in.

1994 also saw a new version of that tiny microelectronic alarm the MusiCall, this time with a 22-second mini concert by the American composer Philip Glass, dressed in a variety of dazzling colors and intricate designs.

The latest collector's Swatch, called Crystal Surprise, came in a mini gunny sack complete with drawstring and label, while the larger than life-size Maxi Swatch was enlivened by a further six variations. POP Swatch wearers were encouraged to wear them anywhere but on their wrists: The Summer Special POP looked to have a straw-plaited strap (designed by Stéphane Plassier) and was presented in a straw hat with a cord that turned it into a bag.

The Chrono was now accurate to a tenth of a second and some had a date thrown in while the Scuba 200 acquired a luminescent dial (activated by a push button for when the light is dim) and an even odder name—Loomi. Another newcomer for Swatch lovers was the AquaChrono, which they say was baptised in Loch Ness. Added to its 1/10th second stopwatch facility is a case water-resistant to 656 feet and a huge movable bezel with notches that made it easy to see and turn if one really was at these depths.

Swatch and Easter

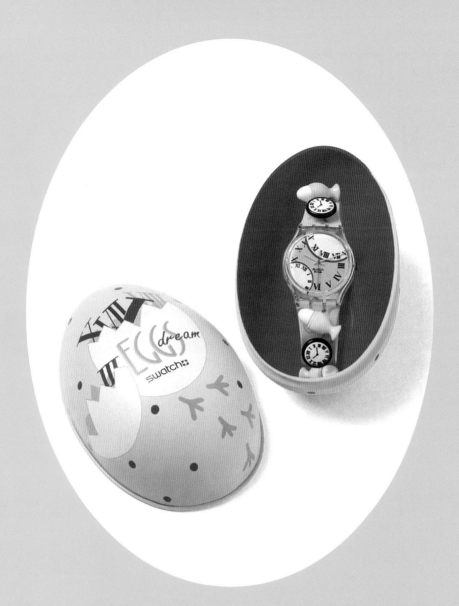

When Swatch introduced its first Special, the Eggsdream, with its customary flurry of publicity in 1994, it also gave its fans a little homily on the origins of Easter Eggs and how the date of Easter is established.

The oldest known example of Easter Eggs goes back to Alsace in 1522, when a gift of eggs was made to the mayor of Strasbourg on Palm Sunday. But popular folklore has it that during the 4th century, the Church forbade the eating of eggs during the 40 days of lent. As a result, a large quantity of eggs piled up in people's pantries; after Lent it was thought the easiest way to dispose of them was to give them to the children. The whole occasion was made more fun by decorating the eggs.

And Easter? This was determined in A.D. 325 by the Council of Nice, which fixed Easter on the first Sunday after the full moon following the spring equinox on March 21. Thus Easter becomes a movable feast, unlike Christmas Day which always falls on December 25.

To launch Eggsdream Swatch organized the cooking of the world's largest omelet. It was 50 feet in diameter, covering 1,300 square feet. It required 160,000 eggs, 2 tons of potatoes, and a ton of onions to make and took two hours to cook. The event took place at the Yokohama Dockyard Garden on March 19, 1994 and an application has been made for entry in the Guinness Book of Records.

Swatch World Journal

Easter 1994

Swatch and the Olympics

> **In June 1994 the International Olympic Committee celebrated the 100th anniversary of the start of the modern Olympic games and His Excellency Juan Samaranch, the president of the Committee, asked Swatch to design a watch to commemorate the event. The IOC 100 Chrono was produced in response and it was agreed that part of its sales revenue would go toward a fund set up by the IOC to help young people all over the world to get off the streets and become more involved in sport.**

In September Swatch learned that it had been selected as Official Timekeeper to the 1996 Summer Olympic Games in Atlanta. It was a tremendous accolade for this newcomer to the horological world and plans were immediately put in hand to get the maximum publicity out of the event. Swatch announced the creation of a Swatch Historic Olympic Games Collection, the first set of which would consist of nine Swatches each commemorating one of the cities in which the Games had been held. They would be available separately or in a limited and numbered boxed set. Three more collections were promised. "Next Stop Atlanta," an exhibition arranged in conjunction with the Atlanta Committee, started out on a world tour.

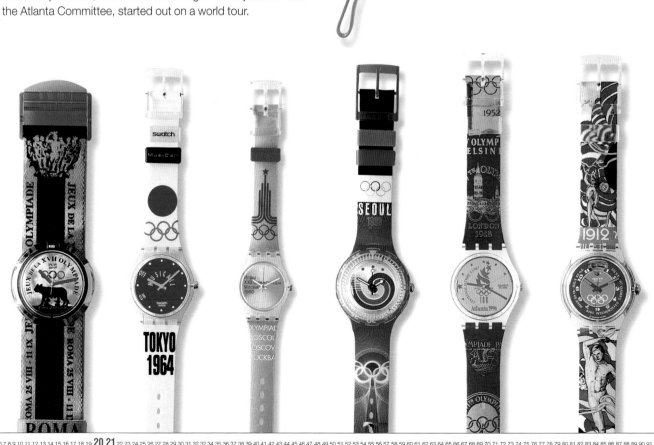

For Honor and Glory

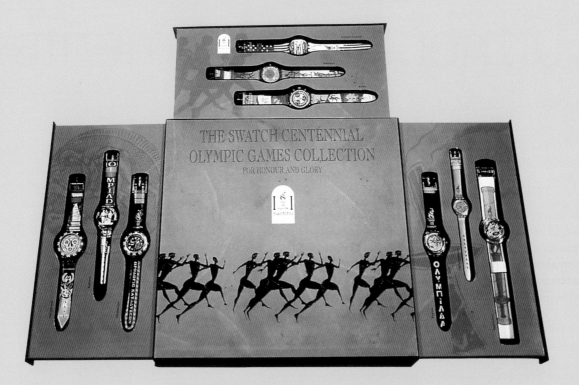

As a run-up to the 1996 Olympic Games, Swatch released the Olympic Games Collections in four stages. In 1995 For Honour and Glory was launched as the second such collection, following on from the Swatch Historic Olympic games Collection of 1994.

Eight Greek towns which hosted the famous Grecian Games were the subject of the 1995 Olympic collection. The full list was as follows: Kalos, a Chrono; Thalassios, a Scuba 200; Nikiphoros, an AquaChrono; Pyrsos, an Automatic; Dolichos, a MusiCall; Kotinos, a standard gents' Swatch; Chrysophorus, a standard ladies' Swatch; and Ippolytos, a midi POP Swatch.

The watches in the collection were available individually or as a set packed in a large orange box, as featured here.

Swatch World Journal

Further Developments

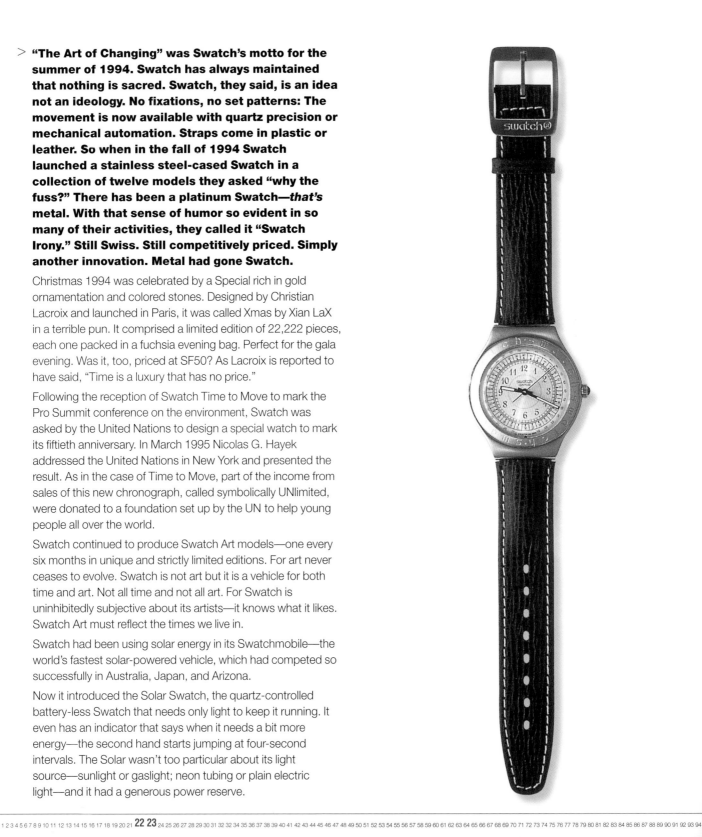

> **"The Art of Changing" was Swatch's motto for the summer of 1994. Swatch has always maintained that nothing is sacred. Swatch, they said, is an idea not an ideology. No fixations, no set patterns: The movement is now available with quartz precision or mechanical automation. Straps come in plastic or leather. So when in the fall of 1994 Swatch launched a stainless steel-cased Swatch in a collection of twelve models they asked "why the fuss?" There has been a platinum Swatch—*that's* metal. With that sense of humor so evident in so many of their activities, they called it "Swatch Irony." Still Swiss. Still competitively priced. Simply another innovation. Metal had gone Swatch.**

Christmas 1994 was celebrated by a Special rich in gold ornamentation and colored stones. Designed by Christian Lacroix and launched in Paris, it was called Xmas by Xian LaX in a terrible pun. It comprised a limited edition of 22,222 pieces, each one packed in a fuchsia evening bag. Perfect for the gala evening. Was it, too, priced at SF50? As Lacroix is reported to have said, "Time is a luxury that has no price."

Following the reception of Swatch Time to Move to mark the Pro Summit conference on the environment, Swatch was asked by the United Nations to design a special watch to mark its fiftieth anniversary. In March 1995 Nicolas G. Hayek addressed the United Nations in New York and presented the result. As in the case of Time to Move, part of the income from sales of this new chronograph, called symbolically UNlimited, were donated to a foundation set up by the UN to help young people all over the world.

Swatch continued to produce Swatch Art models—one every six months in unique and strictly limited editions. For art never ceases to evolve. Swatch is not art but it is a vehicle for both time and art. Not all time and not all art. For Swatch is uninhibitedly subjective about its artists—it knows what it likes. Swatch Art must reflect the times we live in.

Swatch had been using solar energy in its Swatchmobile—the world's fastest solar-powered vehicle, which had competed so successfully in Australia, Japan, and Arizona.

Now it introduced the Solar Swatch, the quartz-controlled battery-less Swatch that needs only light to keep it running. It even has an indicator that says when it needs a bit more energy—the second hand starts jumping at four-second intervals. The Solar wasn't too particular about its light source—sunlight or gaslight; neon tubing or plain electric light—and it had a generous power reserve.

> Swatch was aware that the cinema was also celebrating its first century so it asked three modern cinematic giants—Akira Kurosawa from Japan, Robert Altman from America and Pedro Almadovar from Spain—for their interpretation of the event. The result was the Swatch "100 years of the Cinema Collection"— one idea, but three contrasting viewpoints.

In May, the Swatch Smart Car, a joint SMH-Swatch/Mercedes Benz project, was presented to the press in France on the site of one of its proposed factories. It was announced that Swatch would be taking responsibility for the electrical engines. Later that month, on a private visit to Mr. Hayek, German Chancellor Helmut Kohl tried out the Smart Swatch car and proved that, although a compact design, it had plenty of room.

The next month at a rapturous reception in Budapest, Swatch's Chairman presented His Excellency Juan Samaranch with a check for $1 million for the IOC's fund for young people and at the same time unveiled the second Swatch Olympic Collection, called "For Honor and Glory," featuring heroes and images from Greek mythology.

Swatch MusiCall got a new sound, from Paulo Mendonça. This time it had a seven-tone sound while for the romantically hearted "For Your Heart Only" was the Special Swatch for Valentines Day, with the hands revolving around Eros.

The "Special" for the summer was Swatch C-Monsta, a limited edition model with weird-looking knobs all over the plastic strap presented in a hideous 1950s woman's bathing cap.

In the fall, 12 major cities marked the countdown to the start of the 1996 Summer Games with the installation of Swatch Art Towers. In Athens, Barcelona, Beijing, Berlin, Hong Kong, Lausanne, London, Paris, Rome, Sydney, and Tokyo the seconds that remained to the Opening Ceremony commenced to be ticked off.

Also in the fall of 1995 came "Themes of the Times"—all the models in the current collections, from the standard men's size to the AquaChrono, were grouped together in themes. Eight separate lines—Tears, Girlies, Techno—with a bunch of Classics and the new Artists models. And to add a final touch to the year, the Christmas special for 1995, Magic Spell, played that old favorite "Jingle Bells" on a limited edition Swatch with a snow-filled dome concealed in a book that tells a romantic winter's tale.

The theme of the Spring/Summer range of 1996 was obviously the Olympics with a host of new designs taking in sport, fashion, music, and art.

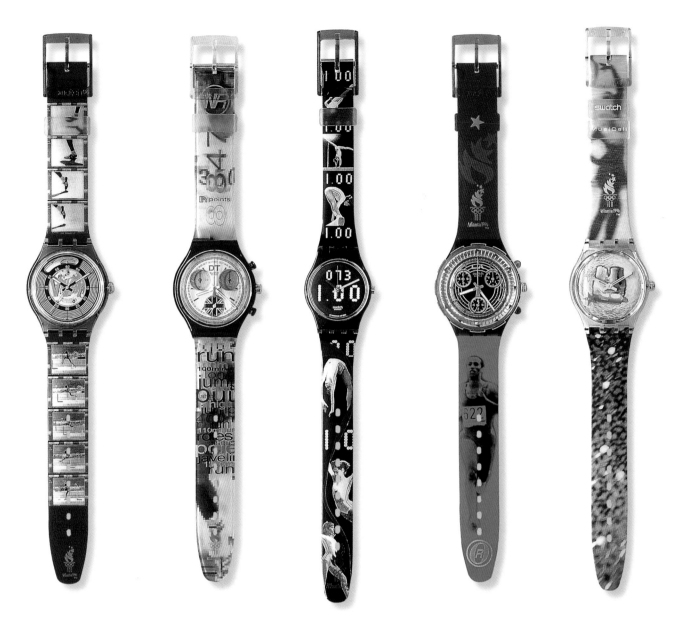

> A small collection of originals with black Arabic numerals on white dials and a variety of soberly colored straps leads into Innocence which brings together influences from different ethnic cultures, from the ancient hieroglyphics of Wise Hand to the exotic palm trees of the POP Swatch Kishoo, taking in a Chrono and an Automatic on the way. Other themes were "Breakfast" with "snap, crackle and Pop" dials and matching straps and fried egg dials complete with frying pan motif; the "Invisibles," a range in pastel shades of case and strap with transparent heads such as the See Through Chrono; "Tech is Cool," which combined sci-fi and technology in Space Trip, an AquaChrono in steel on a metal bracelet and "The Artists"— another set of designs by six artists incorporating influences from Africa, Australia, and Spain, in limited editions of 50,000 each available singly or in boxed sets.

The third of the Olympic Collections, "Olympic Legends," also appeared, consisting of nine wristwatches and a pop-up Swatch named for individual Olympic champions like Sebastian Coe, Mark Spitz, and Daley Thompson. Each Swatch has a different dial indicative of the athlete's particular discipline, a similarly decorated strap and on the reverse a national flag insignia, an autograph, the name of the athlete and sport and a record of his or her Olympic medals. The "Legends" include Automatics, Chronos, MiniCalls, and Scuba Loomi as well as standard models. Once again the watches were available separately or in a special Olympic limited and numbered presentation box.

Further Innovations

> **Another innovation in the Swatch mold, introduced in the Spring of 1996, was Access—a Swatch that included a ski pass. Thanks to its innovative technology, just walking past the Swatch Access Scanner at the ski slopes would open the turnstile— even if worn under a glove or ski jacket. The Swatch Access ski pass was acceptable in some 340 ski resorts in Switzerland and in France.**

The 1996 Fall/Winter collection, true to form, introduced 47 new standard Swatches, four MusiCall, seven POP Swatch, eight Scuba, seven Chrono, seven AquaChrono, six Automatics, and three Access versions as well as three Pop-Up Swatch, the pocket watch type model that stands up on its metal pendant— 89 watches altogether, spread across seven ranges with influences from tarred roads to technology, robots to rockets.

The themes include Signs (the Don't model is like a Do Not Enter sign); Messages, with injunctions like "Protect your Choices"; Information landscape, with models called Website and Bitstream; and Sparkles, with a golden Glitter. Many themes have only three models in them but all the Swatch variations are included with the occasional POP Swatch like Doggy Bag.

Swatch sprang into 1997 with a whole new collection of light, airy stylish models that took full advantage of the brand's fundamental features—lightweight, versatile plastic. The range was aimed at reflecting the flowing iridescent colors and sleek lines seen on the catwalks of Milan, Paris, and London. Some 44

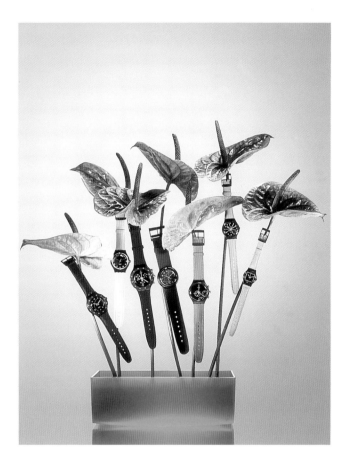

new standard models (how *did* they dream up the names?) were introduced, along with the usual additions to POP and POPup. There were some extra Scuba designs—now almost all with Loomi luminescence and a very special Access called Salzburg. This model, logically enough, provided the freedom of its attractive namesake city in an all-inclusive package tour simply by passing the Swatch Access Salzburg close to a special checkpoint. Presto! you were booked on a tour and a wide selection of hotels, restaurants, bar, concerts, the casino, and even the public transportation system were available, and all charged to the wearer's Swatch Access. There is a snag. You had to get to Salzburg first to load your Swatch Access at the Swatch Store or at certain hotels, or the Information Office.

Themes for 1997 were "Silverlite"—sleek contours and metallic sheens with overtones of the space-age 1950s and 1960s; Exotica shows, butterflies, bird feathers, and even a frog that glows in the dark; "Moviment" is a fashion line in up-to-the-minute colors in browns, yellows, greens, and reds. "UltraAqua" runs the gamut of blues from aquamarine to midnight, while "Time Jockeys" indicates Time to Cook, which lists the cooking times for a variety of food and has a musical alarm to make sure

> nothing burns. Unique is Cuffs from the "Promises" range—a
POP Swatch mounted on an actual shirt cuff and Skinny from
the "Primaries" with superthin strap in sophisticated black.

The watch for Swatch the Club members is Garden Turf, a
Swatch Access. It has a memory of its own—a microchip that
can be programmed with skipasses and admission tickets and a
whole lot of other things—a fabulous bargain for Club members.

There have been many attempts to define the Swatch style.
Swatch has always had a "streetwise" streak—a desire to
provoke. The art form that Swatch really identifies with is graffiti.
The artists who designed Swatch dials were from the new world
of art, not the "mainstream." Typical of Swatch's outlook are the
street painting performances organised in Paris, London, and
Basel, and its participation in the "World Breakdance
Championship" at the Roxy New York.

As part of its promotional activities Swatch organizes design
competitions and promotes new sports such as snowboarding,
mountainbiking, freestyle skiing. Serious art *is* taken seriously—
like the Pierre Boulez concert tour, for example—so long as it is a
shade unorthodox or unusual. Repeat performances are out.

And in a justified spirit of self-advertisement, Swatch has been
proud to organize "events" to celebrate production milestones
like the 5/50 Fest in Bienne when the 50 millionth Swatch came
off the production line after only five years, and "Swatch the
World" event of 1992 in Zermatt to celebrate the 100 millionth
Swatch.

But all this is part of the ambient Swatch style. The real style is in
the product itself—the cheeky colorful timepieces that shattered
a lifetime's notion that a watch is a precious object to be revered
and handed down from generation to generation. Because there
is a Swatch for everyone and every occasion it has no
pretensions to greatness or longevity. It is content if it has
cheered its owner up and kept him or her in good time, even for
a short time.

II

Collecting Swatch

Collecting Swatch

> **Before starting a collection—of anything, not just watches or Swatches)—it is a good idea to find out all you can about the subject. That means reading about its history and all other aspects of it—such as the current situation on prices—that are likely to influence you in building up a collection. Of course the best way to find out about Swatch is to join Swatch the Club.**

One of the items members receive is the twice-yearly Swatch Journal, which contains not only up-to-date information about the latest creations but articles of interest about other Swatch models and promotions and events that members can attend. Part of the fun of collecting is meeting other enthusiasts, exchanging information, and also perhaps swapping models.

Besides the Club, there are other sources of information such as International Wrist Watch, a magazine for watch collectors which publishes articles about Swatch from time to time, including the latest prices at auction and estimates the prices of current models in demand.

This, like other magazines, has a classified section where readers exchange details of models they want to acquire or sell. Auctioneers' catalogs are another useful source of information about what is available and what the prices are. If you can find out about forthcoming auctions it is a good idea to attend, even if you are not ready to buy yet, to get the feel of the market place and to gain experience in the technique of bidding at auctions. Auctioneers' staff are also usually friendly and helpful if you can occasional secondhand one, although most collectors deal only in mint condition, i.e. unworn examples.

The classified columns of local newspapers are another useful source—there are specialist houses who deal only in Swatch and their advertisements are usually in local papers or in a number of specialist magazines.

Having decided you want to start a collection, the next step is to make up your mind exactly what it is you are going to collect.

The Swatch World Journal *was originally produced as a single color information sheet for members of the Swatch Collectors of Swatch Club in the Fall of 1991. It looked a bit like the London* **Times**—*very formal and rather dull.*

However, it soon adapted itself to the company it was keeping—it went into full color and its format became more exciting. With No. 11, in the summer of 1995, it reached its current form with a new design, a new format and different paper (more environmentally friendly). From a 20-page tabloid-size paper it developed into a full-scale bright, busy 40-page magazine, with a special section for Swatch Club members.

Its articles, some of which feature as "Snippets" in this book, frequently contain information about the models or the people associated with them that is not to be found elsewhere.

> There are getting on for 2,000 different Swatch models so the first thing to decide is in which category you are going to specialize. Unless you are very rich, bearing in mind that the rarer the Swatch the higher the price, it is wise to confine your collection to one type. It need not necessarily be all Scubas, or all Automatics. You could start a Swatch collection of models that had flowers on them, or photographic reproductions, or messages. That way your collection could embrace many different types—Standard, Automatics, Ironys, and even Maxis if you have the room—without becoming too extensive.

Having decided on your "theme" you are ready to make your first purchase. If it is a current model—or indeed any piece that you intend to keep in your collection—remember to keep every piece of paperwork about it: the receipt, the packaging, the guarantee and, if it is a Chrono for instance, the Official Certificate from the Swiss Timing Authority. And the same goes for any model you buy privately or at auction. Not only is this essential in proving its provenance if you decide later on to sell it, it is essential if you are to get the current value for it. And it goes without saying—do not wear it! It has to be kept in mint condition.

Once you have started your collection, take care of your watches. Mechanical ones should never, if at all possible, be allowed to stop. Many people think that if it isn't going, it is saving wear and tear on the movement, but that isn't wholly true. If the movement is not kept going, the special oil that lubricates the delicate mechanism will dry up and harden. It may become clogged with dust which will act like emery paper on the tiny bearings and do more harm than if it keeps on ticking away—after all it is designed to tick/tock every second of every day for quite a few years! Winding them once a week will be sufficient to keep your mechanical models (at this stage that means any Swatch Automatics) in good order.

Quartz watches obviously do not have to be kept wound—they will keep going on their own—but do remember that they have a definite battery life. Swatches have three-year batteries and the battery should be renewed before the end of that period as a spent battery can cause damage to the movement.

Keep your collection in an even temperature if at all possible. Although your Swatch is tested to run between zero and 50°C (32°–122°F), no watch likes sudden changes of temperature or humidity. As you build up your collection it is a good idea to make or buy a special cabinet in which to keep it free from the elements that may cause it to deteriorate.

The effect Swatch has had on the collector's market has caused some people to refer to "Swatch mania" and to wonder if the Swatch collecting bubble has burst. Events do not seem to have

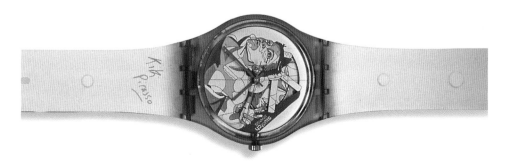

> borne this out. The fantastic sales at £1,000 (about $1,650) each of 600 Tresor Magique in Bond Street in a few hours is one example. And a study of the marketplace as revealed by the auction houses and the classified advertisements would seem to indicate that it is still necessary to pay quite high prices for certain "desirable" pieces.

It is important for collectors to establish which are genuine "limited" editions and which have been reissued. The four models produced to celebrate the 700th anniversary of the founding of the Swiss Confederation, for instance, were supposed to be very rare when first produced, but since the original numbered series several reissues have emerged to reduce the asking price.

So collectors would be advised not to rush in too quickly, nor to pay too much for newly released models until they have some evidence of how they have been received, and if they are of a genuinely limited edition.

The following prices are reprinted, with permission, from *International Wrist Watch*, Issue 18. They are printed purely as a guide to the sort of prices Swatches were fetching then. All prices are for watches that are unworn, in mint condition, with the original box and guarantee.

On the international salesroom circuit, some rare models reach fantastic levels. A prototype of Kiki Picasso's Swatch Art Special sold for 34 million lire (approximately $20,600) and the production model for 32 million lire ($19,500) at an Antiquorum auction in Milan a few years ago. In Hong Kong, buyers paid over HK$80,000 ($10,700) for a Ferrari Swatch and HK$177,600 ($23,900) for a rare Swatch Puff.

	SINGLES		US$
Kiki Picasso	Swatch Art 1985		25,000–40,000
Mimmo Paladino	Swatch Art 1989		15,000–25,000
Desert Puff	Blow your Time Away 1985		15,000–20,000
Original Jelly Fish	Special 1984		7,000–9,000
Velvet Underground	USA Special 1985		5,000–6,000
Breakdance	USA Special 1985		2,000
Olympics Logo	Special 1984		1,800
Hollywood Dream	Christmas 1990		1,500
Tennis Stripes	1983		1,500
Mozart	Christmas in Vienna 1989		1,000
	SERIES	**No. in set**	**US$**
Keith Haring	Swatch Art 1986	4	60,000–80,000
Alfred Hofkunst	One More Time Pop Art 1991	3	2,000–3,000
Fondation Maegt	Swatch 1988	3	2,000–3,000
700th Anniversary of Swiss Federation	Swatch Specials 1991	4	2,000
Jean-Michel Folon	Swatch Art 1987	3	2,000

But a glance at recent classified advertisements in the United Kingdom showed that some early Swatches could be obtained for far more modest figures—£350 ($565) for a Golden Jelly, or £90 ($145) for a Vivienne Westwood Orb. A Chandelier 1992 Christmas Special—one of 1,000 sold in one day in a shop opened specially for the occasion in London's Covent Garden—was offered at £165 ($266); another collector, an American, offered a similar model at US$1,000 (£620). Its original price was £45 ($72).

And in all cases, remember the old adage "Caveat emptor" (Buyer beware!). You have to bear in mind that the values of such collectibles may vary considerably from month to month. Make sure you keep up-to-date with them.

Swatch The Club

> **Swatch became a collector's item very early on in its life—a situation which was quite unforeseeable in a product designed to be low-priced and expendable. One of the reasons for Swatch's policy of launching two fresh collections each year—what they called their philosophy of change—was to keep the prices affordable to a wide market. But the customers started collecting them—and kept on collecting them—much to the concern of the management, because it tempted some outlets to hold back on supplies, consequently forcing up prices, which was the exact opposite of what Swatch had originally set out to do.**

In order to rationalize the situation, in August 1990 Swatch launched a club called, rather clumsily, "The Swatch Collectors of Swatch Club." Fans from all over Europe—and other parts of the world (2,000 came from the United States)—rushed to join and barely one year later the *Swatch World Journal* printed the names of the first 20,000 members in alphabetical order starting with Emanuele Abata and ending with Jüngkarl Zysset. Among them was Nayla Hayek.

The larger group of fans was in the 26–35 age bracket, followed by the over 35s; third largest was aged 19–25. They were divided in the proportion two females to three males.

Members received a membership card and pin; the *Swatch World Journal* twice a year; *Swatch News* update every three months; the opportunity to buy exclusive Swatch merchandise; invitations to international and national events and priority tickets to some of them and, of course, a free Club watch—exclusive to Club members.

Members also receive a catalog update and the right to purchase particular Swatch Specials. The original club was set up, naturally, in Switzerland. As a foretaste of the sort of event the Club was to organize for members, the Swiss Club had a whale of a time at the "Festival du Rive" in Montreux that year.

Soon, Italy, France, Germany, and Spain had their own Clubs and in 1993 the members joined together for a Swatch Cruise in the Mediterranean. In October 1993 a branch of the Swatch Collectors of Swatch Club was launched in the United Kingdom.

Typical of the sort of event organized by national clubs in support of an international Swatch launch was the Sea Fever party organized by the UK Swatch Club in July 1995 to introduce the C-Monsta.

Of the 30,000 models released worldwide, Great Britain received just 750, which were available on a first come, first served, one per applicant basis on Brighton beach on July 29, 1995 for £50 ($82).

The offer was open to the general public but for Club members alone a strictly limited supply of 365 Pacific Beach models—a

CONGRATULATIONS TO THE FIRST 20'000 MEMBERS

Katharina Abeler; Simone Abendschön; Maurizio ...bram; Lazaros Abramidis; Wini Abresch; Barba- ...Acampora; Marco Accardi; Pierpaolo Accattini; ...erbi; Roberto Acevedo; Ralf Achenbach; Marie- ...Peter Acker; Heiner Ackermann; Robert Acker- ...Ursula Ackermann-Liebrich; Wilfried Acker- ...na Adam; Herta Adam; Claudio Adami; Arman- ...Marco Addevico; Silja Adena; Gunnar Ader; Ju- ...Aeberhard; Marlies Aeberhard-Kramer; Michae- ...ebersold; Roland Aebi; Leni Aebischer; Steven ...eby; Kerst Aengeneyndt; Peter Aeschbach; Wer- ...Jean Aeschlimann; Liliane Aeschlimann; Peter ...Affluant; Christoph Affolter; Margrit Affol- ...o Agliano'; Carlo Aglietti; Roberto Agnoli; Nico- ...ostini; Maria Agostini-Schwarz; Ferdinando Agresta; Manue- ...ard Ahlstroem; Klaus Ahrend; Helga Ahrendt; Ulrich Ah- ...ide Aiello; Angelo Airaghi; Angelo Airoldi; Giuseppe Aita; ...; Ivano Alaimo; Francesca Alati; Annalisa Albani; Riccardo ...asini; Massimo Albasini; Wolfgang Albeck; Johannes Alber; ...ers; Axel Alberstätter; Ralf-Werner Albert; Andrea Albertaz- ...berto Alberti; Zoia Albertina; Marco Albertini; Ralf Alberts; ...enato Albonico; Reto Alborghetti; Franca Alborghetti; Alex- ...Klaus Albrecht; Oliver Albrecht; Peter Albrecht; Rudolf Al- ...; Andrea Alciati; Giuseppe Aldeghieri; Helen Alder; Gabri- ...dra; Claudio Alessandri; Antonio Alessandro; Luisa Alessan- ...lbert Alexander; Stev Alexander; Giuseppe Alfano; Antonio ...ieri; Karin Algasinger; Ferdinando Alghisi; Turkün Algun; ...Eugenio Allaria; Ilio Allas; Andrea Allegri; Delicata Allegri- ...nann; Heinz Allemann; Ursula Allemann-Eicher; Willy Alle- ...Stefan Alles; Gaby Allet; Maddalena Alleyson; Lutz Allhu- ...Alliod; Lilly Allmendinger; Ivano Allodi; Diego Allomazzo; ...Gabriella Aloi; Olga Aloisio; Omar Alquati; Bettina Alsters; ...o; Rolf Altermatt; Volker Altevogt; Christine Althaus; Panu- ...sabeth Altherr; Salvatore Altieri; Frank Altmann; Hans Alt- ...André Altreiter; Werner Altreuther; Bruno Aluffo; Ermanno ...her; Orfeo Amadei; Davide Amadesi; Carlo Amadio; Marco ...ella Amaduzzi; Linda Amann; Katrin Amann; Per Amann; ...nno Ambrosetti; Anita Ambrosetti; Carol Ambrosetti; Jean- ...o; Daniel Ambühl; Hans Ambühl; Alberto Ameletti; Marta ...que Ammann; Iris Ammann; Nancy Ammann; Regina Am- ...ndola; Helmut Ammer; Lars-Oliver Ammer; Martin Ammer; ...mmon; Stefano Ammon; M.pia Amodeo; Salvatore Amore; ...ne Amrein; Anselm Amrhein; Heidi Amrhein; Margrit Am- ...ntonio Ancona; Claudio Ancona; Francesco Andaloro; Ursu- ...helm Anderl; Christian Anders; Ina-Maria Anders-Lienert; ...ndré; Daniel Andreae; Simone Andreano; Ulrike Andreas; ...ndreini; Alessandro Andreis; Carla Andreoli; Maria Andreo- ...eotti; Rachele Andreozzi; Staale Andresen; Dirk Andresen; ...udio Andronico; Pia Andry; Alessandro Anelli; Rita Marina ...adine Angele-Blener; Amos Angelini; Gianfranco Angelini; ...Alfino Angeloni; Lior Angelovici; Silvia Angelozzi; Marco ...domenico Angius; Roberto Angivoni; Fabio Angri; Giulio ...Annechini; Ruedi Anneler; Bernard Annen; Juerg Anner; ...ella Annoni; Romano Annovazzi; Carlotta Ansaldi; Arturo ...nselmetti; Edmondo Anselmi; Luca Anselmini; Gabor An- ...; Francois Antille; Antonio Antinolfi; Roberto Antognozzi; ...na Antonelli; Settimio Antonelli; Stefano Antonelli; Giancar- ...nicoli; Alessandro Antonin; Alessio Antonini; Claudio Anto- ...anja Antonovie; Giancarlo Anzani; Mauro Anzi; Lucio Anzi- ...Apolito; Cristina Apostolo; Agostina Apotheloz; Uwe Ap- ...sy Appl; Peter Appl; Marcel Appréderis; Gianni Aquilani; ...kie Arany; Archie Arany; Daniela Arata Cinquanta; Amalia ...oberta Arcangeli; Carla Arcieri; Daniele Arcoria; Francesco ...issone; Vanessa Ardito; Marco Ardizzoni; Claudio Ardizzo- ...Sylke Arends; Urs Arendt; Barbara Arendts; Valeria Alessan- ...osy Arienti; Adele Ariola; Giovanni Arioli; Roberto Ariotti; ...acomo Armani; Paolo Armanni; Deborah Armati; Philippe ...Eugenio Armici; Brigitte Armiento; Adelina Arnaldi; Alber- ...o Arnaudo; Kaspar Arnett; Louis Arnitz; Andrea Susanne ...e Arnold; Gabi Arnold; Gaby Arnold; Hans Rudolf Arnold; ...Arnold; Markus Arnold; Mina Arnold; Pius Arnold; Theres ...Arns; Sascha Daniel Arns; Paola Aronson; Gabriela Arpa- ...igo; Alessandro Arrigoni; Andrea Arrigoni; Gianluigi Arrigo- ...rco Arteconi; Angela Artioli; Nina Artioli; Peter Artmann; ...Nicolo' Asaro; Alexander Asbach; Agnese Ascari; Alberto ...dreas Ascherl; Joel Aschkenasy; Norbert Asch- ...en; Paola Ascoli; Gianluca Ascolini; Leon Luci- ...rancois Assar; Gertrud Assmann; Birgitta Astol- ...ano Attus; Paolo Atzeri; Stéphane Aubin; Jan ...der Mauer; Wolfgang Auffenberg; Holger Niels ...Urs Augstburger; Daniele Aulari; Barbara Au- ...der Beek; Alexander Aust; Grazia Auteri; Gaeta- ...Alessandro Avelardi; Francesco Avigo; M.grazia ...manuele Aymerich; Pier Luigi Aymerich; Carlo ...co Azzone; Celestino Azzoni; Guido Azzopar- ...lberto Babboni; Giuliano Babetto; Ina Babilon; ...amilla Baccalini; Alessandro Baccani; Massimo ...Anna Maria Bacci; Marco Bacci; Luca Baccin; ...acher; Carolin Bacher; Giorgio Bacherini; Mark ...a Bachmann-Ammann; Erica Bachmann; Evely- ...Bachmann-Räz; Peter Bachmann; Raoul-Philip ...ann-Ebel; André Bachofner; Marco Bachthaler; ...der; Michael Backhaus; Luca Bacoccoli; Rodolfo ...der; Peter Bader; Remo Bader; Torsten Bader; ...; Uwe Badtke; Ernst Baechi; Markus Baechler; ...; Dieter Baer; Doris Baer; Peter Baer;

Biagini; Chiara Biagini; Antonio Luca Biagini; Cecilia Biagioli; Valerio Biagioni; Luigi Biagioni; Caterina Biagioni; Roberta Biagiotti; Rose Bialek; Mauro Biancardi; Tomaso Biancardi; Danila Bianchessi; Moreno Bianchetto Songia; Andrea Bianchi; Anna Bianchi; Antonella Bianchi; Corrado Bianchi; Gian Marco Bianchi; Giovanni Bianchi; Giuliano Bianchi; Isabelle Bianchi-Villiger; Leopoldo Bianchi; Lucia Bianchi; Marco Bianchi; Marino Bianchi; Neva Bianchi; Paolo Bianchi; Roberto Bianchi; Rosemarie Bianchi; Tatiana Bianchi; Vittorio Bianchi; Stefano Bianchini; Gianluigi Bianchini; Massimo Bianchini; Daniela Bianchini; Giacomo Bianchini; Emanuele Bianchini; Fabio Bianciardi; Fabrizio Bianco; Gianluca Bianco; Aurora Bianco; Davide Bianco; Carlo Bianco; Daniele Bianconi; Luca Biancoviso; Lisa Bianculli; Umberto Bianchetti; Brunello Biasini; Maura Biasissi; Chiara Biasoli; Tobias Biber; Fabio Bicci're; Claudine Bichet; Silvia Bichi; Claudia Bichler; Daniel Bichsel; Ursula Max Bichweiler; Manfred Bick; Rolando Bida; Stefano Bidetti; Mario Bidone; Milde Bieber; Anneliese Bieber; Thomas Bieber; Wilhelm August Bieber; Timo Bieber; Ralf Biebricher; Roland Biechy; Alain Biedermann; Silvana Biedermann; Rosmarie Bieger; Klaus Biehn; Dagmar Biel; Matteo Biella; Francesco Biella; Paola Bielli; Antonella Bielli; Helmut Bienefeld; Marille Bienek; Oliver Biener; Guenter Biener; Eva Bierbrauer; Herbert Bieri; Josiane Bieri; Peter Bieri; Alexander Bieri; Hans-Peter Bieri; Heinz Bieri; Dirk Bierkamp; Monika Biermann; Roland Biersack; Hans-Jürgen Bierschenk; Stephan Bierwirth; Giorgio Biestro; Gian Franco Biffi; Roberto Bifulco; Rosario Bifulco; Antonello Bigazzi; Stephan Bigger; Roger Bigger; Allessandro Bigger; Massimo Biggio; Elisabetta Biggio; Alessandra Bighetti; Andreas Bigler; Gian Carlo Biglia; Irma Bignami; Piermauro Bignotti; Beatrix Bihrer; Thomas Bihrer; Barbara Bihrer; Roland Bijaoui; Alessandro Bilancione; Karina Bic; Biliotti Milton; Ingrid Bilk; Claus Bilk; Marie-Isabelle Bill; Frank Biller; Wolfgang Biller; Christina Biller; Andrea Billeri; Diana Billian; Thomas Billig; Hans-Martin Bilsdorfer; Thomas Bilsing; Stephan Bilsing; Carlo Bimbo; Mario Bin; Claudio Bina; Ferdinando Binaghi; Riccardo Binaghi; Michele Binaghi; Pierluigi Binda; Camillo Binda; Felix Binder; Stephan Binder; Urs Binder; Katja Binder; Stephane Biner; Jean Yves Binet; Mike Bingesser; Christiane Binggeli; Martin Binggeli; Dirk Bingler; Karin Bingold; Andrea Bingula-Grilec; M.cristina Bini; Alberta Bini; Ernst Binner; Richard Binns; Doris Binz-Gehring; Wolfgang Binzegger; Giacomo Biondi; Paolo Biondolillo; Arturo Biraghi; Daniel Bircher; Gabriela Bircher; Franco Birkemeyer; Karin Birkenbach; Christiane Birkenfeld; Francesco Biroli; Chiara Biroli; Bruno Birrer; Maurizio Bisagno; André Bisang; Fulvio Bisanti; Giorgio Bischeri; Beatrice Bischof; Daniel Bischof; Dionys Bischof; Paul Bischof; Peter Bischof; Reinhard Bischof; Urs Bischof; Hartmut Bischoff; Norma Susan Bischoff; Tom Bischoff; Susanne Bischofsberger; Tommaso Biscotti; Marco Biselli; Anders V. Bisgaard; Mara Bison; Corinna Bissaga; Susanne Bissey; Marco Bissi; Vitaliano Bissi; Thomas Bissig; Ute Bissinger; Enrica Bistagnino; Martin Bister; Andy Bittig; Rosie Bittig; Astrid Bittl; Claudia Bittner; Sandro Bizzarri; Massimo Bizzarri; Marco Bizzarri; Roland Björkman; Claude Blaettler; Isabelle Blaettler; Peter Blaha; Maria Grazia Blais; Junod Blaise-Alain; Mauro Blanc; Magali Blanc; Carina Blanchi; Thomas Blank; Dirk Blank; Laura Blank; Jörg Blanke; Yves-Claude Blankenbuehler; Frank Blankennagel; Stephan Blann; Eddy Blans; Claudia Blaschke; Yvonne Blaser; Rolf Blaser; Monika Blaser; Stephan Blaser; Domenico Blass; Christine Blatter; Annamaria Blatter; Stefan Blattner; Nadja Blattner; Angelika Blauel; Monika Blaumeiser; Gudrun Blecher; Arno Bleckert; Ulrich Bleile; Michael Bley; Jürg Blickenstorfer; Wolfgang Blieninger; Susanne Bloch; Waltraud Bloch; Raymond C. Bloch; Ursula Block; Ingo Bloedorn; Hildegard Bloem; Yvan Blomme; Michele Blonna; Giovanni Blotto; Klaus Blucke; Roswitha Bluethmann; Peer Bluhm; Cord Bluhm; Melanie Blum; Marion Blum; Blum; Karin Blum; Cornelia Blum; Manfred Blum jun.; Roswitha Blum-Kleinert; Marianne Blume; Patrick Blumenschein; Karin Blumenthal; Marianne Blumer; Jürgen Blümlein; Enrico Bo; Roberta Boario; Giovanni Boasso; Silvia Boasso; Delia Bob; Silvana Bobbia; Giancarlo Bobbio; Raffaella Bobst; Aldo Edoardo Bobst; Ornella Bobst-Moccetti; Giuseppe Boccaccio; Bettina Boccafuoco; Carlo Boccalatte; Silvia Bocchini; Mauro Bocchio; Alessandro Boccingher; Claudio Boccolari; Federico Boccucci; Bruno Bocedi; Corinne Bocherens/Snamprogetti SA; Gisela Bock; Christian Bock; Josef Bock; Jürgen Bockholt; Kristina Bockhorn; Martin Boecksch; Simone Bodden; René Bode; Christoph Bodenschatz; Jeannette Bodensohn; Gunter Bodensohn; Sibylle Boder; Edmund Bodewein; Marco Bodigoi; André Bodmer; Christoph Bodmer; Dominic Bodmer; Heidi Bodmer; Helen Bodmer; Marc Bodmer; Michèle Bodmer; Werner Bodmer; Willy Bodmer; Thomas Bodner; Silke Bodschwinna; Eva Boeckel; Christoph Boegli; Michel Boegli; Helga Boegli-Bohren; Bettina Boehle; Manuela Boehm; Cedric Boehm; Barbara Boehme; Enno Boek; Ursula Boelte; Giorgio Boemo; Rolf Boening; Werner Boer; Franco Boero; Ernst Boesch; Cristiano Boetani; Roland Bofelli; Serenella Boffi; John Bogazzi; Francesca Boggeri; Alberto Boggi; Carla Boggiatto; Eleonora Boggio; Andreas Bögli; Silvia Bogliardi; Angela Bogliolo; Ellen Martina Bogner; Alberto Bogoni; Paolo Bogoni; Marianne Boguslawski; Ricardo Bohl; Thomas Bohl; Nicole Bohle-Finkeldei; Michael Böhlke; Uwe Bohlmann; Petra Böhm; Andreas Böhm; Jürgen Böhm; Ulrich Böhme; Vivien Böhmer; Thomas Böhmer; Daniel Bohn; Juerg Bohne; Elke Bohner-Necker; Willy Bohnet; Inese Bohorquez; Markus Böhringschulte; Jochen Bohse; Massimo Boidi; Marco Boido; Eric Boillat; Alain Denis Boillat; Olivier Boimond; Michel Bokhobza; Alexis Boklund-Riviera; Patrizia Boldrini; Andrea Boldrini; Andrea Bolduan; Elena Bolengo; Nicolai Boleslawsky; Lilian Ann Bolgiani-Schutzbach; Wolfgang Bolinski; Tomaso Mario Bolis; Emmanuele Bolla; Adriana Bolla; Ruben Bollag; Cornelia-Jeanne Bollag; David Bollag; Pier Franco Bollati; Marco Bollato; Ruedi Boller; Sam Bolleter; William Bolleter; Remo Bolli; Giuliano Bollich; Jean-Pierre Bollier; André Bolliger; Christoph Bolliger; Eva Bolliger; Jost Bolliger; Rosmarie Bolliger; Urs Bolliger; Eugen Bollinger; Dominik Bollinger; Karin Bollinger; Gabriella Bologna Crespi; Guido Bolognesi; Axel Bolte; Andrea Bolten; Mauro Boltrizzi; Thomas Boltshauser; Ellen Boltshauser; Giampaolo Bolzacchini; Maurizio Bombarda; Deborah Bombeck; Paolo Bombelli; Michael Bomke; Sabine Bommel; Alessandro Bon; Giampaolo Bon; Lorenzo Bona; Marco Bona; Roberto Bona; Alan Bona; Gabriele Bona; Giacomo Bonacchi; Pietro Bonacchi; Vincenzo Alessandro Bonaccorso; Alessandro Bonaconsa; Monique Bonaconsa; Alessia Bonade'; Lucia Bonafede; Edoardo Bonaiuti; Valter Bonalumi; Marco Bonalumi; Pierpaolo Bonanomi; Paola Bonardi; Anna Bonardi; Stefano Bonasoni; Fabio Bonassi; Silvana Bonati; Oscar Bonato; Amina Bonato; Bruno Bonato; Franco Bonaventura; Manuela Bonazza; Simone Bonazzi; Fabio Bonci; Riccardo

mas Bohl; Nicole Bohle-Finkeldei; Michael Böhlke; Uwe Bohlmann; Petra Böhm; Andreas Böhm; Jürgen Böhm; Ulrich Böhme; Vivien Böhmer; Thomas Böhmer; Daniel Bohn; Juerg Bohne; Elke Bohner-Necker; Willy Bohnet; Inese Bohorquez; Markus Böhringschulte; Jochen Bohse; Massimo Boidi; Marco Boido; Eric Boillat; Alain Denis Boillat; Olivier Boimond; Michel Bokhobza; Alexis Boklund-Riviera; Patrizia Boldrini; Andrea Boldrini; Andrea Bolduan; Elena Bolengo; Nicolai Boleslawsky; Lilian Ann Bolgiani-Schutzbach; Wolfgang Bolinski; Tomaso Mario Bolis; Emmanuele Bolla; Adriana Bolla; Ruben Bollag; Cornelia-Jeanne Bollag; David Bollag; Pier Franco Bollati; Marco Bollato; Ruedi Boller; Sam Bolleter; William Bolleter; Remo Bolli; Giuliano Bollich; Jean-Pierre Bollier; André Bolliger; Christoph Bolliger; Eva Bolliger; Jost Bolliger; Rosmarie Bolliger; Urs Bolliger; Eugen Bollinger; Dominik Bollinger; Karin Bollinger; Gabriella Bologna Crespi; Guido Bolognesi; Axel Bolte; Andrea Bolten; Mauro Boltrizzi; Thomas Boltshauser; Ellen Boltshauser; Giampaolo Bolzacchini; Maurizio Bombarda; Deborah Bombeck; Paolo Bombelli; Michael Bomke; Sabine Bommel; Alessandro Bon; Giampaolo Bon; Lorenzo Bona; Marco Bona; Roberto Bona; Alan Bona; Gabriele Bona; Giacomo Bonacchi; Pietro Bonacchi; Vincenzo Alessandro Bonaccorso; Alessandro Bonaconsa; Monique Bonaconsa; Alessia Bonade'; Lucia Bonafede; Edoardo Bonaiuti; Valter Bonalumi; Marco Bonalumi; Pierpaolo Bonanomi; Paola Bonardi; Anna Bonardi; Stefano Bonasoni; Fabio Bonassi; Silvana Bonati; Oscar Bonato; Amina Bonato; Bruno Bonato; Franco Bonaventura; Manuela Bonazza; Simone Bonazzi; Fabio Bonci; Riccardo

Boncompagni; Francesco Boncompagni Ludovisi; Andrea Bondavalli; Stefan Bondeli; Fabrizio Bondi; Carlo Bondi Mazzoni; Grazia Bondioli; Alessandro Bonelli; Valeria Bonelli; Madeleine Boner; Lidwina Boner; Bernhard Boner; Urs Boner; Giorgio Bonesio; Virginia Bonetta; Enzo Bonetti; Luca Bonetti; Luciano Bonetti; Marco Bonetti; Rosalba Bonetti; Andreas Bonetto; Amedeo Bonetto; Fatima Bonfa'; Diego Bonfadini; Domenico Bonfanti; Laura Bonfanti; Marina Bonfanti; Silvano Bonfanti; Carlotta Bonfanti; Angelo Bonfati; Davide Bonfigli; Arianna Bonfili; Massimo Bonfio; Norbert Bongardt; Luca Bongiorni; Alessandra Boni; Anna Maria Boni; Barbara Boni; Dario Boni; Ezio Boni; Matteo Boni; Rossana Boni; Ciro Boni; Alessia Bonifazi; Ildo Bonifazi; Marie-Angele Bonin; Renata Bonin; Antonella Bonincontri; Marco Bonin; Claus Bönisch; Claudia Bönisch; Donatella Bonivento; Eric Bonjour; Andreas bonn; Klaus Bonnet; Barbara Bono; Giancarlo Bonoldi; Umberto Bonollo; Walter Bonomi; Renato Bonomini; Elena Bonora; Luigi Bonora; Enzo Bonoretti; Domenico Bonpatore; Dietmar Bonsch; Barbara Bontempi; Tiziana Bontempi; Rodolfo Bontempi; Giovanni Maria Bontempi; M.antonietta Bontempo; Gabriele Bonu; Roberto Bonuccelli; Luciano Bonvini; Tamara Bonzi; Pierpaolo Bonzo; Ruth Boos; Roland Bopp; Claudia Bopp; Katharina Borchard; Daniel Borchardt; Gunter Borchers; Kai Borchert; Marcel Borchert; Reinhard Borck; Franco Bordegnoni; Edgar Bordier; Roberto Bordin; Claudio Bordin; Giuliano Bordin; Gianfrancesco Bordogni; Roberto Bordoni; Giuseppe Bordonzotti; Marianne Borel; Tiziano Borella; Alberto Borellini; Arianna Borellini; Roger Borer; Lukas Borer; Heidi Borer; Luigi Boretti; Michael Borgeest; Framca Borghese Formi; Michele Borghi; Paolo Borghi; Vittorio Borghi; Andrea Borghi; Massimo Borghi; Nora Borghi; Federica Borghini; Elena Borghino; Gianfranco Borgni; Chiara Borgo; Marco Borgogna; Giuseppe Borgogna; Andrea Borgogni; Lorenzo Borgognoni; Elisabetta Borgognoni; Carolina Borgoni; Simona Borgonovo; Andrea Borgonovo; Roberto Borgonovo; Pierangelo Borgonovo; Axel Borhauer; Mirella Borin; Daniele Borin; Luca Borin; Fulvio Borinato; Martin Boritzki; Stefan Bork; Wolfgang Bork; Pierluigi Borliona; Heinz Jürgen Borma; Juliane Bormann; Heinz Born; Sylvia Born; Barbara Born; Joachim Born; Wolfgang Bornemann; Hans Bornemann; Susanna Borner; Roslyn Börner; Henri Bornhauser; Hans Bornhäuser; Axel Bornhoft; Eveline Borntraeger-Stoll; Giusi Boroni; Nicola Borra; Marianne Borreano; Alberto Borrelli; Angelo Borrello; Giuseppe Borrello; Francesca Beatrice Borri; Massimo Borri; Antonella Borri; Marcello Borri; Jean-Pierre Borrini; Luca Borromeo; Fabrizio Borroni; Jeannette Bors; Andreas E. Borsari; Roberto Borsatti; Giuseppe Borsci; Paola Borsellini; Christine Bortenlänger; Albarosa Bortolin; Marco Bortolotti; Massimo Bortolussi; Anna Borzillo; Riccardo Borzoni; Elisabetta Bosca; Massimo Boscaratto; Andreas Bösch; Guido Boschert; Flavio Boschetti; Renzo Boschetto; Gloria Boschi; Vittorio Bosger; Bruno Bosco; Cristina Boscolo; Tyll Böse; Sabrina Bosetti; Giulio Bosetti; Angela Bosi; Andrea Bosi'; Stefano Bosia; Beat Bösiger; Grazia Bosin; Geo Bosini; Elena Bosio; Virginio Bosisio; Anthonia A. Bosman; Davide Bosoni; M.luisa Bosoni; Sandra Boss; Peter Boss; Dory Boss-Stucki; Michael Bossart; Hans Peter Bossart; Michael Bosse; Heike Bosse; Horst Bossemeyer; Pascale Bossert; Christel Bossert; Lorenza Bossetti; Renato Bossetti; Dora Bosshard; Hans-Juerg Bosshard; Martin Bosshard; Marcus Bosshard; Corinne Bosshardt; Sabine Bosshardt; Paolo Bruno Bossini; Gianfranco Bossis; Solange Bosson-Igunbor; Gabriele Botarelli; Luigi Botta; Federico Botta; Christiano Botta; Massimo Bottaccini; Sandra Bottai; Paolo Bottamedi; Igino Bottani; Diego Bottaro; Bruna Bottazzi; Gianluca Bottazzo; Michael Böttcher; Olivier Botteron; Viola Böttger; Andrea Botti; Miriam Botti; Sebastiano Botticella; Carlo Bottinelli; Giampiero Bottino; Federico Botto; Giorgia Botto; Damiano Botturi; Andreas Botz; Theo Bouchat; Benedikt Boucke; Jean-Pierre Bourdy; Nathalie Bourgeois; Nicolas Bourgeois; Nicole Bourgeois; Willi Bourgett; Heide Bourget; Erika Bourquin; Etcie Bourquin; Niklaus Boutard; Georg Boutellier; Roland Boutellier; Myrtha Boutellier-Knechtle; Danilo Bovari; Giuseppe Bove; Philippe Bovigny; Christophe Bovigny; Patrizia Bovino; Marco Bovone; Michael Boxheimer; Larry Boxler; Mirko Bozic; Ana Bozic; Leonardo Bozza; Stefania Bozzi; Roberta Bozzola; Bianca Bozzolan; Davide Bozzoli Parasacchi; Piergiorgio Braccioni; Zefferino Bracconi; Anna M. Bracher-Palvin; Sergio Brachi; Anita-Elisabeth Brack; Bernardo Bragalia; M.pia Bragaglia; Mauro Bragagna; Gianfranco Braglia; Hans Konrad Brahtel; Andreas Brake; Ella Braker-Schmid; Roberta Bramanbilla; Paola Brambilla; Patrizia Brambilla; Silvio Brambilla; Dierk Brammann; Alessandro Branca; Barbara Brand; Irene Brand; Markus Brand; Melitta Brand; Ronald Brand; Thomas Brand; Uwe Brand; Viola Brand; Kai Brandau; Thomas Brandeis

Castagno; Walter Castagno; Daniela Ca- lan; Simon Castellan; Jarno Castellani; lano; Massimo Castellengo; Marcella C... stelli; Annalisa Castellini; Guido Caste... Claudio Castignani; Antonio Castillo; F... no; Maddalena Cataldi; Luce Cataldo;... Catena; Francesco Catenacci; Norbert C... neo; Graziella Cattaneo; Davide Cattan... ruzza; Passera Cattleya; Patrick Catto;... Luigi Cavadini Lenuzza; Pierre Cavagn... Cavallari; Alessandro Cavallari; Piergion... lini; Daniele Cavallini; Roberto Cavallo... ro Cavicchioli; Lara Caviggioli; Mauro... Massimo Ceccanti; Leonardo Ceccantini... Giampiero Ceccarelli; Sabrina Ceccatell... la Cecchinato; Carlo Cecchini; Eleonora... Cecere; Fabio Cecilia; Giovanna Cecovin... sto Cella; Enrico Celli; Elena Celli; Gia... no; Nicolo' Centemero; Emilia Centi;... Alberto Cerbai; Claudio Cerbai; Isabe... Ceres; Patrizia Ceresani; Nathalie Cere... ta Cerisara; Luca Cerrato; Gisella Cerr... Angela Cervone; Valeria Cesana; Maur... Cettuzzi; Liliana Cettuzzi; Luca Cettuz... Chabloz; Raphaëlle Chalaby; Felix Ch... Chappatte; Philippe Chappuis; Jnes Ch... Chatelan; Camille Chautems; Andrea C... ci; Bruno Cheluggi; Ugo Cherubini; N... bai; Giuseppe Chiabra; Francesco Chiar... dia; Giorgio Chiarcos; Roberto Chiare... Chiaroni; Monica Chiarottini; Nathali... Mercurio; Luigi Chiella; Gian Maria Ch... co Chiesa; Gaia Chiesa; Simona Chiesa... Flavio Chiminello; Jimmi Chimmi; Car... Chinitzky; Stefano Chinni; Alfonso Chi... dio Chirardini; Riccardo Chiriatti; Mar... ti; Carlo Chiurlo; Piero Chiusano; Ala... Christ; Joachim Christ; Kai-Uwe Chris... Brigitte Christen; Kathy Christen; Marle... line Christinet; Andrea Christmann; Er... lo Ciabatti; Carlotta Ciacci; Emanuela... Ciampini; Grazia Ciampitti; Guido Cia... Claudio Ciarmela; Davide Ciaroni; Ren... to Cibrario; Settimio Cicala; Massimo... chetta; Massimo Cicchi; Katia Cicchi;... Cicero; Fabio Cicognani; Danilo Cicut... Cinzia Cilia; Emilio Ciliberti; Damian... lo Cimo'; Silvana Cincinelli; Emanuela... luca Cinnante; Giovanni Cinnirella; Gi... fi; Giovanni Cioffi; Sorin Cionca; Andr... lia Cipolla; Paolo Cipolla; Francesca Ci... Mariangela Ciriello; Pasquale Ciriglian... Cisotti; Giuseppe Citarella; Marco Citt... Lindo Ciuffetti; Primetta Ciuffetti; Lor... tella; Birgit Claaen; Eva-Maria Claasse... Clausen; Arne Clausmitzer; Taike Clau... mens; Giorgio Clemente; Riccardo Cle... te Clorius; Bruno Clouet; Elisa Cobessi... ni; Cristiano Codato; Federica Codella... Cohen; Madeleine Cohen; Orietta Col... Roberto Coli; Thierry Colin; Lenao Co... Maurizio Collina; Fabrizio Collino; Gi... Carlo Colombi; Giorgio Colombini; A... Camillo Colombo; Chiara Colombo; Gi... gio Colombo; Giuseppe Colombo; Lor... zio Colombo; Paola Colombo; Patrick... drea Columbano; Marco Comand; Al... Antonino Comi; Giovanni Comin; Rob... Enrico Comoglio; Elena Comotti; An... Christine Comtesse; Alessandro Comuz... Antioca; Patrizia Conconi Pellandini; V... ri; Alessandro Confalonieri; Flavio Com... fortola; Cristina Confortola; Alberto Co... Consolascio; Giannicola Consolini; M... Marco Contardi; Andrea Conte; Danilo... stabile; Carlo Conti; Claudio Conti; F... Conti Rossini; Laura Conti; Luca Con... Conti; Luigi Contini; Stefano Contini;... Conzo; Bob Coolen; Carmel Coombes... Coppola; Angelo Coppola; Fernando... Marisa Coralli; Tano Corallo; Pieter Co... Corbelli; Cristina Corbu; Biagio Corda... Corelli; Roberta Coretti; Milena Corna... Ottilie Corradi; Alessandro Corradi; D... do Corradini; Bruno Cornias; Giulio C... Cortella; Franco Cortellazzi; Annelise... Angelica Corti; Giulio Corti; Tullio Co... Cossio Di Codroipo; Sergio Cossu; Ma... lo Costa; Mauro Costa; Pietro Costa;... Claudio Costantini; Luca Costantini; Ri... Costanzo; Dominik Coste; Gianni Cos... Cottinini; Jürgen Couball; Christian Co... Mariella Covadonga; Gianfranco Covin... la Cragnolini; Anita Crain; Claude Cr...

> Scuba 200 with a message in a bottle—was available through what they call a "Right to Buy" draw. All the members had to do was complete a form and send it in accompanied by a check, 14 days before the launch. The watches could be collected by the successful applicants from the Swatch Fever Shops at a nominated point on Brighton beach on the great day.

The Sea Fever party was open to all UK club members, each of whom could bring up to three guests. To judge by the photographs it was a highly popular event.

On January 1, 1996 the name was changed to the much more with-it form of Swatch the Club and members prepared for another exciting year. Members were obviously kept abreast of many events and privileges organized for them mainly around the Atlanta Games. The rest of the word was not forgotten, however, and in October about 800 members attended the IMAX Film Festival in Luzern, Switzerland—Swatch has been an official partner in the Festival organization.

In November came the trip to Salzburg which was also the occasion to launch the wallet-in-a-watch Swatch Salzburg Access.

Swatch the Club all over the world

> **On the same occasion at Salzburg, the 15 heads of Swatch companies all over the world got together to discuss the problems of the Swatch fans whose countries had no Swatch clubs of their own.**

It was decided to form "Swatch the Club All over the World." From now on fans who don't have a Swatch the Club in their own country will be able to be members of Swatch the Club and will enjoy the same special offers, the *Swatch World Journal* and *Swatch News*, and to take part in events organized by the Club as members in other countries.

Swatch the Club now exists in Germany, France, Great Britain, Italy, Austria, Belgium/Luxembourg, and the United States, as well as, of course, Switzerland.

Swatch the Club All over the World will be based at the Swatch headquarters in Biel/Bienne in Switzerland where Swatch the Club International will take it under its wing as it does, for example, for the Swatch the Club Spain and Swatch the Club Netherlands.

Among the recent events for members were a week's vacation in February 1997 in one of Switzerland's winter sports areas; the launch of the romantic St. Valentine Special (Pounding Heart) and best of all perhaps, the Club Special for 1997, the Garden Turf Swatch Access model, free to members, which has also gained its owner reduced price tickets to some 15 rock and pop events all over Switzerland during the year.

There was an invitation to attend the Olympic collector's World Fair in March in Lausanne, with free entry to the Olympic Museum and a chance to meet some of the Olympic personalities such as Daley Thompson.

"The Sound of Swatch" was an extraordinary event held throughout August 1997 at the Kongresshaus in Salzburg during the traditional music festival. To the theme of music and watches, the exhibition included a "virtual orchestra"—the first electrical orchestra to be conducted by a watch! Well-known musicians who have been associated with Swatch MusiCall models—like composer Peter Gabriel and Saxophonist Candy Dulfer, also performed live. Naturally the Swatch Access Salzburg could be used for admission to the exhibition, concerts, restaurants and public transport.

Other events for members included a weekend in April to enjoy the snowboard racing at Flims and a Swatch Garden Party at the Club Med in Vittel, France in June.

Details of all these events, new product launches, and special offers are given to Swatch the Club members in *Swatch News*, Swatch Mini Newsletters, or the *Swatch World Journal.*

Very dedicated fans of Swatch have the unique opportunity of becoming a "Gold" member of Swatch the Club.

See page 159 for a full list of addresses.

III

The Swatch Directory

> After two years planning and three years of unremitting work by a group of some 30-40 technicians, designers, and managers variously known as the Team or the Crew, Swatch was eventually launched on March 1, 1983 in Switzerland, Germany, and the United Kingdom.

It was a water-resistant, shockproof watch in a simple round case of synthetic material that could be produced in a range of colors. It combined quartz accuracy with an incredibly competitive price. And it was Swiss made.

It was soon to have variations, additions, innovations. The various types of Swatch that have evolved over the years are listed here and illustrated in this chapter.

Each Swatch shown in the Directory has an information chart giving its name, code, and date of issue. In many instances the Swatch will belong to a series, and in these instances the name of the series is listed too.

The selection of Swatches in this chapter is based on the author's choice and aims to give a broad representation of Swatch development over the years—with an emphasis on the sheer diversity of innovative design that is such an integral part of Swatch.

Swatch Categories

38	**Standard Swatch**
61	**Swatch Art**
73	**POP Swatch**
82	**Maxi Swatch**
84	**Swatch Specials**
91	**Swatch Christmas Specials**
96	**Chronograph**
103	**Scuba 200**
110	**Automatic**
117	**Swatch the Beep**
121	**Stop-Watch**
123	**MusiCall**
127	**AquaChrono**
132	**Irony**
136	**Solar Swatch**
138	**Access**
141	**Olympic Collection**
146	**Collector's Models**

Standard Swatches

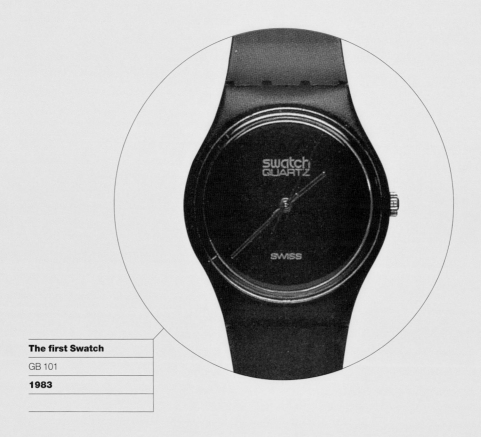

The first Swatch

GB 101

1983

83 84 85 86 87 88 89 90 91 92 93 94 95 96 97

> Two styles—women's and men's. One shape, a thousand colors, a thousand trends. Designed to match a mood, a piece of clothing, a loved one's eyes. On plastic straps or metal bands. Standard prices.

The first models were conservative with simple numerals on plain white or black dials, although they were not as bad as the earlier prototypes, which one marketing man described as "Small, black, and anything but beautiful."

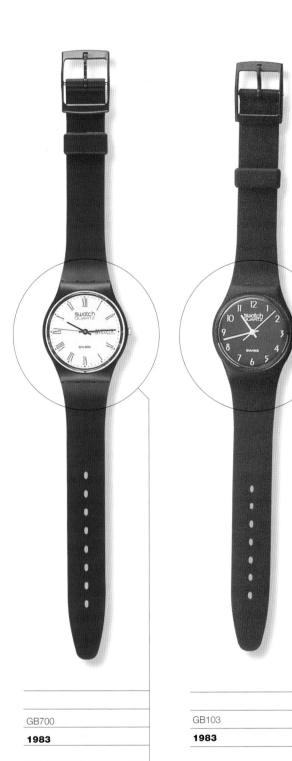

> More imaginative designs soon followed and right from the start women's models were produced—fulfilling an early promise. One Swatch feature was the method of fixing the straps to the case—a unique system and one that gave a very smooth transition.

By the spring of 1984 colorful straps, which matched the plastic cases, were added to complement the variety of dial designs. Each of the men's models had an identical but smaller women's version; the dreary code numbers were enhanced by stylish names, such as Windrose and Yellow Racer.

Windrose	Yellow Racer
GW103, LW103	GJ400, LJ100
1984	**1984**
Skipper	Waikiki Surf

GB700
1983

GB103
1983

> Swatch was continually changing. Provocative dials challenged the conventions: straps contrasted rather than complemented. Center seconds, date and day dates were alternative features that were soon available.

"Fashion that ticks" was a catchphrase from the early years. 1985 saw even more imaginative designs alongside the sober Pinstripe and a re-issue of the white dial in a black case.

Really wild combinations like the tartan-inspired McGregor and McSwatch pair were features of the fall of 1985 collection. Here with Sir Swatch, a heraldic role creeps in.

Compu-tech	**Pinstripe**
GR401	GA102
1984	**1985**
Graffiti	Carlton

Classic	**McGregor**
GB706, LB107	GJ100
1985	**1985**
Plaza	Street Smart

> While Nautilus had a vaguely aquatic feeling, Tonga an echo of pointed teeth and tribal carvings, and Horus a remote hint of Egypt, Vasily defied association with any theme.

Many of the early designs were the work of Jean E. Robert, a designer with a feeling for watches. Later others joined the design crew, bringing a fresh and provocative approach.

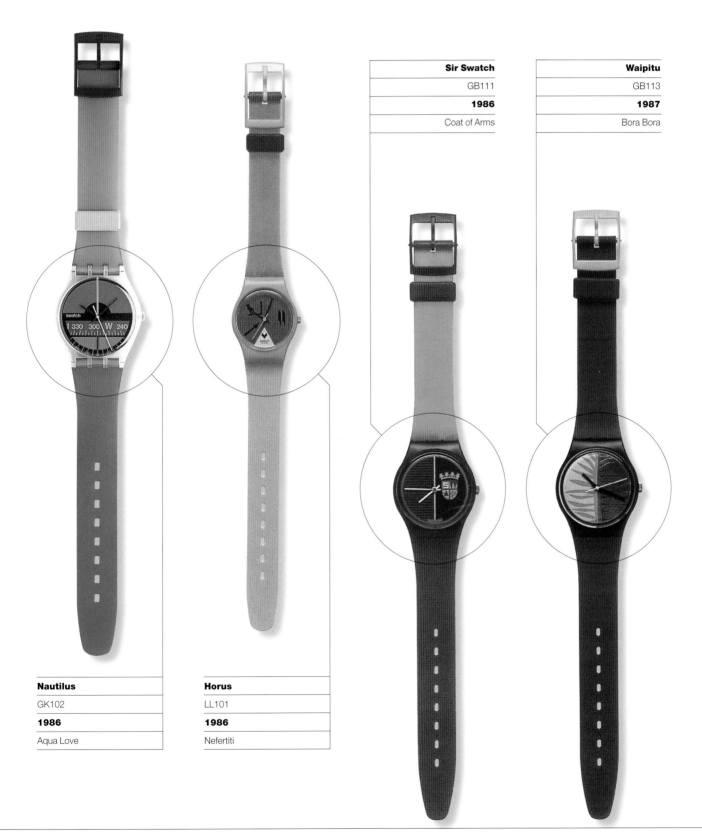

Sir Swatch
GB111
1986
Coat of Arms

Waipitu
GB113
1987
Bora Bora

Nautilus
GK102
1986
Aqua Love

Horus
LL101
1986
Nefertiti

> After much debate about the shape Swatch should be, it became clear that the ideal was a perfectly round case. Dial, hands, strap, and buckle could change in material or color as in Waipitu, so long as the shape remained immutable.

Every year 500 finished designs are debated before the final selection of some 70 models for each collection is produced. By mid-1987, some 30 million Swatches had been sold, so the formula must be working. Two typical 1987 designs were Calafatti and Borgo Nuovo.

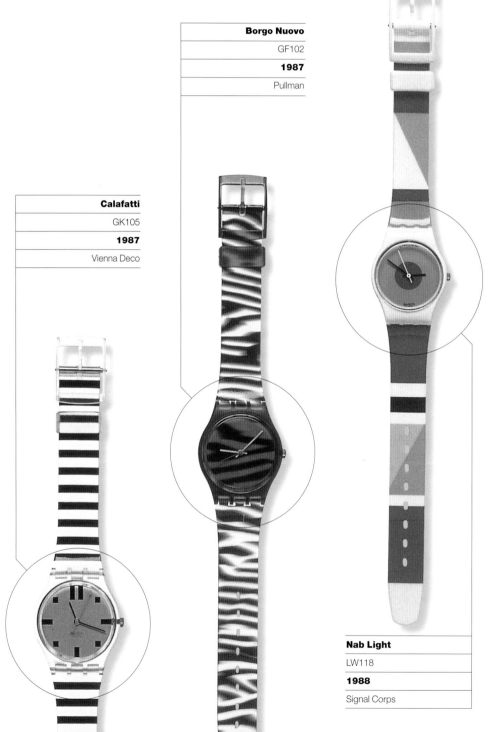
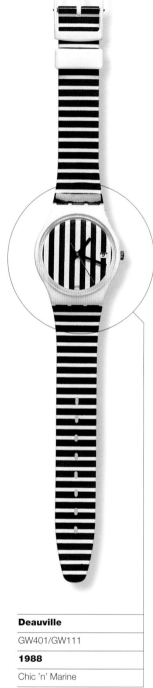

Borgo Nuovo

GF102

1987

Pullman

Calafatti

GK105

1987

Vienna Deco

Deauville

GW401/GW111

1988

Chic 'n' Marine

Nab Light

LW118

1988

Signal Corps

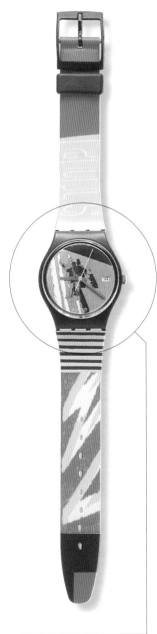

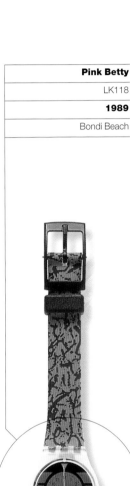

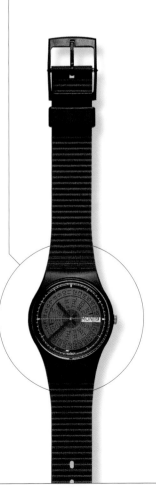

Pink Betty

LK118

1989

Bondi Beach

Tickertape

GB713

1988

Wall Street

Old Bond

GG102

1988

Maybridge

Taxi-Stop

GB410

1989

Street Smart

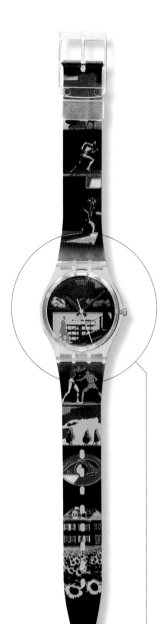

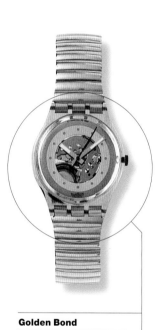

> Stories now seem to be the thing—though just what story Rush for Heaven illustrates is not easy to define. Medicis is truly artistic—but then as Swatch explains it is a short step from design to Art (and vice versa).
>
> Complementary his and hers seem to be all the rage in the 1990 Spring collection. The Comic Heroes of Robin and Betty Lou are offset by the pale coolness of Tutti and Frutti.

Robin
GJ103
1990
Comic Heroes

Betty Lou
LN111
1990
Comic Heroes

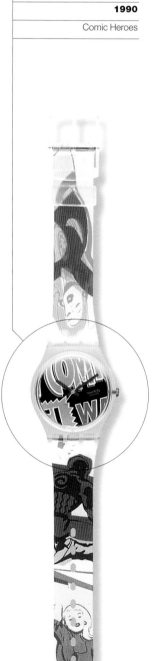

Golden Bond
GP101/102
1989
Irongate

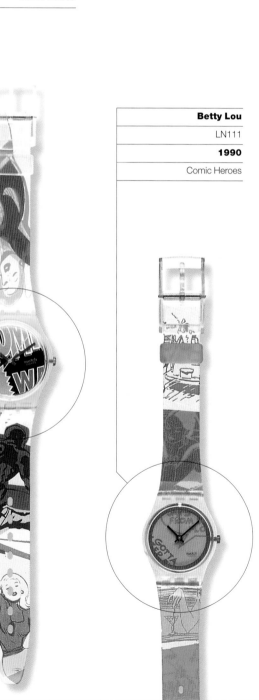

Rush for Heaven
GN105
1989
True Stories

> "African Graffiti" is the generic theme (all Swatch models by Spring 1990 had generic themes) of African-can and Bongo, while a pair of bracelet models Red Line and Freeway—the first for a woman—illustrate "Highway Patrol."

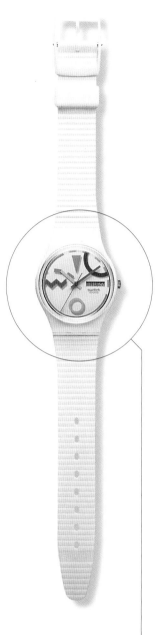

Tutti

GW700

1990

Lolita

Frutti

LW126

1990

Lolita

Freeway

LY100

1990

Highway Patrol

> Ravenna and Byzanthium are an intriguing and unusual pair of mosaics; Stucchi has more than a hint of the formal gardens of Versailles, echoed by the more restrained delicacy of the lady's Brode d'Or.

Robustly different is the bucolic Country-side with a saddle-stitched leather strap, though its dial is palely insignificant and its partner Real Stuff is not much better, proving that even Swatch can get it wrong sometimes. Copper Dusk has a metallic bracelet matching its dial; Blade Runner is a first bimetallic bracelet for women.

Ravenna

GR107

1990

Mosaiques

Brode D'Or

LA102

1990

Versailles

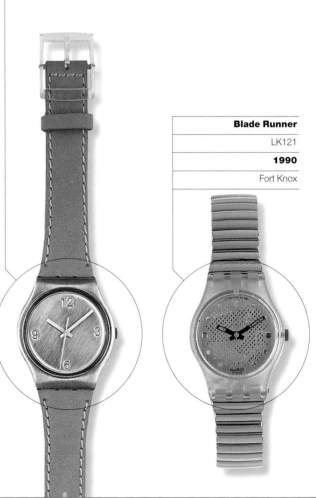

Country-side
GX114
1990
Home Made

Blade Runner
LK121
1990
Fort Knox

> Back to tropical exotica with the highly colorful Ibiskus and Dahlia while Mark and Franco illustrate most graphically their theme "Color of Money" in what must have been a triumph of delicate printing.

Bold Face and Typesetter introduce a new world of typography under the Swatch theme "Press Release"; in contrast, Blue Flamingo and Gold Inlay have a surrealistic touch, their theme being "Décode."

Dahlia
LL109
1991
Flower Basket

Franco
GG110
1991
Color of Money

Blue Flamingo
GN114
1991
Décode

Typesetter
GK131
1991
Press Release

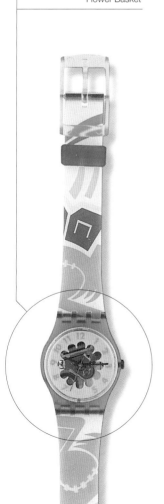

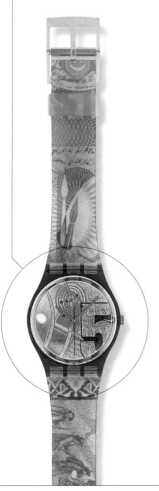

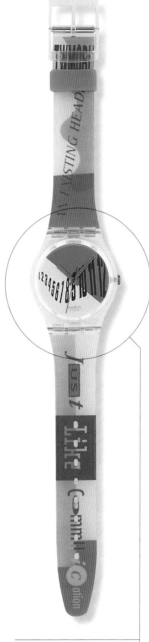

> 1991 ends with Gulp!!! and Crash!!! two equally way-out designs counterpointed by the classical elegance of Cupydus and Sappho. Since 1989 the Creative Lab in Milan has been responsible for Swatch designs.

For 1992 Swatch again went into glorious Technicolor, with the exuberance of High Pressure, Chicchirichi, and Mogador being offset by the more restrained PDG.

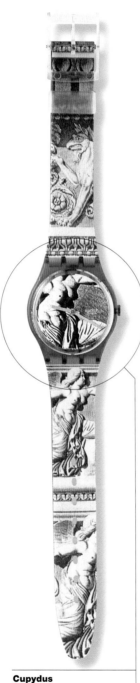

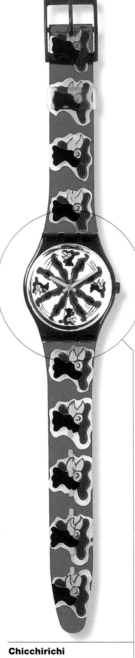

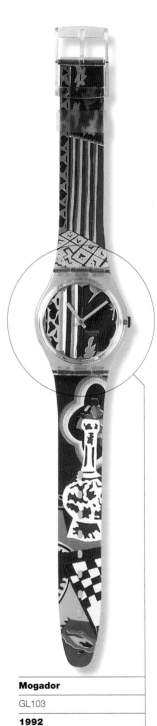

Gulp!!!	**Cupydus**	**Chicchirichi**	**Mogador**
GK139	GG112	GR112	GL103
1991	**1991**	**1992**	**1992**
Giacon's	Lovefrieze	Zoo Loo	Marocolor

> A definite note of aquatic fun enlivens this group from Spring/Summer 1992, although the lady's model Essaquiva has possibly a more Moroccan flavor.

Golden Waltz and Perlage, a pair of bracelet models in bicolor steel and gold plate, were in strong contrast to the Fashion Square theme of Tweed and Tailleur and their Scottish ensembles.

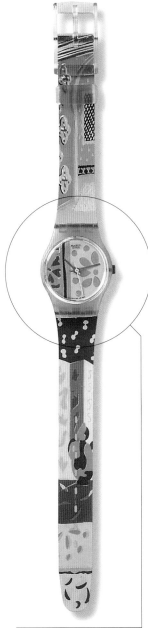

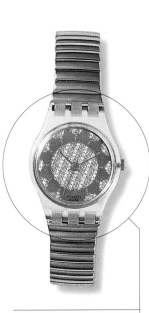

Essaouira
LP111
1992
Marocolor

Perlage
LK133
1992
Candlelights

Tweed
GB147
1992
Fashion Square

Tailleur
GM109
1992
Fashion Square

> 1992 ended with another group of photographic reproductions on strap and dial in Baiser d'Antan, Glance, and Photoshooting. Steel Lite is a bracelet model with almost transparent hands and an ingenious circular date mechanism.

Masquerade set 1993 off with a touch of the orientals, supported by Delhi (generic theme "Curry Taxi"); Chaise Longue reminds one of beach towels and deck chairs and Tourmaline introduces a jeweled note in a pretty lady's bracelet model.

Photoshooting
GN122
1992
Hearts of 70's

Steel Lite
GG403/404
1992
Tooling

Baiser D'Antan
GB148
1992
Fairy Tales

Glance
GB149
1992
Fairy Tales

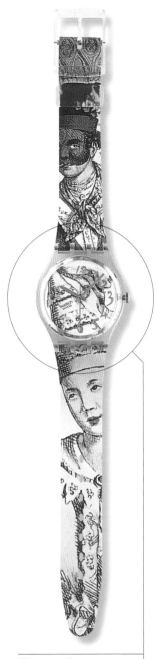

Masquerade

GP105

1993

Nostalgic Carnival

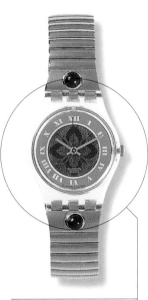

Tourmaline

LK142

1993

Deco Stones

Top Class

GK707

1993

Graduation

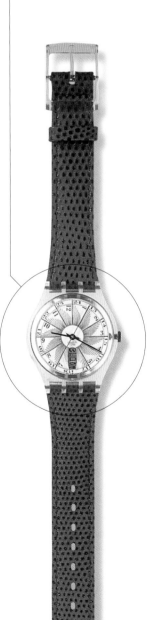

Voie Humaine

GX126

1993

Umzug

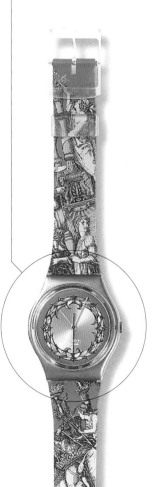

> Top Class introduced a more restrained look with its simulated green lizard strap and unusual day date display at 6 o'clock; Voie Humaine is another reminder of the mysterious East while we are back to Swatch exuberance with Le Chat Botté (Puss in Boots). Rocking with its 24 hour dial is another Swatch innovation.

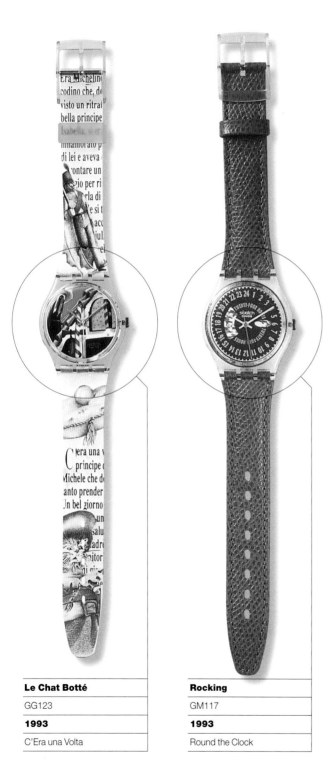

Le Chat Botté	Rocking
GG123	GM117
1993	**1993**
C'Era una Volta	Round the Clock

Swatch joined the Venice Biennale in February 1993 in a big way. Musicians dressed in historic costumes played Renaissance music on a number of gondolas which had been designed specifically for the occasion.

There were readings from stores and fables in Venice's many fascinating squares and an exhibition of work by artists associated with Swatch.

Some 2,000 Swatch Collectors Club members were entertained by dozens of artists, on Giudecca Island in the Grand Canal and enjoyed a carnival atmosphere of dance and song.

Swatch World Journal
February 1993

> The 1994 collection starts off with two very Pop-Art designs (Magnitudo and XXL) with large figures and contrasting dials and straps. Cougar's artistic Roman figure dial is set off by an elegant saddle-stitched leather type strap. Sex-Tease shows that Swatch is not immune to the erotic (theme "Kamas-Ultra").

The Fall collection went very animalistic with Rap (and a similar women's version called Garage). Gold Breeze (also with a similar small model) was designed to evoke memories of golden sands. Floral Story, under the theme "Jungle Fever," was self-explanatory while First had an interesting twist, the arms and legs of the Eve-figure acting as the hour and minute hands, pointing to rosy apples!

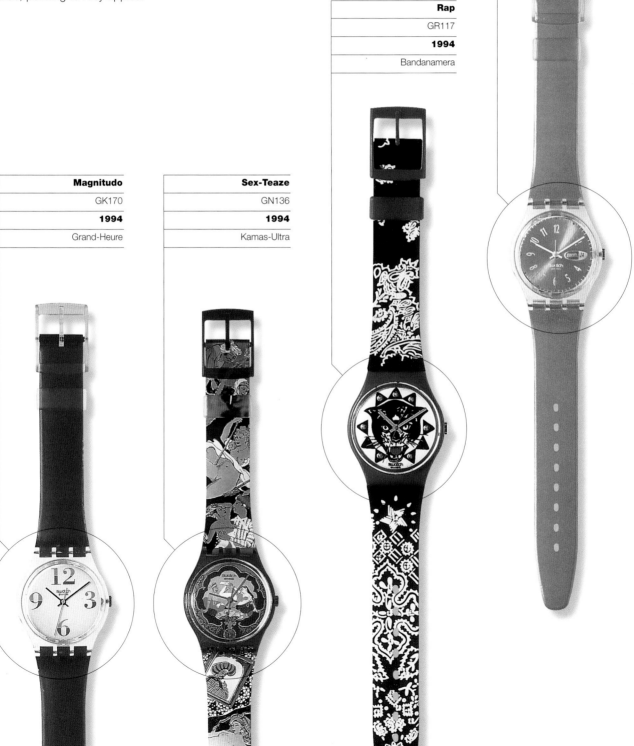

Gold Breeze
GK710
1994
Sandy Show

Rap
GR117
1994
Bandanamera

Magnitudo
GK170
1994
Grand-Heure

Sex-Teaze
GN136
1994
Kamas-Ultra

> The final designs for 1994 varied from the evil-eyed Monster-Time, the Mediterranean seaside peace of Sole Mio, to the fun-poking pair of historic memorabilia Aiglon and Aiglette—Napoleon and his Empress immortalized by Swatch.

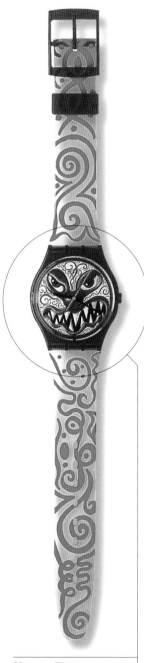

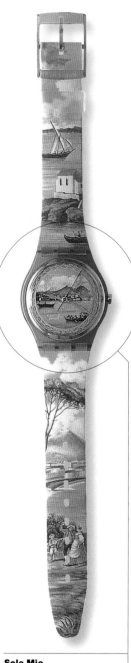

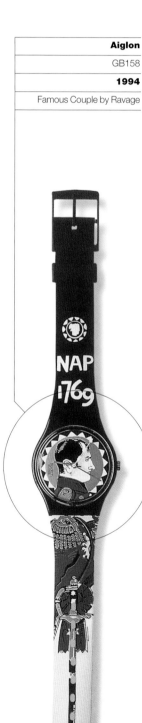

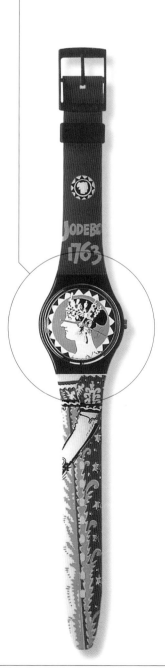

Aiglon
GB158
1994
Famous Couple by Ravage

Aiglette
GB159
1994
Famous Couple by Ravage

Monster Time
GR121
1994
Kenny Scharf

Sole Mio
GM124
1994
Tarantella

> Always different yet always the same runs the official Swatch story. Turnover from the 1995 Spring collection has certainly a different appearance—in spite of the same black plastic case and strap—as the 1983 original. Rapper is fun, Brouillon a modern whirligig, and Silver Plate a very up-to-the-minute (no pun intended) bracelet model.

Lolita's interest lies in the continuation of the design through strap and dial and Tai Sun is a riot of golden orientation. Red Flame reminds one—quite intentionally—of a motorcyclist's speedometer and rivet-studded leathers; while For Your Heart Only is a romantic Valentine's Day message, complete with special pack, from Swatch.

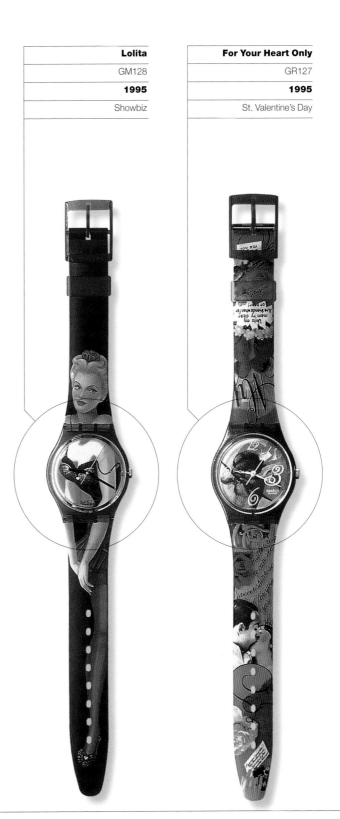

Lolita	**For Your Heart Only**
GM128	GR127
1995	**1995**
Showbiz	St. Valentine's Day

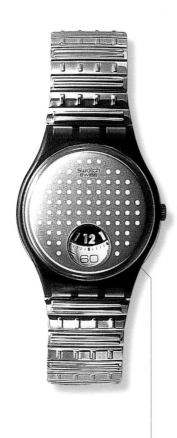

Silver Plate
GM129/130
1995
Metal Techno

> Under the theme "The Big Cold," Ice Dance pays tribute to the Dance Federation and Frozen Tears with a tearful seal-pup dial and a hairy strap is another story. Canard Laqué has a highly unusual numerical dial and Mc Square rounds off 1995 with a very smooth tartan for Hogmanay.

The rather weird effect of Transparent from the 1996 Spring collection is counteracted by the highly decorative bracelet model of Wise Hand; the tribal decoration of Sina Nafasi, its strap enlivened with hand-sewn silken thread, is balanced by the delicate lady's Cool Mint.

Frozen Tears

GK202

1995

The Big Cold

Ice Dance

GK201

1995

The Big Cold

Mc Square

GG137

1995

Highland Stories

Canard Laqué

GK714

1995

Varnish Fair

> Good Morning epitomizes breakfast with its pictures of corn flake packages; in contrast is the 1996 Swatch St. Valentine's Romeo and Juliet, the lovers depicted very decoratively on strap and dial (it also comes with a beautifully drawn pack). More down to earth are Don't; a Swatch with a No Entry dial, and Protect—the best of the series on the "Messages" theme.

Transparent

GK209

1996

The Originals

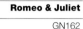

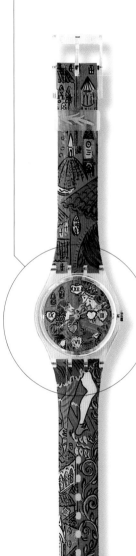

Cool Mint

LG116

1996

The Invisibles

Romeo & Juliet

GN162

1996

St Valentine's

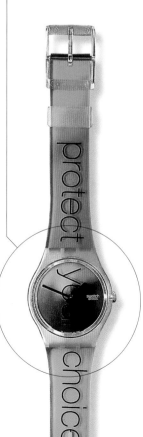

Protect

GK 226

1996

Messages

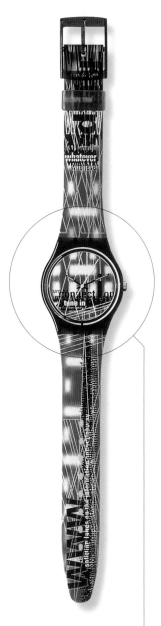

> Information technology gets a nod from Web Site and Coding, two highly decorative models from the 1996 Fall collection; Caution and Conform spell out messages in large letters—the theme was "Asphalt." (Caution was also available as a Maxi Swatch; these being no longer cataloged as separate items.)

Reposition
GB170
1996
Primaries

Weightless
GK229
1996
Primaries

Web Site
GM138
1996
Information Landscape

Conform
GM139
1996
Asphalt

> 1996 was a special year for Swatch, a whole section being devoted to its Olympic creations; the Fall collection is rather limited in consequence; Glitter is what it says, a golden sparkle, Reposition a crazy jumble of figures, Experience a delightfully fey design, and Weightless one of Swatch's fun models. There were the usual classic models in both men's and women's sizes for the more conventional Swatch lovers (unlikely as that may seem—but they must exist or Swatch would not go on producing them).

Mustard leads the 1997 standard collection—a clean yellow strap with contrasting black case and buckle and yellow hands. Very stylish. Centipede is one of a group whose theme is "Comic Hour." The strap and dial are covered in cartoon faces, hands, and claws. Lamp is a Swatch with Loomi—in daylight a white case and strap with black hands; at night a glow worm that says "This is not a lamp." Ingenious. Oxygen is a poem in pale olive green and black in a steel case.

Mustard

GB179

1997

Movimento

Lamp

GW900

1997

Promises

Time to Dance

GK244 A/B

1997

Time Jockeys

Virtual Orange

GK239 A/B

1997

Space Place

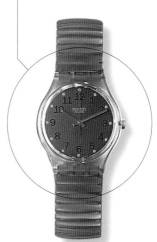

Time to Dance is an automatic model with metallic dial in a metal case on a multicolored flexible metal band while Virtual Orange has an orange metal band to match the dial.

The 1997 fall collection included "Never Seen Before" in which the watch and strap had to be rubbed (1) to reveal (2) a message and (3) a decorative strap with a tabloid effect. Passage to Brooklyn is likely to appeal to car fanatics.

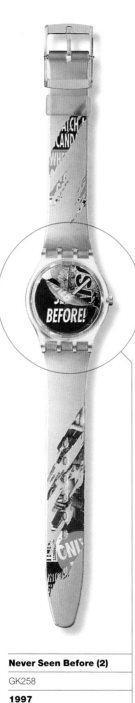

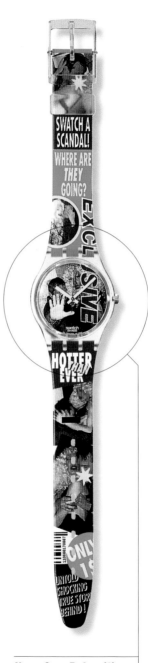

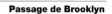

Passage de Brooklyn
GJ120
1997

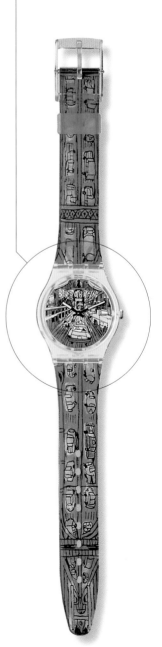

Never Seen Before (1)
GK258
1997

Never Seen Before (2)
GK258
1997

Never Seen Before (3)
GK258
1997

Swatch Art

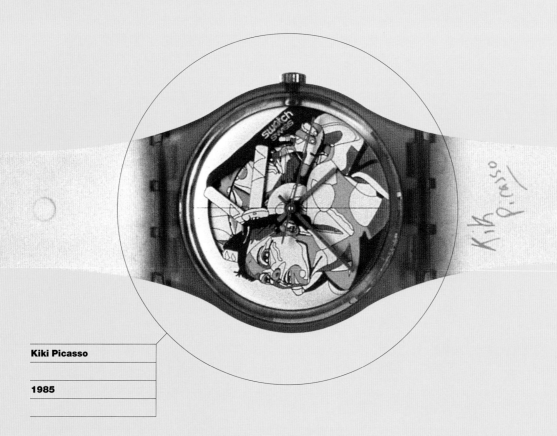

Kiki Picasso

1985

83 84 85 86 87 88 89 90 91 92 93 94 95 96 97

> Artists and designers from different graphic disciplines were commissioned to design one or more Swatches. They were mostly from the field of contemporary art or fashion design, for combining Art and Fashion was one of Swatch's criteria, and it started early on in the brand's history.

From 1985 Swatch has brought Art into everyday life through the contributions of these modern artists, whose work is illustrated in the following pages. The yearly production was not always consistent. There were no Swatch Art watches in 1989, for instance, and 1993's model was a POP Swatch Art Special—a

design all on its own. Recent years have brought a plethora of way-out designs, the explanations of their meaning are not, however, quite so easy to follow. One is reminded of the comment of the original (Pablo) Picasso who, when asked by an earnest American lady the meaning of one of his works, said "Madame, On ne parle pas au pilote!"—in other words, "Don't talk to the driver!"

The "Artists" Collection for 1997 consists of the work of a group of highly talented young women painters from different countries.

For the biographical details of the artists, and the explanations of their creations, the author is indebted to Swatch's own descriptions.

> The first Swatch Art model was created in 1985 by Kiki Picasso whose real name is Christian Chapiron. Born in Nice in 1948 he is a painter, moviemaker, and designer. It was limited to just 140 pieces and is one of the most sought-after Swatch designs.

Keith Haring came to prominence in the 1980s; his graffiti figures typified the unpretentious artistic spirit of the decade.

Jean-Michel Folon, born in Brussels in 1934, has illustrated books and had exhibitions in the United States and Japan as well as Europe.

Rorrim 5 was created by Tadanori Yokoo of Japan for the celebrations to mark the 50 millionth Swatch. He is one of Japan's best-known contemporary artists.

Time and movement have been favorite subjects of Belgian artist Pol Bury, born at Haine-St-Pierre in 1922. This is his attempt to interpret time and movement in terms of Swatch.

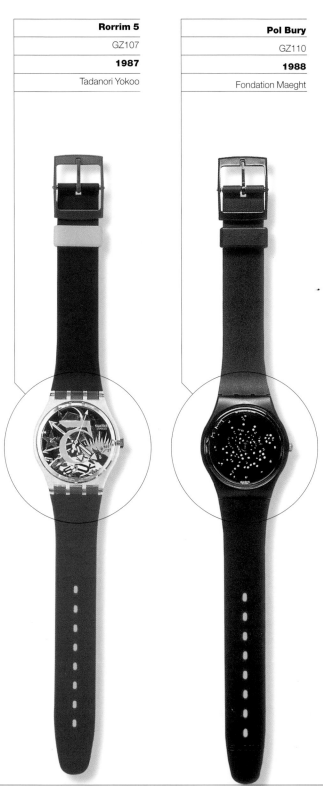

Rorrim 5	**Pol Bury**
GZ107	GZ110
1987	**1988**
Tadanori Yokoo	Fondation Maeght

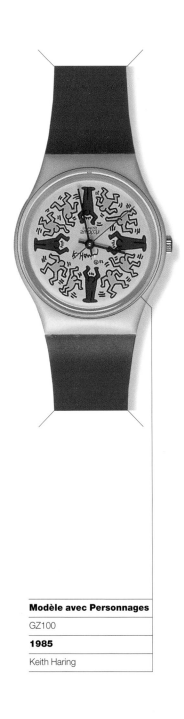

Modèle avec Personnages
GZ100
1985
Keith Haring

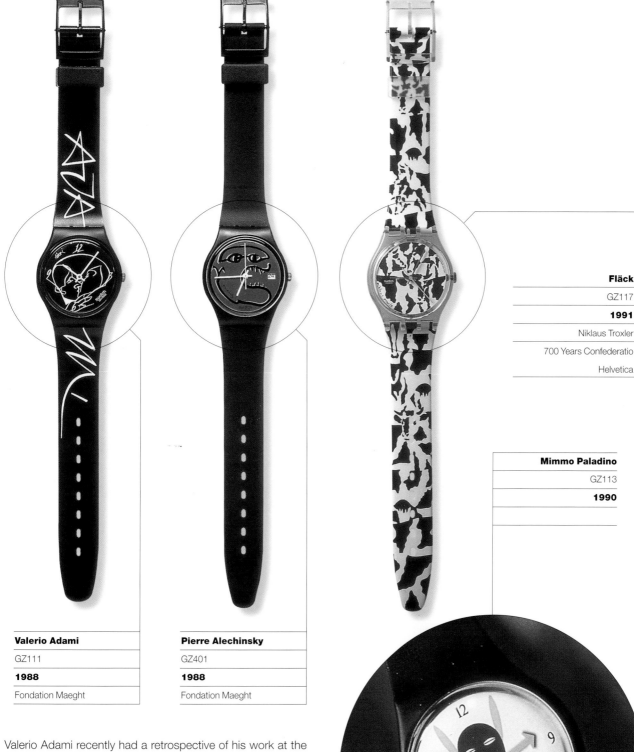

Fläck	
GZ117	
1991	
Niklaus Troxler	
700 Years Confederatio	
Helvetica	

Mimmo Paladino	
GZ113	
1990	

Valerio Adami		**Pierre Alechinsky**	
GZ111		GZ401	
1988		**1988**	
Fondation Maeght		Fondation Maeght	

> Valerio Adami recently had a retrospective of his work at the Centre Pompidou in Paris. Born in Bologna in 1935, he uses his art to explore the secrets of reality.

Born in Brussels in 1927, Pierre Alechinsky has always been fascinated by calligraphy and typography.

Mimmo Paladino, born in 1948, is completely self-taught and his work has been much influenced by the synthesis of Catholicism and African culture.

Niklaus Troxler was born in Willisau in 1947. An accomplished graphic and poster designer, he designed Fläck to evoke a Switzerland caught between its rural past and its aspirations to modernity.

> Chérif and Silvie Defraoui teamed up in 1975. They called their Swatch Art Special Test to remind us that the measurement of time is simply another way of divining our destinies.

Felice Varini has one interest—spacial sensation and perception.

Not Vital, born in 1948. He claims Wheel Animal is an invocation of prehistoric times, when man was still a hunter and gatherer.

Alfred Hofkunst was born in Vienna in 1942. It pleases him to produce exaggerated pictures of reality, like his Swatchetables, produced in a limited edition of 9,999 pieces.

Verdu (H) RA
PZW102
1991
One More Time: Alfred Hofkunst

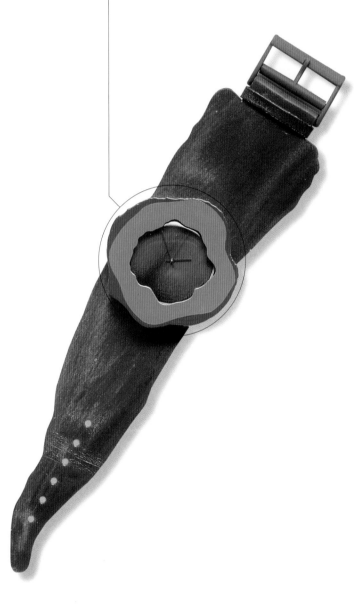

Test
GZ118
1991
Chérif & Silvie Defraoui
700 Years Confederatio
Helvetica

360° Rosso Su Blackout
GZ119
1991
Felice Varini
700 Years Confederatio
Helvetica

> Born in San Mateo, California, in 1923, Sam Francis can look back on a major international career. His Swatch Art Special is unnamed.
>
> Vivienne Westwood has been proclaimed as the doyenne of punk and has the reputation of being more passionate and imaginative than her contemporaries. To shake up the catwalks of *haute couture*, fashion's high priestess designed this Pop Watch Art Special, whose golden dial is surrounded by a crusader's cross at 12 o'clock and is encircled by the blue ring of Saturn.

Mimmo Rotella was born in Calabria in 1918, which makes him one of the oldest of the artists who have contributed to Swatch Art. He likes strong images which explains the forcefulness of his two Swatch Art designs.

Bengt Lindström is a 70-year old Swede who is fascinated by the true force of the north, where winter seems to last forever. His Temps Zero is based on the cycles of creation—the artist becomes the center of the cosmos.

GZ123	**Orb**	**Marilyn**	**Temps Zero**
	PWZ104	GZ133	GB166
1992	**1993**	**1994**	**1995**
Sam Francis	Vivienne Westwood	Mimmo Rotella	Lindström

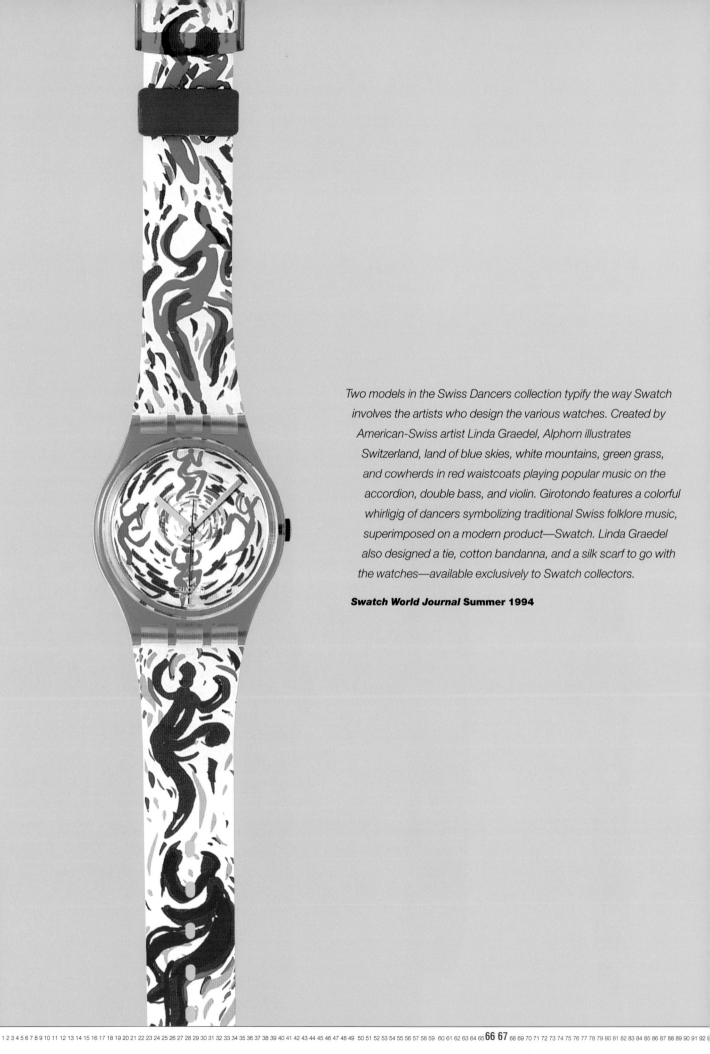

Two models in the Swiss Dancers collection typify the way Swatch involves the artists who design the various watches. Created by American-Swiss artist Linda Graedel, Alphorn illustrates Switzerland, land of blue skies, white mountains, green grass, and cowherds in red waistcoats playing popular music on the accordion, double bass, and violin. Girotondo features a colorful whirligig of dancers symbolizing traditional Swiss folklore music, superimposed on a modern product—Swatch. Linda Graedel also designed a tie, cotton bandanna, and a silk scarf to go with the watches—available exclusively to Swatch collectors.

Swatch World Journal Summer 1994

> Lindsay Kemp, born in Liverpool in 1938, is a dancer and choreographer. In 1967 he staged a "Flowers" dance selecting people with angelic or diabolical expressions. The dial of his Flowers watch is animated by a drawing of a sailor whose eyes, says Lindsay, tempt him to love "time and time again."

Riccardo Licata is a 68-year old Italian who was born in Turin. He sees as time an essential element of space, rhythm, and poetry; whose symbols shine out from the plants in his Swatch Enchanting Forest.

Graphickers, by 44-year-old Hajime Tachibana, creates links between the Western alphabet and Japanese ideograms. This Japanese artist is one of the most influential typographical designers alive today.

Having time means being free, says Dutchman Guillaume Beverloo, who goes by the name of Corneille. Born in 1922, he endeavors in his art to capture the pure essence of all living things.

Enchanting Forest
GL106
1995
Licata

Graphickers
GK208
1995
Tachibana

Flowers
GK207
1995
Lindsay Kemp

Vive la Paix
GK206
1995
Corneille

> Catalan artist Antoni Miralda illustrates his preoccupation with gastronomy in his creation Blue Pasta.

Lens Heaven by Constantin Boym is a picture puzzle with playful numerical motifs drawn from everyday life.

Born in Madrid, Eduardo Arroyo—painter, sculptor, and writer has two passions, boxing and Kangaroos which he combines in his Swatch Boxing.

Kenny Scharf's Fiz n' Zip draws a humorous parallel with the Ying n' Yang symbol.

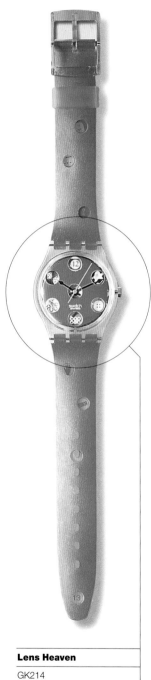

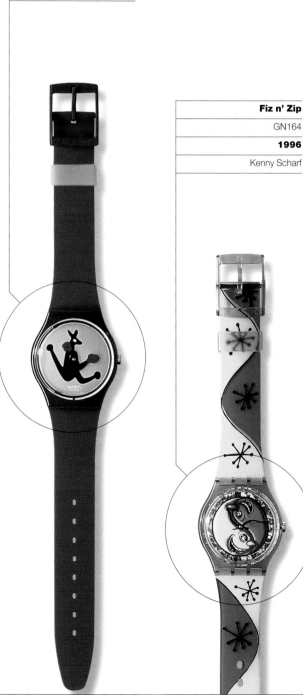

Boxing
GN163
1996
Eduardo Arroyo

Fiz n' Zip
GN164
1996
Kenny Scharf

Blue Pasta
GG138
1995
Miralda

Lens Heaven
GK214
1996
Constantin Boym

> Seventy-year-old Bouabré named his Swatch Cheik Nadio. It combines African pictorial language with symbols from our mass communications society.

Twenty-five-year-old Mutji is an Aborigine. Her Swatch Wanajarra Tjukurrpa shows the earth snake of Aborigine culture sliding into a waterhole.

Min Jun is among China's most important avant-garde artists and his Wild Laugh Swatch questions the systematized uniformity of people whose individuality is deined.

Jim Avignon is a wild young Berlin artist who connects the art world with club culture.

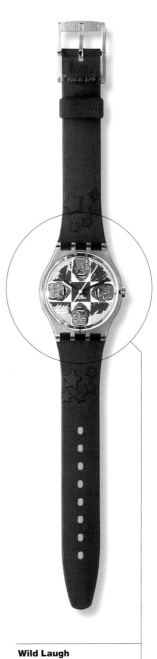

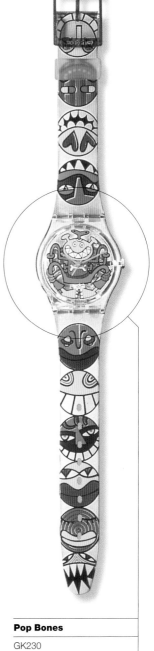

Wanayarra Tjukurrpa
GJ116
1996
Bridget Mutji

Cheik Nadro
GG140
1996
Frédéric Bruly Bouabré

Pop Bones
GK230
1996
Jim Avignon

Wild Laugh
GJ117
1996
Yue Min Jun

> Yoko Ono has been involved in sculpture, painting, theater, films, and music. Her somber black and white film No. 4 is something she hopes will make you smile. Born in 1906, Victor Vasarely is one of the best-known painters of our century. Micha Klein saw the computer as a tool to create synergy between different media. His Swatch Love, Peace, and Happiness "combines all the elements we will need to live together for another 1,000 years!"

Studio Azzurro is a working group based in Milan specializing in video production and artistic experimentation. Tempo Naturale is the result of their combined efforts in Swatch design.

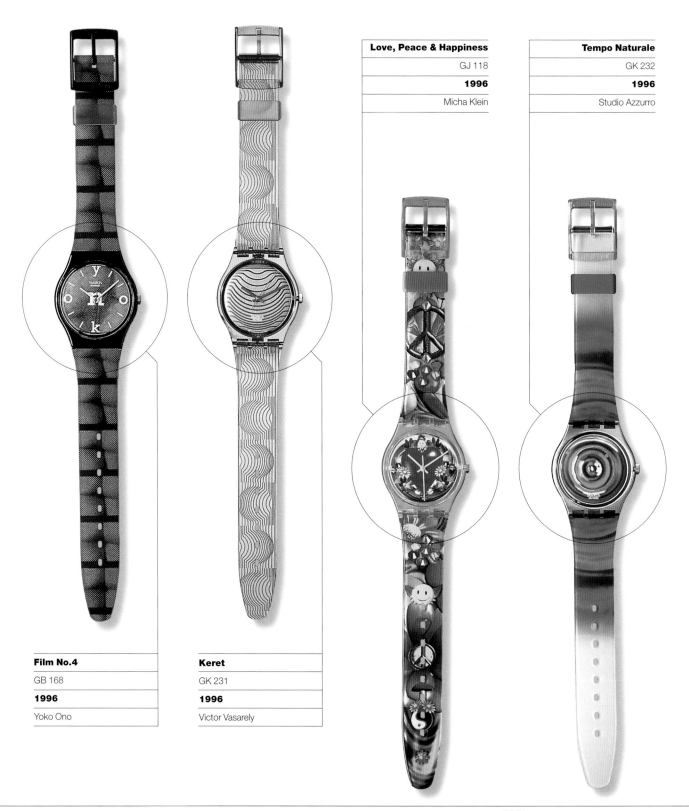

Love, Peace & Happiness		Tempo Naturale
GJ 118		GK 232
1996		**1996**
Micha Klein		Studio Azzurro

Film No.4		Keret
GB 168		GK 231
1996		**1996**
Yoko Ono		Victor Vasarely

> Awarded the Guggenheim Foundation Fellowship in 1992, Irit Batsry has had her work shown extensively in 30 countries. Hands, the Swatch she created, is concerned with human dimensions and the passage of time.

Miriam Fukuda is a 34-year-old Japanese artist; her technique is to combine classical images with computer-generated three-dimensional effects, here employed in her Swatch.

Jo Whaley was born in Sacramento in 1953. She arranges still-life photographs against painted backgrounds to create colorful theatrical effects.

Su Huntley, born in England and Donna Muir, a Canadian, are a partnership that has produced some striking images in the last decade. Their broad experience is expressed in Huntley's Windmeal, which celebrates the housewife and her work in which everything is repeated like the sails of a windmill.

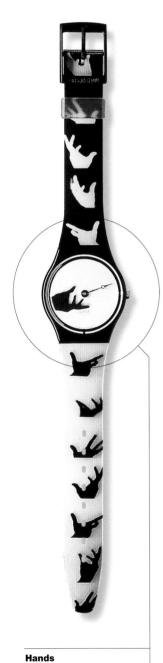

Hands
GN166
1996
Irit Batsry

The Lady & the Mirror
GN170
1997
Miriam Fukuda

Ticking Brain
GK247
1997
Jo Whaley

Windmeal
GG145
1997
Su Huntley

> US-born Nancy Dwyer has exhibited her work throughout the world. Destime expresses those moments in a day when we regret what we have missed and wonder at life's mysteries.

Kvĕta Pacorska was born in Prague when it was still Czechoslovakia. Her design for Swatch Color Scribbler is a colorful juxtaposition of raw colors that aims to give a three-dimensional effect.

Steve Guanaccia, a magazine illustrator and designer of clothes, says Roboboy illustrates a mechanical robot spreading the analogue word in a world gone digital.

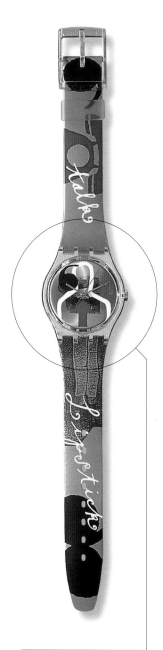

Lipstick

GK248

1997

Donna Muir

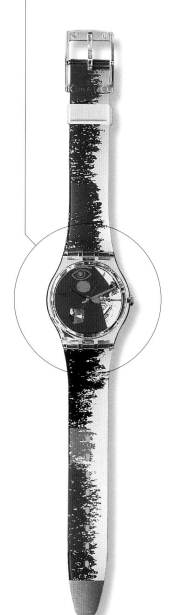

Destime

GG144

1997

Nancy Dwyer

Color Scribbler

GK249

1997

Kvĕta Pacovská

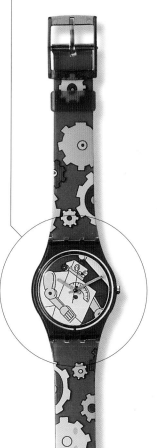

Roboboy

GR135

1997

Steve Guarnaccia

POP Swatch

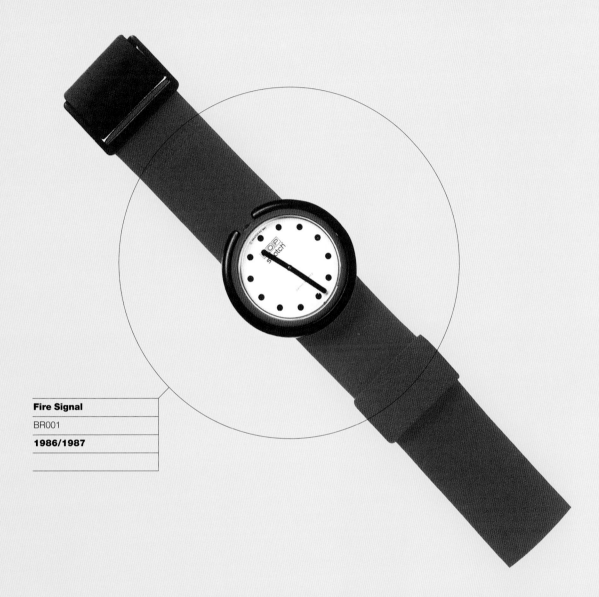

Fire Signal

BR001

1986/1987

83 84 85 86 87 88 89 90 91 92 93 94 95 96 97 98

> The first POP Swatch models did not appear until late 1986. POP Swatch is a daring, extravagant oversized Swatch that can be worn on the wrist, on a shirt or blouse, a jacket or blouson. Based on an aviator's watch it can be worn over a flying suit, a boilersuit, a pullover, or overalls. It can be hung on the wall, around the neck, or indeed almost anywhere. It comes in three versions—on an oversized fabric or flexible watch band, as a pocket watch on a chain, or as a desk watch and travel alarm, with its own stand and a MusiCall melody to sound the alarm.

Some POP Swatches are original designs, some duplicate successful designs from the Standard Swatch range.

POP Swatches have their own Art versions and Specials. Although they ceased to appear in the catalogs as a separate line they still continue to be readily available.

> The first models were simple designs, with plain white dials and unicolor straps. The next year saw a whole gamut of dazzling designs, along with the original plain ones. Transparent dials like Acid Drop vied with jazzy ones which carried on the strap decoration as in Trifoli. A center-second hand became a regular feature.

By 1989 the strap designs had become Pop Art scenes in their own right (though the cases remained a uniform black) until Blanc de Blanc, with a pearl-colored bezel and pearl encrusted band—and a special pack.

It was not until the fall of 1990 that colored bezels became a regular feature; the bands too appear to be of a material with the design woven into the texture (Formula Uno).

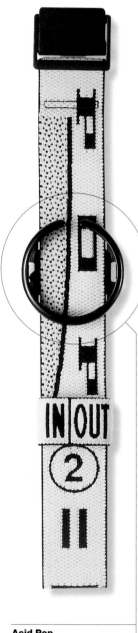

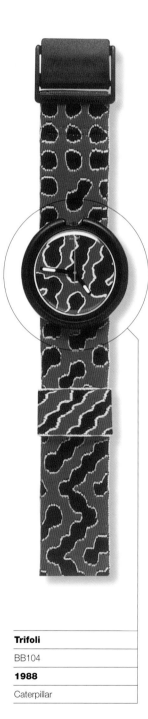

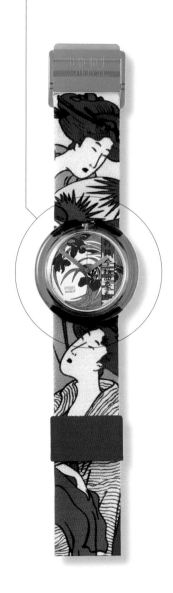

Blanc de Blanc
PWBW104
1989
Haute Couture

Pleasure Garden
PWK152
1991
Asian Time

Acid Pop
BK101
1988
Fun Line

Trifoli
BB104
1988
Caterpillar

> At the end of 1991 the designs on both dials and bands had exploited all the variations already seen on the regular Swatch models. Beach scenes (Lady Octopus) oriental fantasies (Pleasure Garden) led by 1992 to animalistic fantasies (MEEOOWW!) and the sumptuous "En vogue" presentation model Veruschka.

1993 seemed if anything to be more jazzy—Popocatepetl being a riot of colorful curls, Matin à Tanger had a geometric feeling of Algerian arches and mosaics, while The Life Saver went all figurative in a 1920s sense.

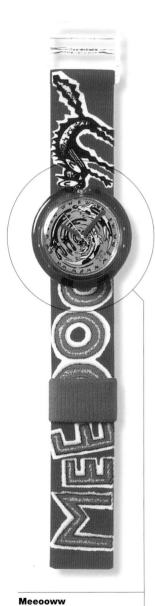

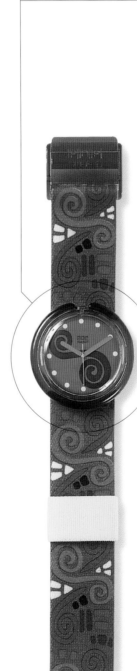

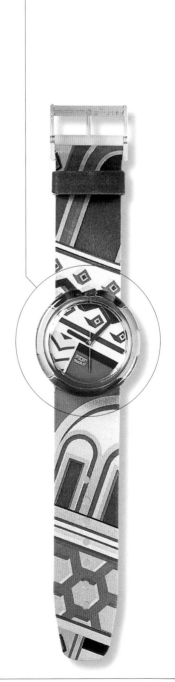

Popocatepetl
PWK173
1993
Maxi-Mex

Matin à Tanger
PWK177
1993
Souvenir D'Afrique

Meeooww
PWK156
1992
Best Friends

Veruschka
PWZ103
1992
En Vogue

> Soupe de Poisson was the featured model for the summer—packed in a seashell, it had a lobster-colored dial and wristband decorated with star fish and ragworms in colored beads. It was not classed as a Special, though it might well have qualified.

The early 1994 designs seemed to go more for geometric designs such as Haute Society and Palace Doors, with its regal air of Versailles, in contrast to the delicate petit point of Patching, so reminiscent of a Victorian sampler.

Soupe de Poisson
PWZ106
1993
Seaside Dream

The Life Saver
PWK180
1993
Holiday Trip

Patching
PMN103
1994
La Divina

Palace Doors
PMO100
1994
Floral Seals

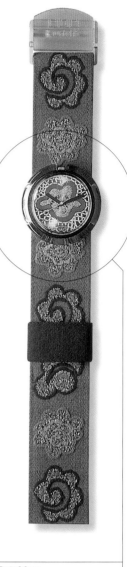
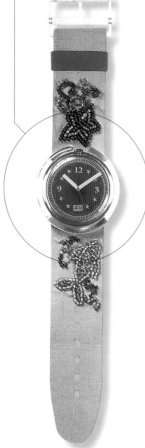
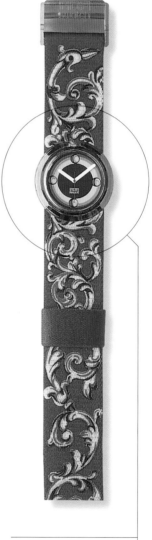

> For 1995 POP Swatch went a bit horticultural with Marguerite and Roses and . . . but these were offset by the slinky Rouge and the somewhat stark Black Widow. Mille Feuille takes us back to gardens and petit point, and Hot Stuff is just a piece of devilry.

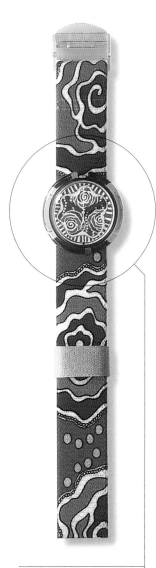

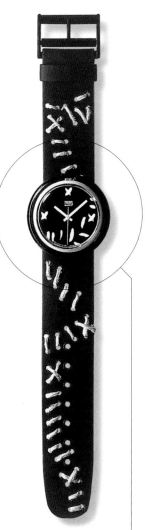

Rouge

PMR100

1995

Junko's

Mille Feuille

PMO101

1995

Short Stories

Roses & . . .

PMM103

1995

Artist's Joy

Black Widow

PMW100

1995

Black or White

> "Ethnosense" was the theme of the first of the 1996 designs Kishoo—a restrained sandy creation in contrast to the humorous face with Fez in Tappeto. Fleurs d'Eté is a florid riot of butterflies and summer flowers, Doggy Bag another fun model alongside the dignified Victorian Knot.

The 1997 collection includes Coffee whose black dial displays an ellipse of flying coffee beans; a black case on a brown leather strap completes the effect.

Kishoo

PMB104

1996

Ethnosense

Tappeto

PMN105

1996

Faces

Fleurs d'Eté

PMK112

1996

Short Stories

Victorian Knot

PMB105

1996

Primaries

> Foulard is an elegant model with a blue textile surround (one can hardly call it a strap) which looks a trifle impracticable. Travel Kit on the other hand is a smart and business-like Pop-up MusiCall with a melody by saxophonist Candy Dulfer.

POP-Ups included One World, a sort of Happy Families number, and Nightstar, which has an astronomical touch. CD Rack has an information technology landscape as a dial and Sayonara, as its name implies, a touch of the Nipponese.

⁄e a MusiCall alarm with a melody by Paulo Mendonça.

One World

PUN100

1996

Faces (Pop-Up)

Nightstar

PUB100

1996

Short Stories (Pop-Up)

Coffee

PMB110

1997

Movimento

Foulard

PMK119

1997

Travel Kit
PUK104
1997

Sound Effects
PUB102
1997

Ringo
PUK102
1997

> Among the 1997 POP-Ups are Ringo, with a transparent dial with luminous dots and Sound Effects with a sort of sunburst numerical dial; both have melodies by Paulo Mendonça. Snake chain attachments to turn them into pocket watches are available.

The first POP Swatch Special was created for Christmas 1988—POP Diva is an all-black model entwined by what look like faceted imitation diamonds on both strap and dial. Encantador (1990) came in a black tube with a see-through center, revealing the POP Swatch swathed in a flimsy golden scrap. Bottone in 1991 was fitted with a strap decorated with big colorful buttons echoed by the colored dots on the silver dial to mark the hours. The buttons were sewn on to the

Encantador
PWB151
1990
Christmas 1990

Leaf
PWZ108
1994
Summer Special 1994

> black velvet by a team of seamstresses who took two months to complete all 14,999 of this limited edition. The watch came with a repair kit consisting of a needle, thread, and thimble! 1994 saw Leaf, designed by Stéphanie Plassier; this summer Special had an amber bezel and a band of plaited straw and was packed in a straw hat with a cord that cleverly turned it into a gunny sack.

Feathers is a Pop Swatch Special adorned with exotic feathers which can be put on or taken off at will. It has a yellow dial and bright red fabric band and comes in a beauty case with a built-in mirror. A limited edition was available from September 1997.

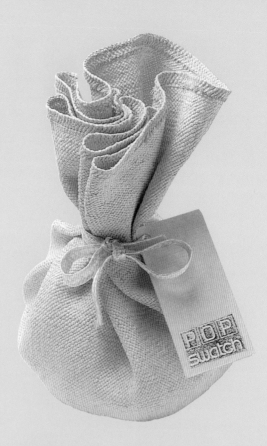

Feathers

1997

Pop Swatch Special

Leaf, the POP Swatch Summer Special for 1994 was meant to evoke the hot days of midsummer, straw hats, long cool drinks of orangeade, walks through fields of lavender. Its gilded orange dice, decorated white hands, symbolizing ears of corn, echo these thoughts; its strap was woven specially of straw, following a traditional method used for making straw hats. And the pouch in which Leaf was packed turns into a straw hat. The whole ensemble was created by fashion designer Stephan Plassier. It was produced in a limited edition of 33,333 pieces worldwide.

Swatch World Journal
Summer 1994

Maxi Swatch

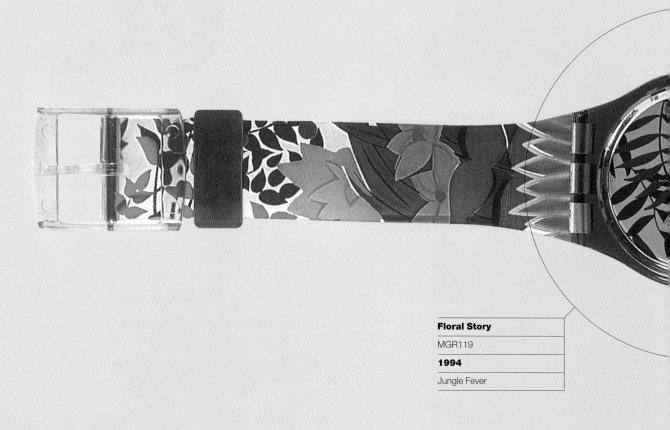

Floral Story

MGR119

1994

Jungle Fever

83 84 85 86 87 88 89 90 91 92 93 94 95 96 97 98

> Maxi Swatch, like POP Swatch, was given the production all clear as early as fall 1983, but again did not appear in person until three years later.

This first big step in the evolution of Swatch was 6.9 feet (ten times the size of a regular Swatch) long and was built to be hung on the wall at home, in the office, or the workplace.

> Some of the early models were blown-up versions of standard Swatches, like Sir Swatch; others were specially created, Volcano being a striking example. Mackintosh (1988) would have looked great in any auto racing pit.

Harajuku (1989) was obviously meant for a Japanese location; Eclipses explored the photorepro possibilities already so graphically employed on Maxi-Swatch's smaller companions. 1990 produced just one model Neutrino, of unfathomable derivation and 1991 saw the launch of Franco and Mark—both featured in the standard range and Stalefish, another graphic puzzler. In 1992 Discobolus went all Greek, its dial an echo of Etruscan art.

There were six Maxi Swatches in 1993, Postcard having a familiar type of illustration, though at 6.9 feet one could hardly send it home from Capri or wherever; Perspective introduced a sophisticated note of graphic art in gray, white, and black.

The 1994 collection of six models could only be described as lurid. Bark Bark had some vague connection with dogs, while Floral Story was a riot of palm leaves on tropical colors. Monster-Time was a duplicate of a standard Swatch already noted but at nearly 7 feet high would be enough to give one the heebie-jeebies if hung on a bedroom wall.

Maxi Swatch do not appear in the 1995 and subsequent collections as illustrated but certain standard Swatches are available in Maxi form.

Swatch Specials

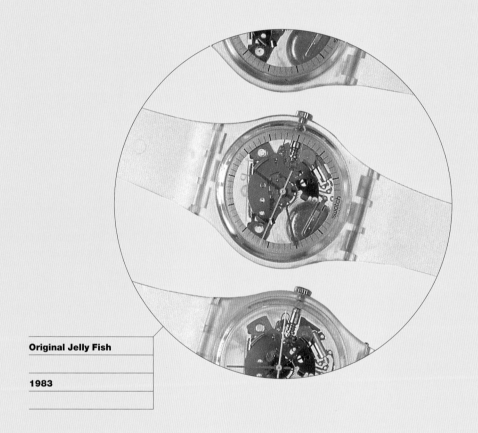

Original Jelly Fish

1983

83 84 85 86 87 88 89 90 91 92 93 94 95 96 97 98

> A Swatch Special is created to mark an extraordinary event or person—or maybe an ordinary person in an extraordinary situation. At all events, it marks an occasion.

Swatch Specials are produced in limited, numbered editions—and then, never again, never reissued. Each one is unique, to commemorate a unique occasion (or like Christmas specials, an annual special occasion).

Created by brilliant designers from all over the world, like Swatch Art, they are a way of remembering something. But they are also meant to be worn. After all, say their creators, if you *do* forget the occasion, the Swatch on your wrist is there to remind you.

Because they are unique and in limited supply, many of them become sought-after collector's pieces.

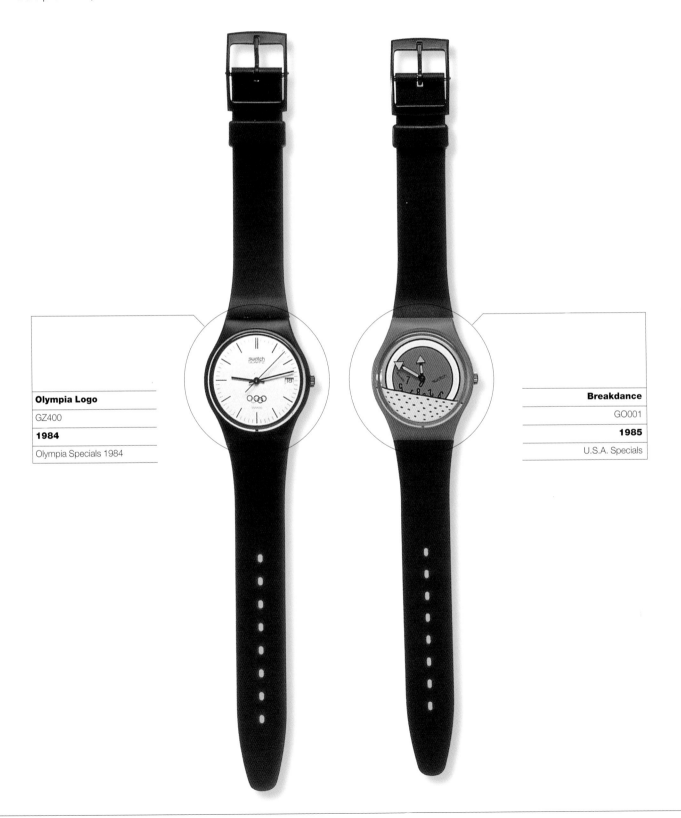

> The first Swatch Special appeared in 1983, not long after the creation of Swatch itself. Called the Original Jelly Fish, it had a transparent case which showed all its works, and a white strap. It was in fact quite like a jellyfish and for anyone lucky enough still to own one, it commands a very special price ($7,000–9,000).

The Olympics obviously cried out for special attention—and certainly got it from Swatch. In 1984 three Olympic Specials were produced, a men's and a women's with a choice of white or black strap. The dial was the classic black strokes on white ground with the Olympic logo added. Other Olympia Specials followed in 1990 but were not remarkably different.

In 1984 Swatch had supported the World Break Dance Championship in New York and in 1985 brought out a Breakdance Special pair as souvenirs. Later the same year came a mysterious creation called Velvet Underground, complete with black strap and case, magenta dial and all over lacy veil. Both these models were confined to the United States.

Olympia Logo

GZ400

1984

Olympia Specials 1984

Breakdance

GO001

1985

U.S.A. Specials

> Under the generic theme of "Blow Your Time Away" Swatch produced, in 1988, a series of six "Puffs"; there was Black Puff, Havana Puff, Royal Puff, Petrol Puff, Cardinal Puff, and Desert Puff. The "Puff" bit came from the different-colored fake fur that surrounded—indeed almost obscured—the dials. On black straps, and packaged in sedate golden boxes that gave no hint of the exotic treasure inside, they looked like a bit of fun. These were never sold commercially— try to buy one now and the asking price is $15,000–20,000—just for one.

In 1990 Swatch brought out a Jelly Fish Chronometer Special, the crystal cut away even more drastically to show the multifunction quartz insides. BMX, also a chronometer with a face not unlike an instrument dial, was presented in a box labeled "Before opening, shake well and throw against a wall." Such confidence! The pack also contained a copy of the COSC chronometer certificate. A BMX Swatch Special was also presented to each purchaser of the Swatch BMX bike—limited to 500 models and available only to members of the Swatch Collectors' Club.

In 1991 Swatch brought out a set of four Specials to commemorate the 700 years of the Swiss Confederation. As each one was designed by a famous artist, the set is dealt with under Swatch Art. In 1992 the only Specials were Chandelier, a Christmas Special (see p.93) and Time to Move, an automatic Special, (see p.87). For 1993, Swatch produced a rather ordinary looking Olympia III not much removed from the 1984 Olympia logo version except that it now featured a date.

However, 1994 opened with a bang with the first Swatch Easter Special. Called Eggsdream (see p.88), its face featured three dials with two more reproduced on the egg yellow strap, surrounded by eggs, egg cups, and bird footprints. An amusing throwback to the days of the Russian Czar and his gifts of Fabergé eggs to his family at Easter, it was even packed in a yellow Easter "Eggsdream" box.

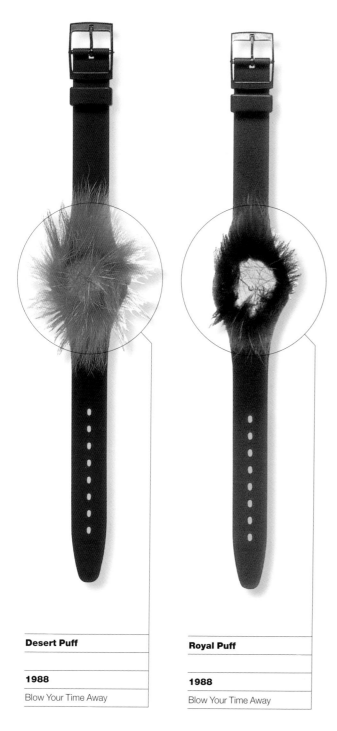

Desert Puff

1988

Blow Your Time Away

Royal Puff

1988

Blow Your Time Away

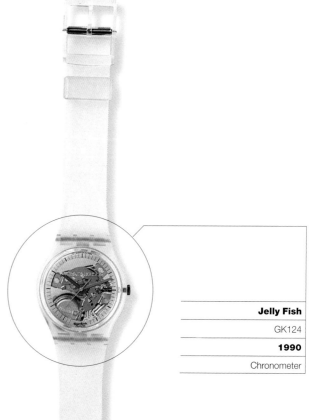

Jelly Fish

GK124

1990

Chronometer

> For the 50th anniversary of the United Nations, Swatch produced, in 1995, UNlimited. Designed by YA/YA (Young Aspirations, Young Artists), a community set up in New Orleans to promote gifted young artists, it was a Chronograph Special designed to portray (with hands of different races clasped together) a note of solidarity against the tide of spiritual neglect and fatalism. Part of its sales revenue went to the United Nations Fiftieth Trust Fund to support educational and communications projects for young people the world over.

Other Specials that year included a set of three to commemorate 100 years of the cinema. Eiga-Shi was designed by Akira Kurosawa, a Tokyo-born director with 50 years' experience of the cinema. This dramatically simple design, which translates as The Eye of the Dream, is his way of opening the eyes of the world.

Time to Reflect is another philosophical title for a fairly staid (for Swatch) model, designed by Robert Altman. Former bomber pilot, producer, and director of industrial films, he made his name with M.A.S.H. Time to Reflect, it is said, could well be the motto of this penetrating man.

Depiste the third of the Cinema Specials, is a multicolored ensemble in a red case enclosing a flamboyant dial, supported by a band composed of hundreds of tiny colored beads. It is the work of Pedro Almodovar, whose biography calls him the enfant terrible of the European cinema. He throws together a

melange of fashion, music, sex, and violence and is a former producer of comic books who wallows in kitsch. Depiste is said to be his reflection of the world as a desire for reality.

Specials come in all forms. C-Monsta is 1995's Summer Special —a garish, luminescent green dial, with a blue bezel and a brash red knobbly strap. Designed, say its makers, to look good in the South Seas, on a coral reef, or with an inflatable crocodile at a barbecue the C-Monsta is a Scuba, water-resistant to 660 feet. It was packed with one of these awful 1920s rubber bathing caps and the whole affair was a veritable orgy of bad taste!

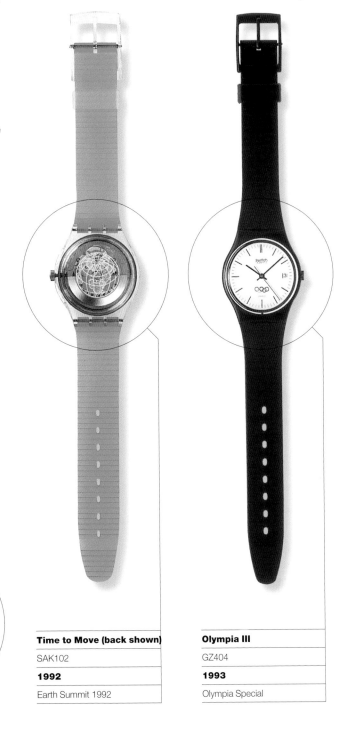

BMX

GP104

1990

Chronometer

Time to Move (back shown)

SAK102

1992

Earth Summit 1992

Olympia III

GZ404

1993

Olympia Special

> 1995 was a vintage year for Swatch Specials. In addition to those already reviewed, there was a MusiCall Special called 11pm; its unique feature was a seven-tone alarm call by Paulo Mendonça, a multitalented musician, whose father was Angolan, his mother Portuguese, and who lives in Sweden. His music is a mixture of black funk, rock, and soul and is embodied in the 11pm Musicall, which has a jazzy dial and a multicolored strap emblazoned with the words "Try to make the world a better place."

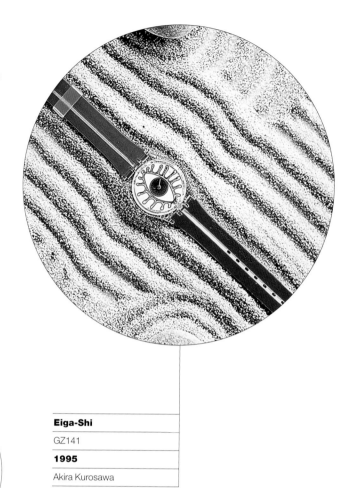

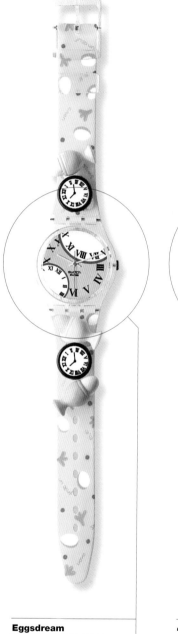

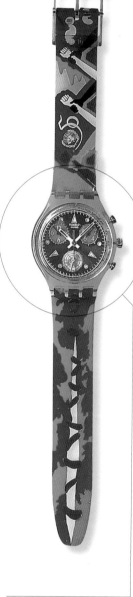

Eiga-Shi
GZ141
1995
Akira Kurosawa

Eggsdream
GZ 128
1994
Easter 1994

«UNlimited"
SCZ103
1995
50 Years United Nations

For 1996 Swatch commissioned video artist and musicologist Nam June Paik to design an Art Special. It is called Zapping and he says it reflects the timelessness of music and the visual image, and incorporates all the audiovisual possibilities open to the artist. The strap features sequences from his video work, and the dial is decorated by stylized TV monitors. It has a luminescent yellow/green transparent case and was the first-ever watch to be sold on the Internet.

Access to Space was chosen by Swiss astronaut Claude Nicollier for his voyage of discovery in the spacecraft Columbia. It was a Swatch Access STS75, developed jointly with SkiData of Austria by the high-tech division of SMH Group and was handed back to Nicolas Hayek for the Swatch Museum by Nicollier after his successful journey beyond the atmosphere and back. The dial of Access to Space features the names of the seven intrepid astronauts. A special Special indeed!

The Atlanta Olympics were obviously an extra special occasion for Swatch—and for the army of journalists and photographers who covered the events for the world. So Swatch produced an Access to the World of Swatch for every member of the press so as to make their path through the security control systems easier or even get them a coke from the vending machine! They could not be bought, they were earned. And came with the compliments of Swatch.

Time to Reflect
GZ143
1995
Robert Altman

Despiste
GZ142
1995
Pedro Almodovar

> Another Special for 1996 was a combination of all that is technologically achievable in a Swatch—an Irony Chronograph/Chronometer Swatch Special complete with COSC Certificate (in the box) produced in a limited edition of just 1,500 pieces called Time Cut. It had an aluminum case and a cool rubber strap and a clear silver business-like dial. If it did not mark a special occasion, it was a tour de force for Swatch itself.

On November 1, 1996 Swatch launched, at the Austrian city of Salzburg, an exciting scheme designed, they say, to keep art untainted by filthy lucre. Swatch Access to Salzburg was the first wallet-in-a-watch! The Swatch could be "charged" with a specific amount of money and enabled its owner to go on a spending spree, paying for transportation, meals in restaurants, admission to museums and galleries, and even the hotel bill—all without cash!

The final Special for 1996 was called Rund um die Uhr (Round the Clock). This UNESCO Special Swatch was created to raise funds to help "Children in Need" through five selected aid projects. The watches were ordered in their thousands and, helped by publicity through radio and television the project, also supported by sponsors such as Nelson Mandela, Michael Schumacher, Hans Dietrich Gensher, and Pélé, raised a considerable sum for the fund.

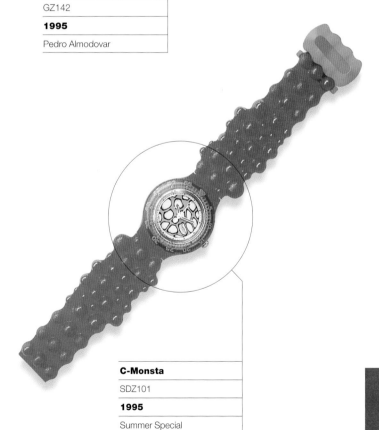

C-Monsta
SDZ101
1995
Summer Special

> For Spring 1997 bearing in mind what a young man's fancy turns to, Swatch produced a St. Valentine's Special. Actually it was a standard Swatch but designed by a trio of Italian artists called, unbelievably, "Plumcake." Gianni Cella, Claudio Ragni, and Romolo Pallota, having created a sensation with their design for the Swatch Art Clock Tower in Atlanta, produced Pounding Heart for Swatch in a riot of galloping hearts in a vibrant melange of orange and blood red on strap and dial in a stainless steel case. It came in a festive pack and is an unlimited edition.

Element was launched at the 50th International Cannes Film Festival as a compliment to director Luc Bresson and his film *Fifth Element*. A Swatch Access, it was the admission ticket for the 850 guests who were invited to the Gala Dinner on May 7: it came in a numbered, limited edition.

Avaton, in shades of blue, lilac and gold, was produced as a tribute to the Treasures of Mount Athos. An Access, its chip has already been programed to give admission to the Museum of Byzantine Culture in Thessaloniki (as well as a 20% discount off the price of the catalog).

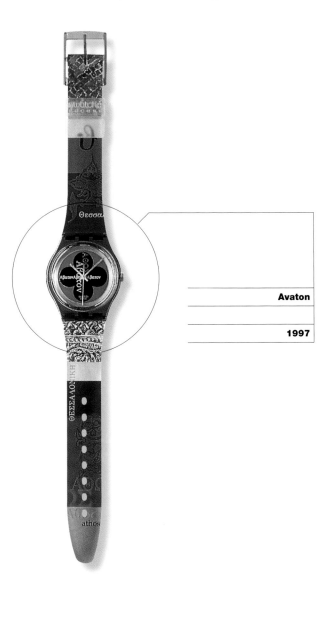

Avaton
1997

11P.M.
SLZ103
1995
Paulo Mendonça

5th Element
1997
Cannes

Christmas Specials

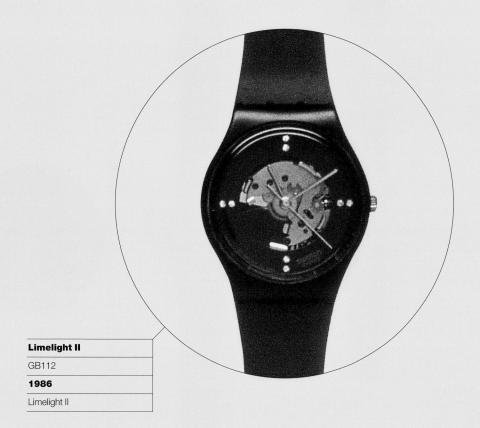

Limelight II
GB112
1986
Limelight II

83 84 85 86 87 88 89 90 91 92 93 94 95 96 97 98

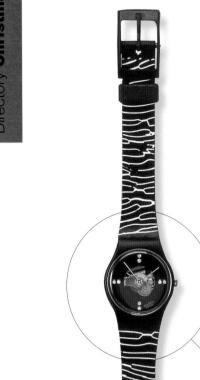

> Christmas gives Swatch an ideal opportunity for extra special Specials. The first Christmas Special was Sir Limelight, 1985, which had a square of actual diamonds on the dial to mark 12 o'clock—there was a matching Lady Limelight to keep it company. The next year's version had the diamonds in pairs at the quarters (Limelight II). In 1987 under the theme "Limelight Re-edition" came a whole clutch of black faced Limelights with crazed black or black and white horizontally striped straps—all in pairs of his and hers and with diamond-bejeweled dials.

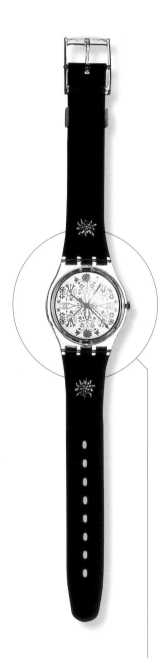

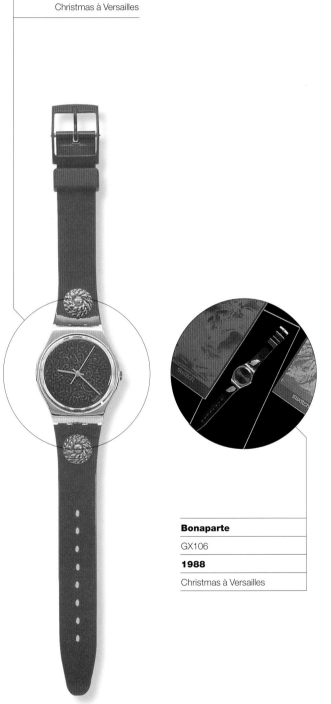

Pompadour

GX107

1988

Christmas à Versailles

Lady Limelight II

LB113M

1987

Limelight Re-edition

Bergstrüssli

GZ105

1987

Christmas 1987

Bonaparte

GX106

1988

Christmas à Versailles

Mozart

GZ114

1989

Christmas in Vienna

Hocus Pocus

GZ122

1991

Christmas 1991

Hollywood Dream

GZ116

1990

Christmas 1990

> 1987 produced Bergstrüssli with a frosted crystal dial; for 1988 there were a pair labeled "Christmas à Versailles"; one was called Bonaparte, the other Pompadour, both elegantly designed and packed. "Christmas in Vienna" was the theme for 1989, with a Swatch labeled Mozart daintily embellished with frilly lace cuffs. The 1990 Christmas Special was Hollywood Dream, a glittering bracelet model suitably tarted up with fake diamonds and a gold plated setting—the center of the dial cut away to show the movement, a typical Swatch move. 1991 went all astronomical—Hocus Pocus—with a sunburst dial and star spangled strap and pack.

Chandelier, produced for Christmas 1992 turned out to be one of Swatch's most treasured models. Festooned with colored balls and crystal drops which were handmade in Venice it was a quite outstanding creation and was presented seated in a glass pod with a wooden box.

For Christmas 1993 Swatch went all French Empire in Roi Soleil, a delicate blue dial with a red and gold decorated chapter ring on a strap of velvet corduroy. The pack featured a portrait of the Sun King himself on the lid and a moiré silk cushion to hold the watch. Swatch certainly doesn't do things by halves.

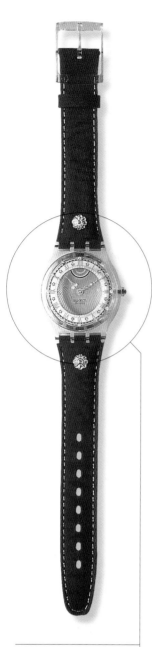

> Christmas 1994 was celebrated by a fantastic creation by Christian Lacroix. Called Xmas by Xian LaX (his name spelt phonetically), it consisted of a red-cased Swatch with a sunburst gold dial surrounded by miniature colored balls. It has no hands, just a single dot moving round the dial every 12 hours. The gold-plated bracelet had decorated links in a miscellany of intaglio stars and ropes and little figures. On the whole it was what one might well expect from one of France's leading couturiers. This fabulous creation came in a casket of gilt and red velvet.

It might be thought that this was a hard act to follow but the Christmas Special for 1995 was up to the task. Called Magic Spell, it had a green case supported by a highly colored strap depicting scenes of Christmas wonder. The dial was covered by a dome containing a three-dimensional snow scene and the whole was packaged in a book whose dark red cover was embossed with magic symbols in gold. A fairy tale indeed!

For their twelfth Christmas Special in 1996, Swatch really pulled out all the stops. The theme of the watch was light, a symbol of hope that takes on special significance at Christmas. Light-Tree is a colorful, modernistic abstract Christmas tree shape.

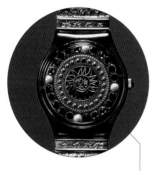

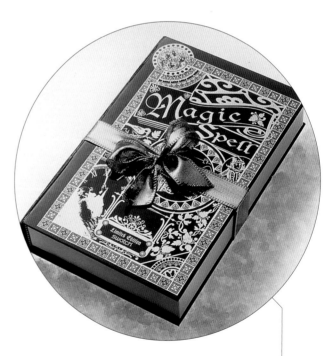

Xmas by Xian Lax

GZ139/140

1994

Christmas 1994

Roi Soleil

GZ127

1993

Christmas 1993

Magic Spell

GZ148

1995

Christmas 1995

> The dial has a decorative surround fitted with fairy lights and a button. Press it, and the diodes start blinking. It comes packaged in a shiny red Christmas Tree ball. This one is a Special Swatch all the way.

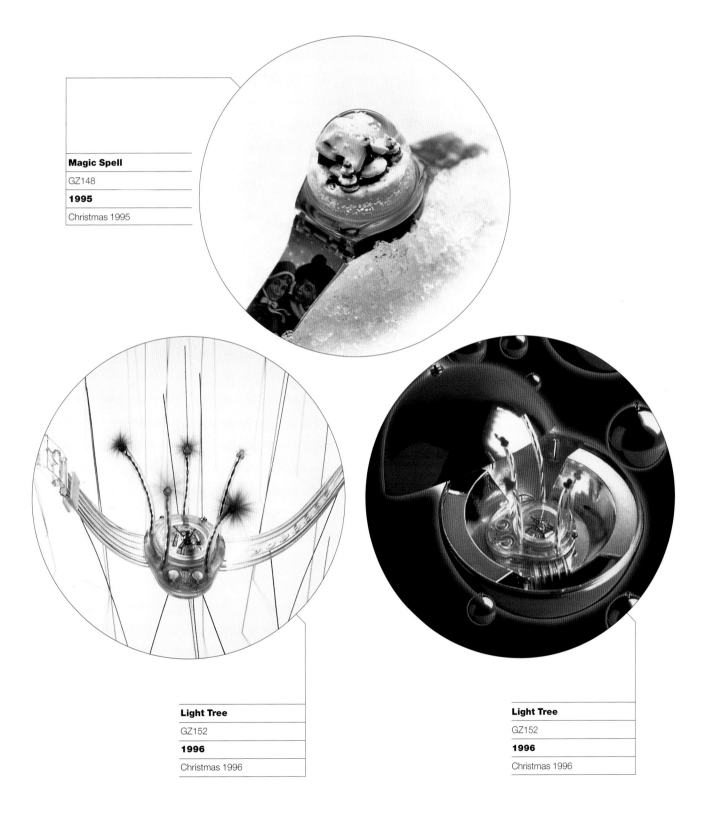

Magic Spell

GZ148

1995

Christmas 1995

Light Tree

GZ152

1996

Christmas 1996

Light Tree

GZ152

1996

Christmas 1996

Chronograph

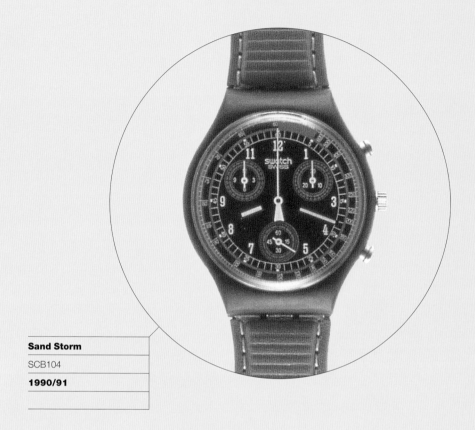

Sand Storm

SCB104

1990/91

83 84 85 86 87 88 89 90 91 92 93 94 95 96 97 98

> In 1990 Swatch engineers took their revolutionary timepiece into the next dimension with the introduction of the Chrono. It hit the market just at a time when many thought the popularity of Swatch had peaked—they just couldn't believe that the cheap plastic phenomenon could go on.

The main objective was to produce a line of Swatches that, like the Standard Swatch, was more reminiscent of classical watches than other lines they had developed.

Whatever the background, the Chrono was an immediate success. Supply could not keep up with demand and even in its early days according to Peter Steiner, the then vice-president of Swatch Sales in Europe, enthusiasts were paying fifteen times the official list price of $75 or SF100—a matter that caused Swatch management some concern.

In appearance, the Chrono did not depart too far from the distinctive colored dials of the standard Swatch but the movement, a multifunction ETA quartz, was a fully functional chronograph. It was a 1/10 second timer with stop and reset facility, subsidiary dials for recording hours, minutes, and seconds; individual lap times and intervals of up to 12 hours could be measured and there was a tachymeter scale for calculating speed.

> The Chrono was launched in 1990 in six versions to start with; Sand Storm had a traditional black dial with the three sub-dials in white and beige in a black case on a sand-colored strap. Skipper was also a fairly conventional model, though with gold-plated buttons, but Skate Bike and Signal Flag soon reasserted the typical Swatch distinctive look. In 1991 came five more models, including Navy Berry in red and white stripes.

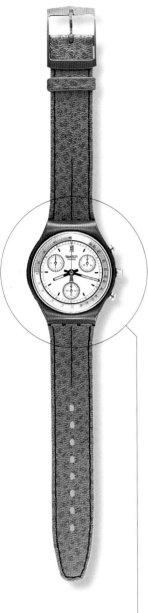

Signal Flag

SCN101

1990/91

Skipper

SCN100

1990/91

Skate Bike

SCB105

1990/91

Navy Berry

SCR100

1991

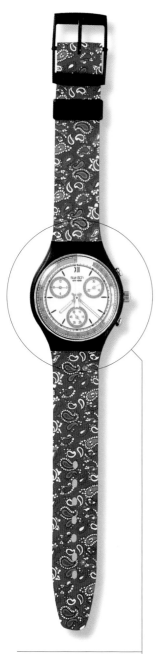

> Award (1992) was dressed in a paisley motif strap, like a Grandee's waistcoat, while Grand Prix had a fluorescent case and dial. In 1993 the collection ranged from the fairly sober Jet Lag through Honeytree, a golden bracelet model to Greentic with its busy looking dial.

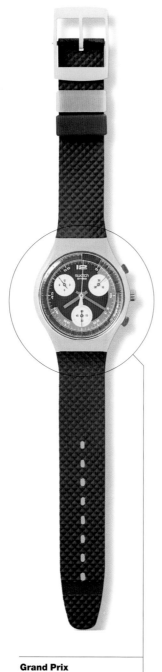

Jet Lag

SCM102

1993

Honeytree

SCN107

1993

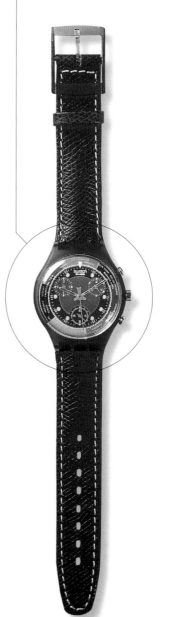

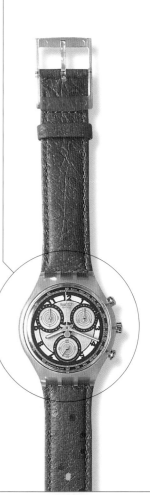

Award

SCB108

1992

Grand Prix

SCJ101

1992

> For 1994 this 1/10th second timer with its water-protected case acquired an additional feature—a date display. Hitch Hiker represented the traditional end, two very stylish bracelet models in Power Steel and Pleasure Dome livened things up a bit, and Dancing Feathers went way over the top with a strap displaying some form of tribal designs and an actual feather attached to the case. (In fact this turned out to be one of Swatch's rare bloomers. It did not take off and stocks of Dancing Feathers were ultimately withdrawn.)

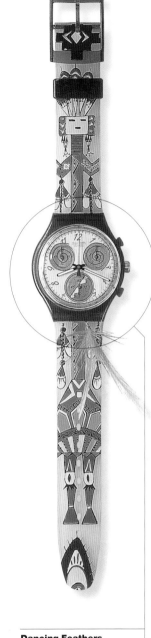

Pleasure Dome

SCM106/107

1994

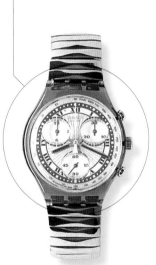

Hitch Hiker

SCG104

1994

Power Steel

SCN110/111

1994

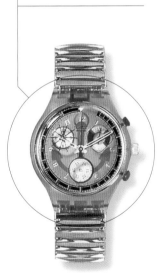

Dancing Feathers

SCO100

1994

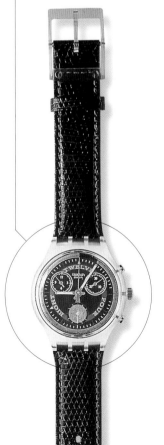

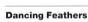

> Swatch described the Chrono as a light-hearted approach to the serious business of precision timing and the 1995 collection was no exception. The sub-dials of The Top Brass were decorated with medal-like military crosses, Count had a most elegant design in beige and black (very Rolex-like) on a tan leather strap, Russian Treasury was a mélange of Czars and Czarinas with Fabergé eggs and Russian icons. Blue Function brought the whole collection back to earth with a blue dial with roman cardinal figures, a clear date aperture at 6 o'clock and a matching blue leather saddle-stitched strap.

The Top Brass	Russian Treasury	Blue Function	See Through
SCN116	SCG107	SCK404	SCK 110
1995	**1995**	**1995**	**1996**
	Russian Inspirations	Short Stories	The Invisibles

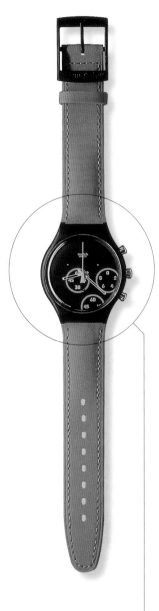

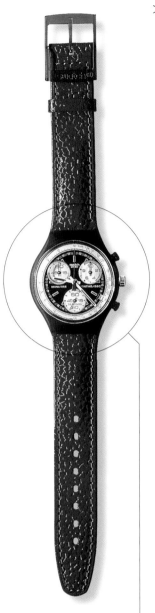

> Papiro headed the 1996 Chrono collection; it had a decidedly Egyptian appearance, though the overdecorated sub-dials must have made the much vaunted precision difficult to read, if not to achieve. See Through, a transparent model with conventional black dial and gray strap, would no doubt have been more practical, if not so much fun. Rallyé was a highly professional-looking model while Specchio offered a cool steel look on a steel expanding bracelet. Slow Down was all dots and circles—eccentric to be sure—and to complete the collection there was a goggle-eyed model in a transparent case on a real steel bracelet called Shiny Start.

For 1997 Excentric led the way—a black cased model with black dial, its subdials outlined in green in an eccentric design. A lime green strap in leather or Lextite, with black buckle, completes the ensemble.

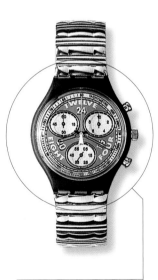

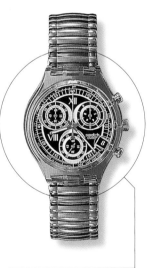

Rallyé

SCM403

1996

Short Stories

Specchio

SCM112 A/B

1996

Short Stories

Shiny Start

SCK407 A/B

1996

Primaries

Excentric

SCB117

1997

Movimento

> Time Dimension is a straightforward chronograph with clear gray dial, transparent case, and stylish black strap. Time to Call has an equally clear dial, white this time, also in a transparent case and bright telephone box red strap enlivened by a drawing of a telephone—old style.

Virtual Green has a pale green dial with large black sub-dials in a pale case and green flexible metal band.

For Swatch, Speed Counters is a fairly conventional chronograph with a black dial enlivened by rather diminutive white figures. Glowing Ice is a more imaginative design with a "glow in the dark" Loomi feature.

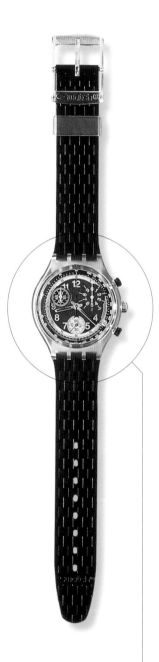

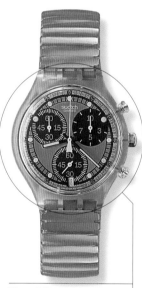

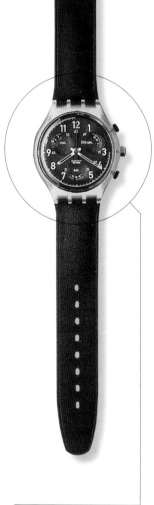

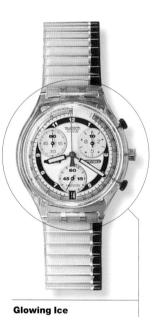

Virtual Green

SCK410 A/B

1997

Space Place

Time Dimension

SCK409

1997

Time Jockeys

Speed Counters

SCK113

1997

Glowing Ice

SCK411 A/B

1997

Scuba 200

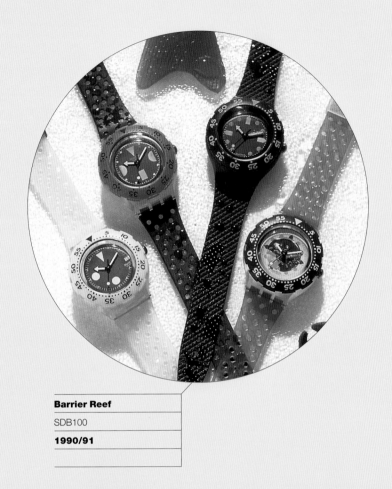

Barrier Reef

SDB100

1990/91

83 84 85 86 87 88 89 90 91 92 93 94 95 96 97 98

> A completely new, high-tech product, the Scuba 200 was launched in the United States at the end of 1990. It combines typical Swatch quartz accuracy with a lightweight case and dials with a flair for fashion—an art at which Swatch have long been adept.

It is water-resistant to a depth of 660 feet—out of reach of all but the most experienced Scuba divers—but its forte will undoubtedly be with the young people who play on the beach rather than under the water.

Should it be required as a diver's companion its bezel can be turned counterclockwise and set to measure a diver's submersion time with the customary Swiss precision. The bezel cannot be turned accidentally.

Until Scuba, most diver's watches were pretty austere—possibly to match the black wetsuits and flippers of the earlier days—but as water sporting gear has become more colorful, Swatch's Scuba, with its sea-greens and coral pinks and the intense blue of tropical skies, will liven up the scene on the beaches—and, for that matter, anywhere else.

The Scuba, like the Chrono, proved so popular that demand quickly outstripped supply—in spite of a 35 percent step-up in production—causing some concern to the management team. They saw the Scuba changing hands at vastly inflated prices—a situation totally against their policy of making good quality timepieces available to everyone.

> The distinguishing feature of the Scuba 200 is the larger case, fitted with a turning bezel, notched to make it easier to handle underwater or with wet hands or gloves.

Of the first four produced in 1991 Barrier Reef was the one that looked most like a conventional diver's watch, with clearly marked dial and corrugated rubber band. The second collection of four models was much more in the Swatch tradition with colorful dials and straps, of which Happy Fish was a prime example.

The 1992 collection was much the same; Jelly Bubbles had a transparent dial and bezel, while Divine had an unusual blue/black case, dial, and bezel on a custard yellow sewn strap—an effective combination.

Happy Fish/Hyppocampus	**Jelly Bubbles**	**Divine**	**Over the Wave**
SDN101/SDK103	SDK104	SDN102	SDN105
1991/92	**1992**	**1992/93**	**1993**

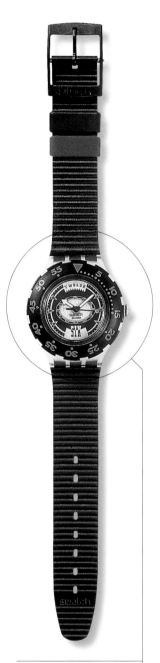

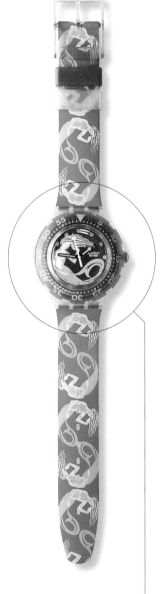

> The mixture seemed to be as before for 1993, the occasional scenic strap as on Over the Wave making a change from the plain colors of the general run; some of the dials were transparent, which although displaying the Scuba's high quality quartz movement, might have proved difficult to read had anyone actually attempted to get down to over 600 feet.
>
> Tech Diving seemed a more workmanlike model, although the younger element would undoubtedly go for Sailor's Joy. A rather stylish model, Mint Drops, with matching green bracelet, joined the collection.

Tech Diving

SDK110

1993

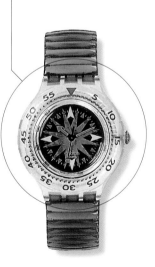

Sailor's Joy

SDG100

1993

Mint Drops

SDK108/109

1993

Lunaire

SDK113

1994

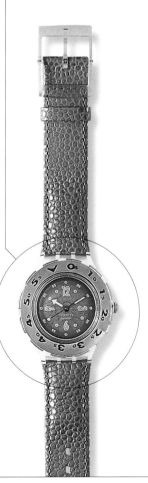

> For those with actual experience of diving to anything more than a couple of fathoms, the Scuba's lightweight case must have been a boon. The 1994 collection carried on the tradition of fun cases and straps—Lunaire being a particularly colorful model which also managed to look elegant. Black Gondola and Underpressure (with a somewhat eccentric dial) offered bracelet versions for those who preferred to demonstrate their Scubas above water. Mind the Shark included the latest Swatch innovation—an illuminated dial (called Loomi) at the press of the button situated just above the crown.

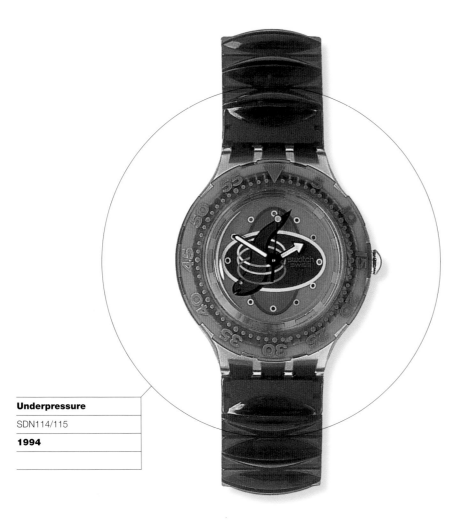

Underpressure

SDN114/115

1994

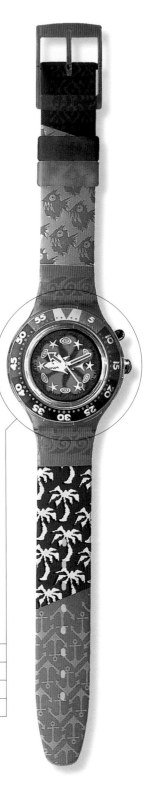

Mind the Shark

SDK902

1994

Scuba 200 Loomi

> For 1995 the Scubas varied between the normality of Goldfish and the intriguing combination of blue and silver of Waterdrop to the frankly fantastic Tovarisch, its strap a parody of Russian workers' art. The Loomis were represented by Fluoscope, the bezel of which did indeed seem fluorescent.

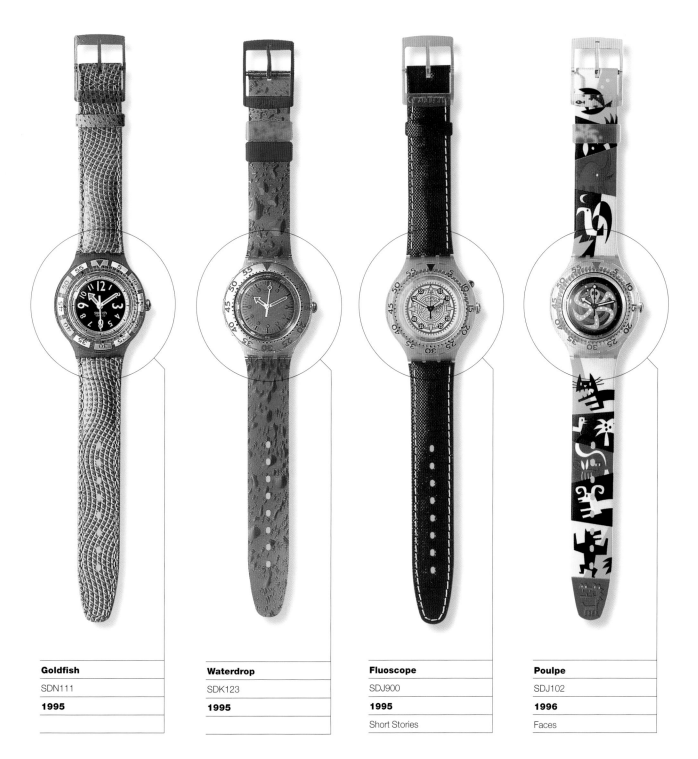

Goldfish	**Waterdrop**	**Fluoscope**	**Poulpe**
SDN111	SDK123	SDJ900	SDJ102
1995	**1995**	**1995**	**1996**
		Short Stories	Faces

| **Walk-on** |
| SDK907 |
| **1996** |
| Tech is Cool |

| **Stripp** |
| SDN120 |
| **1996** |
| Utopia |

| **Pink Pleasure** |
| SDN900 |
| **1996** |
| Short Stories |

| **Washed Out** |
| SDB109 |
| **1997** |
| Movimento |

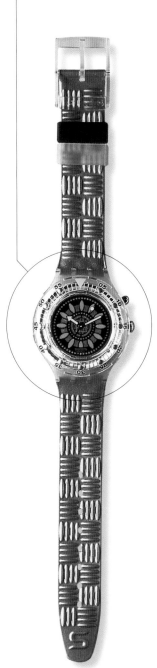

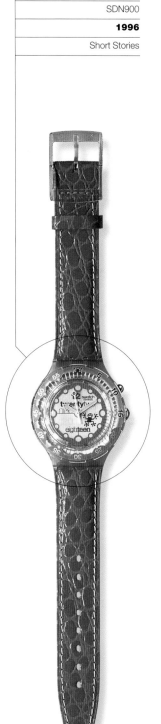

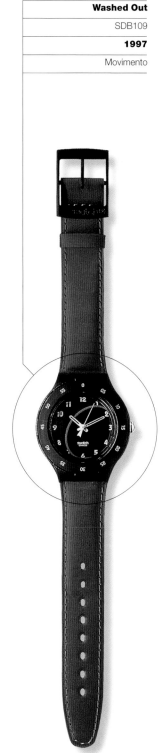

> "Merely a watch for genuine Scubans?" asks the introduction to the 1996 collection, which goes on to suggest that the Scuba 200 is at home in a street parade as it is at 200 meters in Davy Jones locker space. Poulpe is a gaudy mixture of animals and fish with an octopus dial. Walk on is a Loomi that looks as if it has aspirations to be worn by a gladiator and Pink Pleasure must be the most difficult to read, even if the most highly decorative, Scuba ever produced.

But the *pièce de resistance* of the 1996 collection must be Stripp. Here is a Scuba ready for a space walk complete with space suit, a couple of windcheaters, and a Swatch the Club T-shirt. A difficult act to follow, but Smile, with its feeling of a Breton fisherman's smock, brings the collection back to earth (or perhaps water) again, supported by Scuba Loomi Tsunami, with its wavelike decoration on both dial and strap, which had a very "classy" look.

Luminosa
SDJ901
1997
Exotica

Reef
SDL 900
1997
Primaries

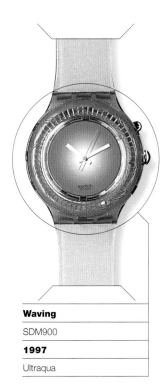

Waving
SDM900
1997
Ultraqua

Automatic

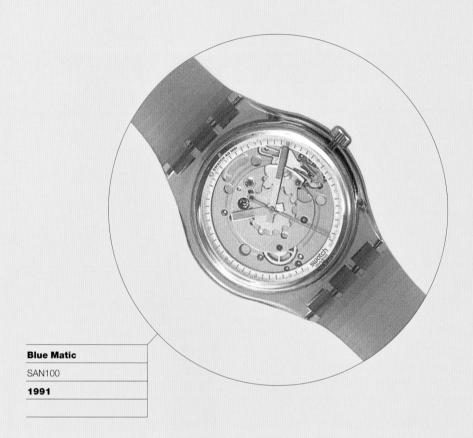

Blue Matic

SAN100

1991

83 84 85 86 87 88 89 90 91 92 93 94 95 96 97 98

> For a brand that had flaunted its innovative quartz movement, with its unique construction and minimum parts sustaining incredible accuracy, it seemed at first a negation of all its principles to introduce a model with a mechanical movement.

But then, the one unchanging thing about Swatch is that it is continually changing. For those who don't need to track time precisely to the second, for whom an accuracy of +/- 15 seconds a day is tolerable; for those with a more casual approach to the passage of time and an appreciation of fine mechanical workmanship, the Automatic is the natural choice.

So the Swatch Automatic was launched to meet requirements of a different sort, and it proved—if that were necessary—that Swatch was also capable of producing a classical mechanical watch, waterproof, and shockproof, at as reasonable a price as its quartz companion and of equal aesthetic distinction.

> The innovative Swatch Automatic appeared in a collection of three models in 1991. All had dials variously cut away to show the automatic movement and had transparent backs to reveal the oscillating rotor. Blue Matic and Black Motion illustrate the fairly sedate approach of these mechanical Swatch pioneers.
>
> Three more appeared in 1992 on much the same lines, soberly strapped, discreetly cut away dials, shiny metallic cases. François 1er and Red Ahead are two of that year's modest additions.

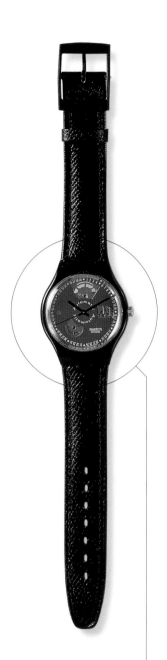

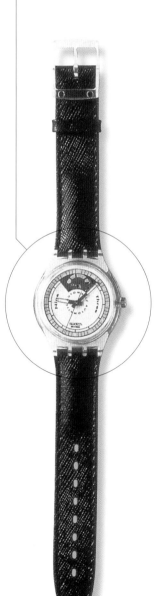

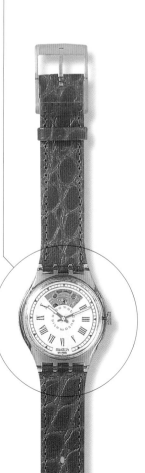

François 1ER

SAK100

1992

Gran Via

SAG100

1993

Black Motion

SAB 100

1991

5th Avenue

SAB101

1992

> Then came an extra special automatic. Time to Move was a UN Special Swatch Automatic created to commemorate the Earth Summit '92—a United Nations Conference on the Environment (see pages 86–87). Purchasing this Swatch signified a commitment to the Earth Pledge and Nicolas G. Hayak, Chairman of the Swatch Board of Directors, handed over a substantial check to Secretary Strong when addressing a meeting in the UN Assembly Hall in New York in March 1992 when Time to Move was launched.

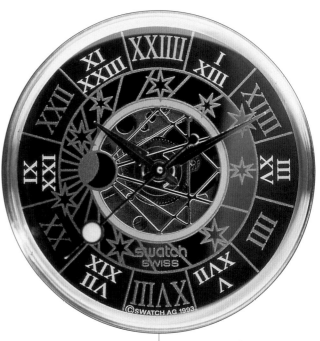

St. Peter's Gate
SAK106
1993

Black Circles
SAB102
1993

Trésor Magique
SAZ101
1993
Automatic Special

Avenida
SAG400
1994

> The renaissance in mechanical timekeeping that was taking place in the watch market embraced even Swatch. The 1993 collection saw the addition of a date display and at last some more adventurous straps of which Mappamondo is an example; its dial cut away even more almost to skeletal degree. Gran Via is an unusual, but good-looking combination of green case and brown simulated crocodile strap. St. Peter's Gate is another model highly decorated in an Italianate fashion from this period; Black Circles has a very smart, if rather eccentric dial.

The Automatic Special for 1993 was Trésor Magique, the fabulous Swatch with a platinum case and crown of which much has been written elsewhere in this book. It came in a steel presentation case with an acrylic glass inlay complete with spare interchangeable strap in mock croc leather, its own individual number and what looks like a miniature bottle of water. It was priced at £1,000 (about $1,600) and two thirds of Britain's allocation of 1,000 pieces was sold in three hours in London on the launch day.

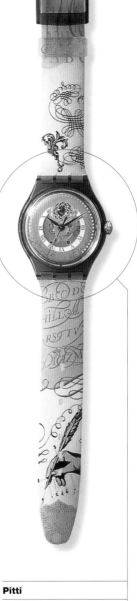

Arcimboldo
SAO100
1994

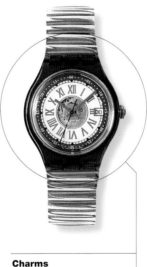

Charms
SAM401/402
1994

Pitti
SAM105
1995

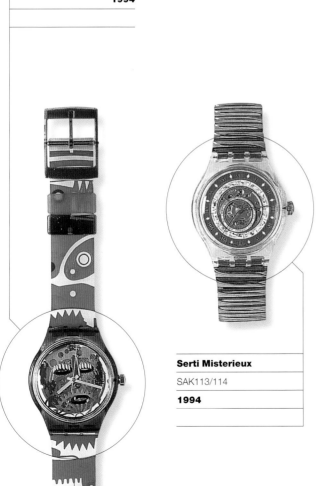

Serti Misterieux
SAK113/114
1994

After that, the 1994 collection seemed a little tame, though Avenida with its clear dial and tan strap had an air of luxury quite belying its attractive price. Arcimboldo reminded the world that Swatch could still be outrageous. Serti Misterieux and Charms, appeared in time to catch the Christmas trade.

For 1995 Swatch once more went fairly conventional although enlivened by an elegantly calligraphic Pitti and a model with a computer graphics dial called Blackboard. Missing had a very attractive gilt case on a handsome strap though its Roman figured dial had a rather forlorn chunk between 12 and 2 o'clock missing (hence the name).

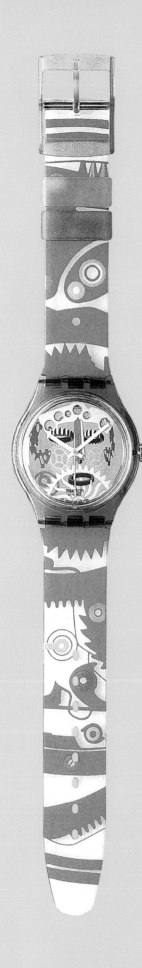

Swatch derives its inspirations from many sources. Arcimboldo is the name of an automatic in the 1994 Spring/Summer collection. Arcimboldo was the name of a 16th-century Milanese painter in the Courts of Vienna and Prague who composed highly symbolic portraits of the Hapsburgs and their courtiers for the Imperial collection of curios.

Shells, vegetables, and fruits became princely ears, noses, and mouths. Cabbages from Europe, artichokes from North Africa, and the newly arrived eggplant from India were all used by Arcimboldo in his fantastic creations.

Surrealists caught his message. Max Ernst, Dali, and Miró followed in his footsteps and cartoonists, graphic artists, and designers are still today inspired by his works.

Swatch World Journal
Spring/Summer 1994

> Ethnosense appeared again as a theme in the 1996 Automatic Collection—in this case featuring a remarkable mixture of colors on strap and dial depicting what looked like leaping stags and minuscule whales; it was called Aniak.

Nugget is a quite attractive model with an amber case and a bracelet that looks as if it really is carved from a nugget of gold. Numé-Rotation in a nice combination of browns and has a dial with a numeric design nearly as weird as the name.

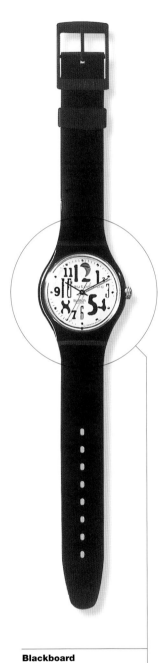

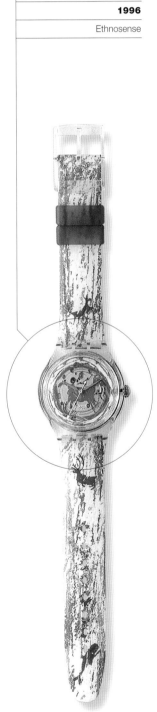

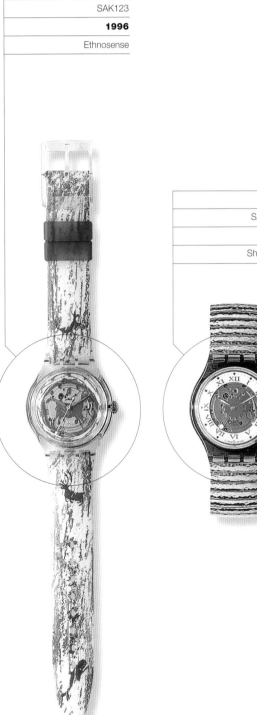

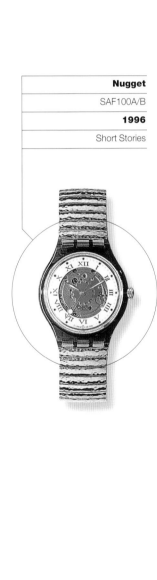

Aniak
SAK123
1996
Ethnosense

Nugget
SAF100A/B
1996
Short Stories

Blackboard
SAB103
1995
Black or White

Missing
SAJ100
1995
Short Stories

> Tarsia heads the 1997 collection with a black cased model on a white genuine leather strap; it has gray hands and numerals and an intriguing cutout on the black dial from 9 to 12 o'clock. Last Week, Next Week has a yellow wholly visible date ring (these are normally hidden under the dial, the date showing through an aperture) with a magnifier over the actual day in an otherwise fairly standard case and black plastic or leather strap.

Sposa, in a steel case shows all its works under a transparent dial; it has an unusual gray textile leather strap. A similar model on a black strap that is optionally leather or velvet is Velvet.

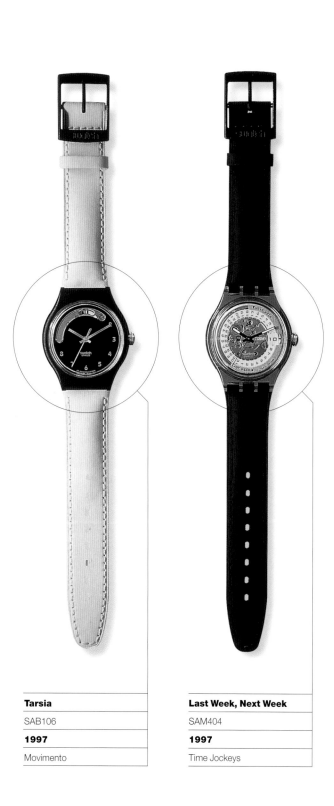

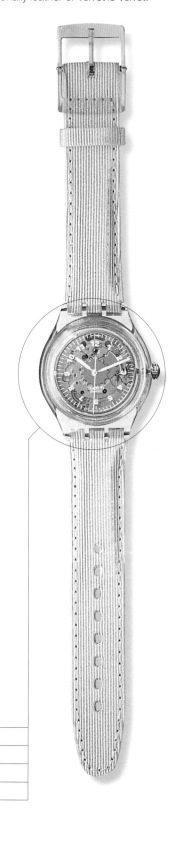

Tarsia	**Last Week, Next Week**	**Sposa**
SAB106	SAM404	SAK129
1997	**1997**	**1997**
Movimento	Time Jockeys	

Swatch the Beep

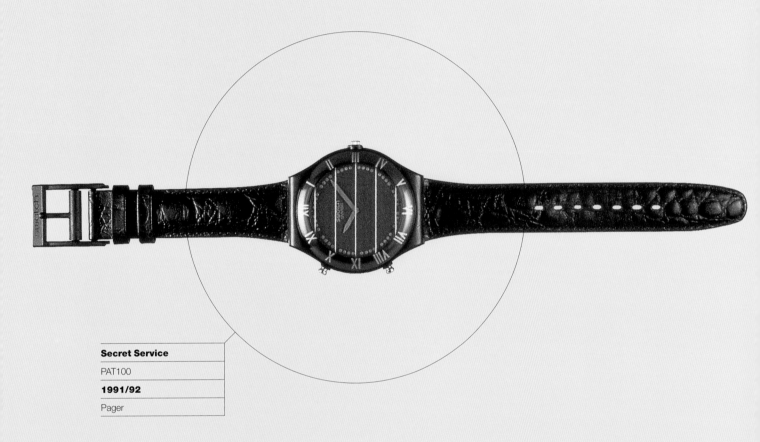

Secret Service

PAT100

1991/92

Pager

83 84 85 86 87 88 89 90 91 92 93 94 95 96 97 98

> It was always intended that, when the time was ripe, Swatch would expand into other areas of consumer products that would benefit from the experience and know-how it had acquired in the development of Swatch itself. In particular it had ambitions to introduce new ideas into the field of telecommunications and its first move in this direction was to produce the Pager—later called the Beep.

It was launched in Switzerland in December 1991 after five years of research and development. At 2.1cm it was the world's smallest mobile paging device, its size being kept to a minimum by two patented design features. Firstly, an integrated antenna which is instantly recognizable by the five metallic strips placed across the face of the watch; and secondly, a battery compartment fitted as an extension of the watch strap.

> It was a pager designed to be worn on the wrist and not on the hip. Up to the arrival of the Swatch design, pagers came in little rectangular boxes that were clipped to waistbands or wherever. They were not really handy for the well-dressed male and were impossible for the elegant woman executive. Now Swatch had produced a pager that could be worn inconspicuously. The name incidentally, comes from the French "le page"—the little lad who darts around hotel lobbies, "paging" a guest who is required on the telephone.

It is an all-Swiss product, manufactured entirely in Switzerland and as well as being a pager it is also a high-quality analog quartz wristwatch with a specially developed movement. It is unaffected by high and low temperatures within the normal range.

Its electronics require 122 square mms of silicon compared with the 35-square-mm integrated circuit of an ordinary Swatch. It can memorize four numbers, each of which has its own special signal, identifying each caller. It did not take Swatch engineers long to produce the second generation of pagers, in which the caller's number was shown on a liquid crystal display. And it had the advantage that its beep could be silenced if desired.

The two functions of Swatch the Beep—timekeeping and Pager—are quite separate and can be accessed using the watch crown either extended or in neutral position. The pager and watch are powered by a 3 volt lithium battery providing around 55 hours of usage.

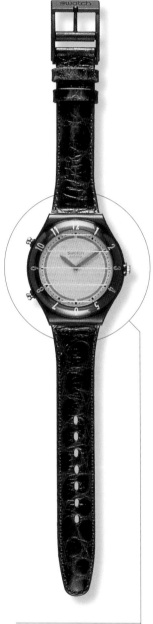

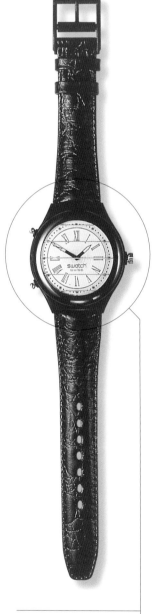

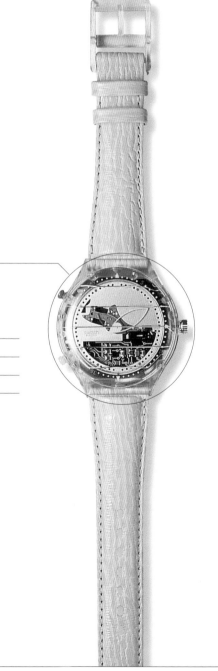

Yellow Ribbon	
PAT113	
1993	
Beepop Tone	

James' Choice	
PAT101	
1991/92	
Pager	

After Hours	
PAT111	
1993	
Beepop Tone	

> The pager was launched initially only in Switzerland and a monthly fee of SF15 (later reduced to SF5) had to be paid to the Swiss Telecom Authorities (PTT). It became available nationally in the UK in October 1994 in a joint launch by Swatch and their airtime provider BT. It carries no airtime contracts and no airline charges. The pager function operates on a "caller party pays" facility. Each call to a Swatch the Beep costs the caller 25p (42c)—just under the cost of a UK first-class stamp.

The pager can receive, store, and scroll up to ten messages of a maximum of 20 characters. The arrival of a message is signaled by a series of beeps lasting ten seconds. The wearer can delete a message at any time and the Beep will protect selected messages from automatic deletion.

If the wearer does not wish to be disturbed, the Beep can be put on silent mode when it will keep track of messages which can be retrieved later. It will automatically delete the first message on the arrival of the 11th and so on.

Swatch the Beep has an automatic timer so it can turn itself off or on whenever the wearer wishes, night or day. The internal digital clock is adjusted to synchronize the pager time with the watch timer and with the real time. Swatch the Beep indicates when a message has been protected, when the memory is full or if the battery needs replacing. Each Swatch the Beep comes with a replacement battery stored in a spare battery compartment in a keyring given away free with it.

The first two Pagers might have been made for 007 himself—in fact one was called Secret Service, its black case featuring a bezel with gilt Roman numerals enclosing a dark gray dial; the crown and buttons were gilt and it came on a black strap. The other model, James' Choice, also had a black case, a white dial and a dark blue mock-croc strap—for James Bond in his Sunday best blue suit.

The 1993 pagers—now named Beep-up—soon adopted the typical Swatch livery. After Hours was a fairly quiet number, but Yellow Ribbon had a cunningly cutaway dial which revealed certain aspects of its microelectronic insides, and an ingenious pair of hands consisting of red and yellow ellipses. It had a yellow strap, naturally.

Les Tuileries was the first of the new Numeric Beep-ups with a clear white LCD display across the lower part of the dial which could display the number to be called back. Or, if you are still in James Bond mode, a coded signal of up to 12 numbers, giving information or instructions. Just agree the code in advance.

By 1994 all models had the digital readout and the watch was known as The Beep Numeric but its functions remained as before. Speaker's Corner had a fairly conventional white dial with gilt markings, in a black case on a lizard looking brown strap. Turn Around had a black dial with chunky Roman figures, while Inspiral had a red spiral design on a blue ground and a blue strap.

By 1995 it had achieved its final name and Swatch the Beep was christened. Golden Wings had a display with smaller, more discreet figures in a transparent case and pale gold strap. Red Banner did in fact display a small pennant on its all red dial, with large white computertype figures, in a blue case on a blue strap. Both these Beeps had only a crown and no other buttons—this depending, like the number of bars in the antennae fitted into the glass, on the telecommunications regulations in the country in which the Beep is to be used.

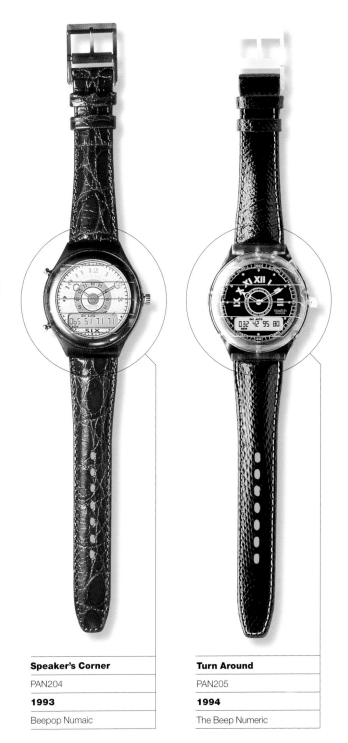

Speaker's Corner	Turn Around
PAN204	PAN205
1993	**1994**
Beepop Numaic	The Beep Numeric

> In 1996 there was yet another innovation—the Beep had become Alphanumeric! the panel on the dial could now display letters as well as numbers.

Bearing in mind the possibility of the "alpha" bit, the 1996 models were Gossip, with a conservative blue dial and brown strap, and Latest News, in a transparent case, gilt Roman dial and dark green strap. So now the wearer didn't have to remember a code; the message, provided it was short enough, could be spelled out in clear words like "I love you" or "Good Luck." Swatch the Beep Alphanumeric is the telephone on your wrist; cordless it may be but it does help you not to lose the thread.

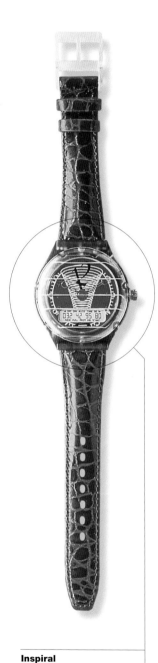

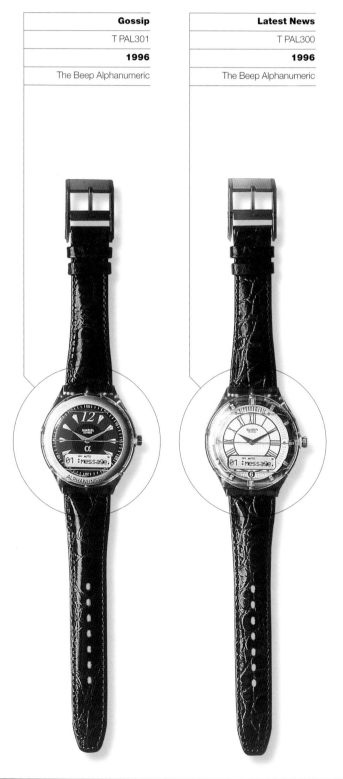

Gossip
T PAL301
1996
The Beep Alphanumeric

Latest News
T PAL300
1996
The Beep Alphanumeric

Inspiral
PAN206
1994
The Beep Numeric

Red Banner
PAN209
1995
The Beep Numeric

Stop-Watch

Coffeebreak

SSK100

1992

83 84 85 86 87 88 89 90 91 92 93 94 95 96 97 98

> A contemporary development with the Chrono was the Stop-Watch. Technically less sophisticated than the Chrono with its four stepping motors, the Stopwatch managed to be a timer as well as a watch with just one pair of hands, without any second hand or any other extra buttons. A simple press of the crown and the two hands jump to the 12 o'clock position ready to function as minute and seconds hand of a timer—with a range of up to six hours.

When it was first launched in 1992 Swatch's little miracle of microelectronics was only available in the Belgian, Dutch, and Swiss markets Later it found its way to France, Germany, the United States, and Great Britain.

> Two models appeared in 1992; Coffeebreak had a timer-like dial divided into two thirty minute periods on a black strap. Jess's Rush, was an all-black case model on a fluorescent green plastic strap, its dial marked in five-minute intervals.

In the Spring of 1993 three more models were introduced, all of them in the typical Swatch genre. Movimento was a flashy number with large numerals and colorful strap; Night Shift a more sinister version all in black, its dial emphasizing its stop function. The three fall models were fairly nondescript for Swatch.

1994 brought Yellow Star, with a transparent case and a jolly yellow strap, its dial a colorful jumble of figures. This year also saw the introduction of some bracelet models, of which Green Speed was a colorful example, with bright green band and a dial with alternating five-minute sections of yellow and green.

Stop-Watch does not appear after this and one can only assume it was not one of Swatch's more successful lines.

Jess's Rush	**Night Shift**	**Yellow Star**
SSB100	SSB101	SSM102
1992	**1993**	**1994**

MusiCall

Europe in Concert

SLB101

1993

83 84 85 86 87 88 89 90 91 92 93 94 95 96 97 98

> In 1993 Swatch launched the latest in its long line of innovative timepieces. It was an alarm—but being Swatch, it was no ordinary alarm.

To start with, it had the typical Swatch plastic lightweight almost indestructible case, and the customary colorful straps. Its revolutionary touch was its alarm call.

No more nasty electronic beeps or pips to irritate or annoy—just a catchy little tune to remind you of dates, deadlines, appointments, meetings, cooking times—or anything.

The first melody was by Jean Michel Jarre, whose multimedia spectacular in Zermatt, in the shadow of the Matterhorn, had helped to celebrate the production of the 100 millionth Swatch with a memorable three-day entertainment in October 1992.

Later the music of other famous musicians—Philip Glass, Paulo Mendonça, and Peter Gabriel—was used to provide a melodious note to remind the wearer of important matters pending or a gentler start to the day.

> Europe in Concert was produced as a memento of the Jean Michel Jarre concert and was launched in March 1993, at the same time as the release of his CD. Its blue dial had a golden sunface and rays and distinct On and Off signs; the strap continued the sun motif and others in colorful profusion on a black background.

Spartito was a more restrained model entirely, its dial an involved design of gold in a dark transparent case on a white dial decorated with music notations in gold. Very tasteful.

The Spring of 1994 introduced the work of another musician, American composer Philip Glass. A single push of the crown on these highly decorative alarm watches and one had a 32-second mini-concert on one's wrist. Tambour was a riot of eccentric whorls and ellipses in high color; Variation a blue and white model on segmented blue bracelet. For those who preferred the glitter of gold, Martingala had a conventional Roman figure dial in a green transparent case fitted with a gold plated bracelet.

Another innovation came about in 1995 in the shape of a MusiCall Special with a seven-tone melody by Paulo Mendonça called 11pm. It was presented in a flat box that looked as if it contained a record, with the watch laid across the disc (see p.90).

Other 1995 MusiCalls—all with melodies by Philip Glass—were Ring a Bell in a transparent case on an impressive green mock croc strap, Dudelsack, another quaintly named model featuring a Scottish piper on its dial, repeated complete with kilt, sporran,

Spartito

SLM101

1993

Tambour

SLJ100

1994

Variation	**Martingala**
SLN100/101	SLG100/101
1994	**1994**

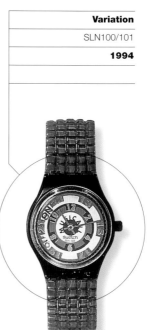

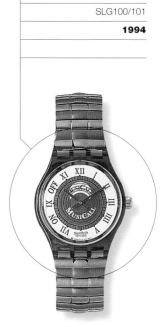

> and Hebridean and Highlands motifs on the strap. After this, Refrain, with its clear Arabic dial and gold-plated bracelet, was quite a change.

In 1996 the melody went back to Paulo Mendonça. In Running Time, Swatch's avant-garde technology is hidden in a fantasy model in blue with childlike drawings of men and trees and houses. Naive and as charming as the catchy melody—and a nice way to start the day!

Take the Rhythm had rather a way-out musical dial, in a pale translucent blue case on a steel bracelet the color of which somehow looked out of place. Wired had a mauve and yellow

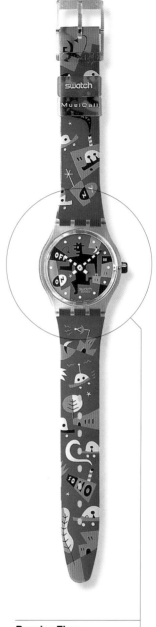

Dudelsack
SLR101
1995
Highland Stories

Refrain
SLM107/108
1995
Short Stories

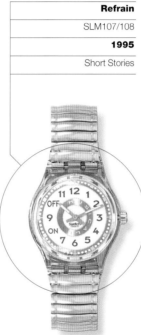

Ring a Bell
SLG102
1995

Running Time
SLK107
1996
Faces

rugby striped strap which jarred slightly with the reddish-orange dial with a yellow cubist face on it. Just when one was beginning to think that Swatch graphic designers had lost their color sense, along comes Peter Gabriel's Adam.

Peter Gabriel, a co-founder of the group Genesis, is an alchemist of sound and vision who has combined technical precision with human biology in his Swatch MusiCall Adam. The mechanism is visible through the transparent back while the domed sapphire crystal reveals through the dial the gongs that play the little melody he composed specially for Swatch. The strap is the color of honey and is decorated with streaks of beeswax. Adam expresses the correlation between man, music, and technology, says the composer.

> The 1997 MusiCalls consisted of a widely differing pair. Time to Cook had a white case on matching strap with black buckle, marked in large letters "On" and "Off." The typically Swatch part came on the back of the strap, which contained some suggested defrosting times and what must have been microwave cooking times for some 30 different foods—from chicken wings to pasta.

Dodecaphonic is also in a white case and strap, with a photographic representation of a musical score on both dial and band. The melody for both alarms is by Peter Gabriel.

A new musician calls the tune in the fall collection of MusiCall Candy Dulfer, whose melody enlivens Bunk Monster, a fantasy in green and purple, Acoustica a rather somber black and white number, and Music Race, a jazzy bracelet model with a bull's-eye dial.

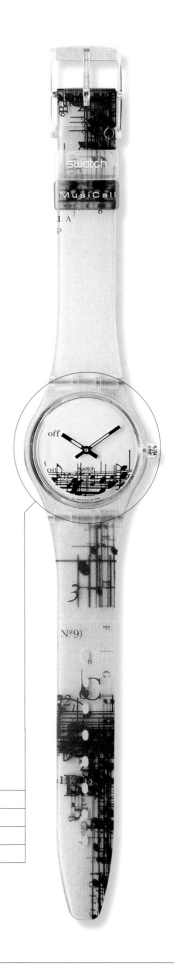

Wired	
SLV100	
1996	
Primaries	

Time to Cook	
SLK114	
1997	
Time Jockeys	

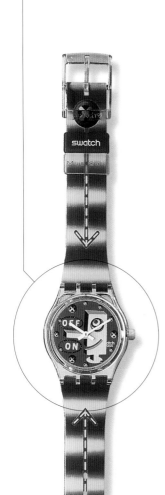

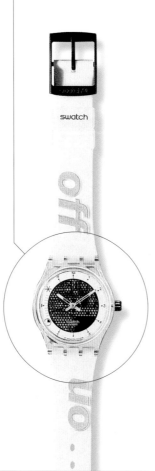

Dodecaphonic	
SLK113	
1997	
Primaries	

AquaChrono

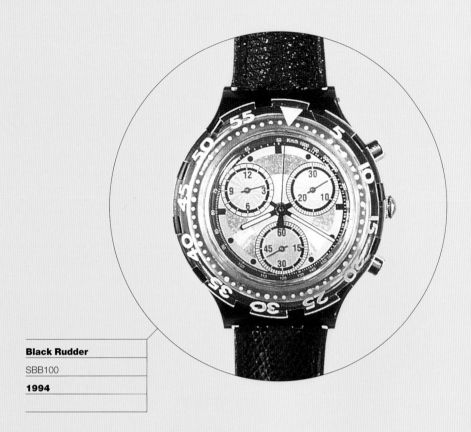

Black Rudder

SBB100

1994

83 84 85 86 87 88 89 90 91 92 93 94 95 96 97 98

> On April 27, 1994 the captain of a 35-foot submarine cruising at 100 feet a minute 660 feet below the surface of Loch Ness reported observing an unidentified object. In the darkness of the lake, just under the battlements of the ruined castle of Urquhart, its powerful searchlights picked up the outline of a cylindrical object. Clutching it in its claws, it brought it to the surface.

It was not entirely by chance that the submarine, owned by Swatch, made a rendezvous with the mysterious cylinder. On the battlements of the Castle stood representatives of Swatch and what seemed like half the world's press corps with their photographers. It was another dramatic launch in the history of the development of Swatch.

With the aid of a chainsaw, the cylinder was cut open to reveal the latest Swatch Scuba—the AquaChrono. Franco Bosisio, Director of SMH Italia and Chief Executive of the Swatch Lab at Milan, introduced his latest invention to the crowd. It was a Scuba with a difference; water-resistant to 660 feet; it had 30-minute and 12-hour counters, and a stop/start and zero mechanism; it was a Scuba 200 and a Chronograph combined. And its price was very competitive SF100.

> There were five Aquachrono models in the Spring 1994 collection. Most professional looking was Black Rudder, a transparent case holding a black and white dial featuring the three sub-dials and the customary diver's markings around the turning bezel. The 1/10 second stopwatch is operated by two buttons either side of the crown and for all its complexities it is very little larger than the normal Scuba. Silver Moon was a blue and silver variation on the same theme. Later that year a dynamic black and yellow version on what looked like a transparent bracelet was introduced. Waterpower looked an absolute winner.

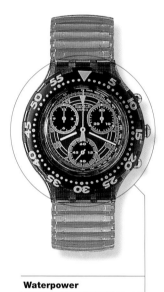

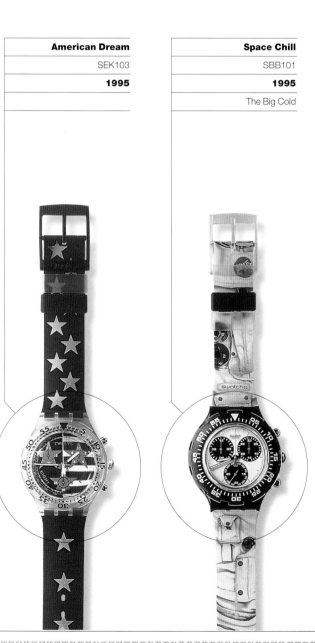

American Dream	Space Chill
SEK103	SBB101
1995	**1995**
	The Big Cold

Waterpower

SBM100/101

1994

Silver Moon

SBK100

1994

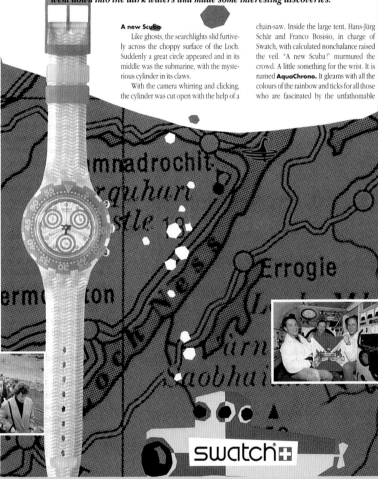

The mysterious Loch Ness in Scotland. A monster. A rusty cylinder in a fold in the lake bed, 300 million years old. An unusual ticking in the hidden depths. Enough to titillate the imagination and encourage adventurers and explorers to investigate the phenomenon. The Swatch submarine went down into the dark waters and made some interesting discoveries.

A new Scuba

Like ghosts, the searchlights slid furtively across the choppy surface of the Loch. Suddenly a great circle appeared and in its middle was the submarine, with the mysterious cylinder in its claws.

With the camera whirring and clicking, the cylinder was cut open with the help of a chain-saw. Inside the large tent, Hans-Jürg Schär and Franco Bosisio, in charge of Swatch, with calculated nonchalance raised the veil. "A new Scuba!" murmured the crowd. A little something for the wrist. It is named **AquaChrono.** It gleams with all the colours of the rainbow and ticks for all those who are fascinated by the unfathomable

swatch

The submarine used in the launch of the Aquachrono was part of a project called Rosetta under the direction of naturalist Adrian Shine, which was sponsored by Swatch to examine the bottom of Loch Ness (at 24 miles long, Britain's largest lake) which is reckoned to have been formed 300 million years ago.

Several 12-foot cones of sediment have already been extracted and examined by a number of international scientific bodies.

The submarine can house five people in addition to its captain and can remain submerged for more than a week with a full complement.

After the AquaChrono launch it was used to take intrepid tourists on a tour of the lake bed—some 750 feet down—at £68.50 (about $110.00) a head. Submarines in wartime films always have an echo-sounder "ping"; since the Swatch sub did not have one, a tape recording was used to avoid disappointing the customers.

Swatch World Journal
April 1994

> There was not much change in design in 1995—there are, after all, limits to what can be done with the elements that go to make up a diver's chronograph, but Sea and Sun rang the changes on the color combinations while still remaining fairly legible. American Dream went all Yankee Doodle Dandy with Stars and Stripes almost everywhere. It is produced in mid-size, though whether this would be practicable for a female diver—and there are many such—is debatable. (It is probably OK over a wetsuit.) Space Chill, as its name implies had a far out astronaut-ish strap, but a very readable dial.

The 1996 Spring collection included a very aptly named Space Trip—a bracelet model which really looked as if it belonged aboard *Columbus*.

In contrast, Sun Garden, another midsize model, would look equally at home in a tropical rain forest, although the sub-dials might be difficult to read in the half light.

Just as appositely named was Truck Driver in an effective combination of black and yellow that simply yelled to be hurtling along the Autobahn (its generic theme was "Asphalt"). Its 660 feet water-protection might be a wee bit redundant (except in a thunderstorm) but one could certainly read the dial in a fog.

Another fall 1996 model was Fluosite in a color combination that puts one in mind of wetsuits on Bondi Beach near Sydney, Australia. Quite striking and very legible.

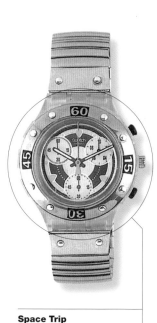

Truck Driver		Fluosite
SBB103		SBK112
1996		**1996**
Asphalt		Primaries

Space Trip

SEK107 A/B

1996

Tech is Cool

Sun Garden

SEG100

1996

Nat Code

> Big Red (1997) is a simply huge model with a black case and dial, on a red textile strap in a ribbed material (was it, I wondered, water-resistant?). The sub-dials were indicated by small white figures, which had red lines across them as well as small red hands. Rather confusing. The hour and minute hands were white skeleton type.

Silver was just that; a silver case and bezel with absolutely miniscule figures in black, similarly insignificant sub-dials, but fairly clear black hour and minute hand. All on a silver strap. Cartographic was very similar, with a few blue figures on the bezel and blue sub-dial hands. The hour and minute hands were almost invisible. Inky Water at last gets back to basics, with a clear white dial, in a blue case and bezel with clear white figures and the all important arrow on a dark blue strap.

I know a Swatch spokesman said the Scubas and AquaChronos were as much at home on a beach parade as in the water, but they are sold as diver's watches and I think the designers should at least pay some attention to the function. The figures on the bezel don't have to be conventional—they could be fun figures, but they ought to be legible—that's what they are there for.

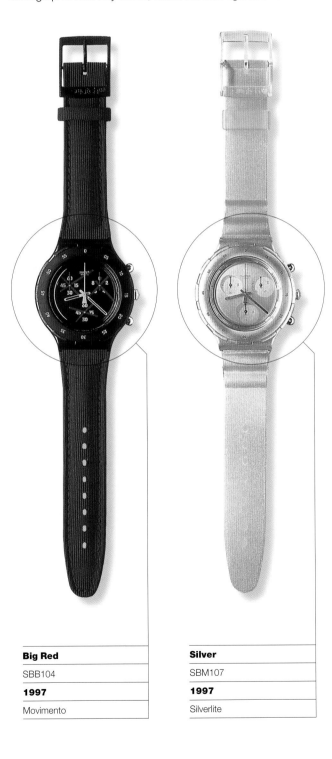

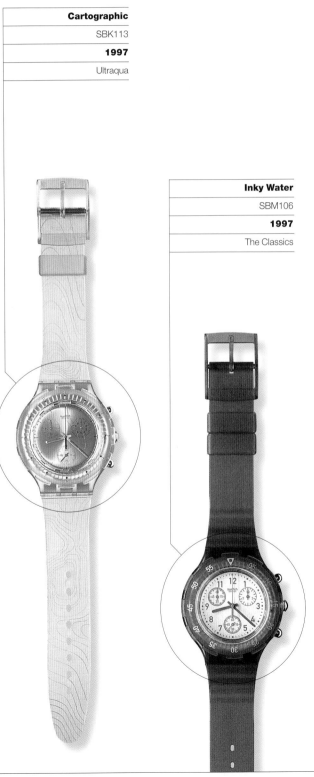

Cartographic	
SBK113	
1997	
Ultraqua	

Inky Water	
SBM106	
1997	
The Classics	

Big Red	
SBB104	
1997	
Movimento	

Silver	
SBM107	
1997	
Silverlite	

Irony

Happy Joe

YGS400

1994

Warriors

83 84 85 86 87 88 89 90 91 92 93 94 95 96 97 98

> By the beginning of 1994 Swatch had been going for ten years and had established its own niche in the market. Sales had exceeded 165 million pieces and it was known all over the world for its colorful plastic cases and fun strap. Its stated aim was to ensure a state of permanent revolution on the wrist. (Well, that's what they said!)

So, because nothing is sacred—particularly to Swatch and having made its name for an inexpensive colored plastic-cased watch, it now introduced a metal-cased collection; it was called, aptly, Irony. Now the customers had another choice; they could already have quartz or mechanical movements, plastic or leather straps. Now they could have plastic or metal cases.

Swatch had already had a platinum case —that wasn't plastic, they said to their critics. So they introduced stainless steel models, gold-plated models, and, later on, aluminum models.

> The first collection was not outstandingly different—Happy Joe, with a somewhat satinized case, blue dial, and black strap looked conventional enough. Ocean Storm had a busy looking dial and a bright blue strap. Two women's models were included—Red Amazon was, if anything even more conventional than its masculine counterpart, with a white dial with open numerals reminiscent of the 1930s. Sleeping Beauty had a gold-plated case and a very feminine dial in gilt and green. On the whole it was a pretty disappointing lot which hardly lived up to the hype!

Ocean Storm

YGS103

1994

Air'ony

Nespos

YGS102

1995

Irony Big Stainless Steel

Seatrip

YCS102

1995

Irony Chrono Stainless Steel

Superblu

YDS4000

1995

Irony Scuba Aluminum

> "Always new, always different," says the introduction to the 1995 collection. Among the stainless steel models Nespos had an interesting dial and Le Grand Soir a gold-plated case in mid-size designed to attract women. Seatrip is certainly new—a huge Chrono in a stainless steel case with a very interesting blue dial matched by its blue mock-lizard strap.

Sea Lights was an Irony Scuba in a very handsome and distinctive steel case and notched bezel and a polished metal dial. Superblu was another Irony Scuba in an aluminum case, its polished bezel contrasting with its smooth satin-finished surround, enclosing a black dial. Its name was, without doubt, derived from its brilliant blue strap.

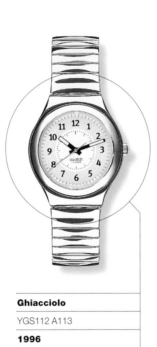

Ghiacciolo

YGS112 A113

1996

Irony Big Stainless Steel

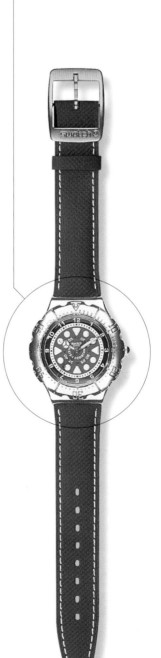

Wind-jammer
YDS104
1996
Irony Scuba Stainless Steel

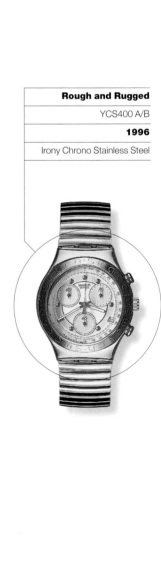

Rough and Rugged
YCS400 A/B
1996
Irony Chrono Stainless Steel

Sealights

YDS100

1995

Irony Scuba Stainless Steel

> 1996 was obviously a good year for Irony. The spring collection included a number of bracelet models—Ghiacciolo in all steel with a pale green dial and Réserve Speciale, an all-gold day-date with a dark brown dial being typical examples. Perfect Twelve and Crazy Alphabet were two versions of a bracelet model in aluminum with contrasting dials.

L'Elue and Reverence were two genuine woman's sized (as opposed to medium) bracelet models in goldplated stainless steel in combination. Both had strap versions.

Windjammer, an Irony Scuba in stainless steel had an effective looking dial while Big Time had an even bolder dial and bezel in an Irony Scuba Aluminum combination on a matching bracelet. Equally huge but in polished stainless steel was Rough and Rugged, a Chrono on a stainless steel bracelet.

Mengedenga was another Chrono, in aluminum with a mid-brown dial and bezel with white sub dials and figures. Complemented by a brown strap in a ribbed fabric which perhaps was waterproof.

A very special Irony indeed appeared in 1997. Called Rotor, it was designed by Arnaldo Pomodoro, an Italian sculptor renowned for his metal work. It has a sand-blasted stainless steel case, a metal dial featuring cryptic reliefs which are echoed in the decoration of the unique metal band. A special boxed limited edition engraved by the artist will be followed by a general release later.

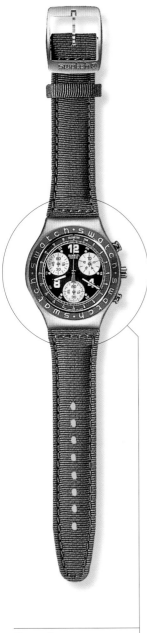

Mengedenga		
YCS1004		
1996		
Irony Chrono Aluminum		

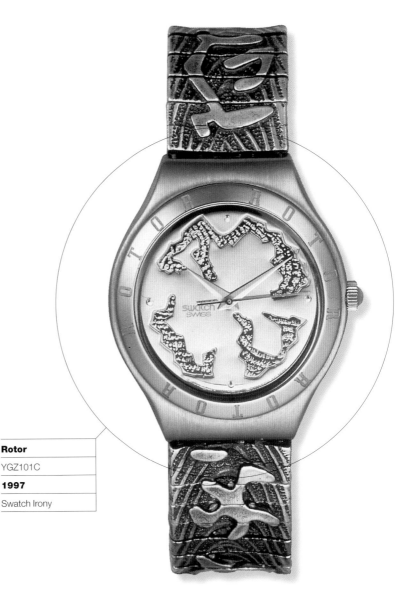

Rotor		
YGZ101C		
1997		
Swatch Irony		

Solar watch

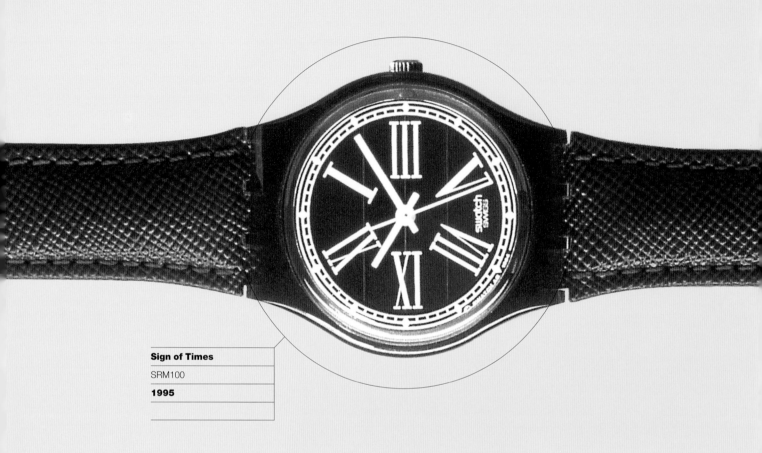

Sign of Times

SRM100

1995

83 84 85 86 87 88 89 90 91 92 93 94 95 96 97 98

> For some time Swatch has sponsored a solar-powered car called "Spirit of Biel/Bienne" and built by the School of Engineering in Biel—now in its third version—which has participated in and frequently won competitions for the largest distance or the fastest time for such a vehicle.

As a result of the experience learned, Swatch decided in 1995 to launch a Swatch Solar. As a means of using light as an energy source, the idea was not new—there were a number of solar-powered watches already on the market.

What differentiates Solar Swatch from its competitors is, as ever, its highly colorful approach to the subject. This battery-less quartz watch could take its regeneration from any source of light—neon light or sunlight and it had a power reserve of 40 hours which enables it to keep going even if deprived of light for some time. And it signals when it needs some more energy by causing its seconds hand to jump at four second intervals. And its other advantage is its modest price.

Planetarium
SRG100
1995

Lots of Suns
SRJ100
1995
Short Stories

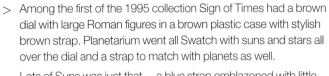

> Among the first of the 1995 collection Sign of Times had a brown dial with large Roman figures in a brown plastic case with stylish brown strap. Planetarium went all Swatch with suns and stars all over the dial and a strap to match with planets as well.

Lots of Suns was just that —a blue strap emblazoned with little suns in a yellow case and black dial. Sunscreen had a black dial overlaid with astrological looking signs, a smoky transparent case and a chunky gold-plated bracelet.

There were just four models in 1996—Recharge, a black-faced model in a translucent green case on a plastic strap enlivened by a variety of designs; Fuocco in a combination of black dial, blue case, and tan leather strap, and High Temp, another black dial in a steel case with a strap graduated temperature-wise from a cool blue, through warm yellow to a hot orange. Sunscratch was an all-black model with matching black bracelet—a stylish number with red hour and minute hands and a white center seconds hand.

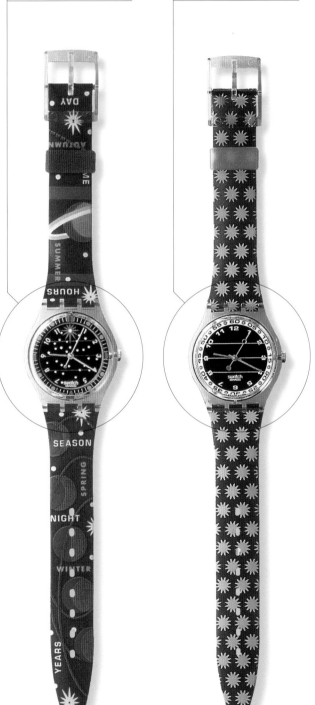

Sunscreen
SRM101/102
1995
Short Stories

Sunscratch
SRM103 A/B
1996
Tech is Cool

Access

Freeride

SKK100

1996

83 84 85 86 87 88 89 90 91 92 93 94 95 96 97 98

> Swatch Access was originally designed to give winter sports fans an electronic key that would open all the gates to the ski lifts, automatically and hands free.

Developed by Swatch in cooperation with Ski Data of Austria, at the heart of the watch is a microchip which can be programed to send a signal to a turnstile, or a hand-held reader. Its aerial is wound around the case.

The program can be tailored to individual requirements—to open certain gates so many times a day, for a given number of days; to give access to Europe's 463 ski slopes and, later on, to more international ski resorts.

A further development gave Swatch Access holders a wallet-in-a-watch facility at Salzburg, where it could be programed to give access to transportation, to participating restaurants and cinemas and museums—even to the casino. Swatch will be the official Access to the Expo 98 in Lisbon where Swatch could give Access to the event via some 70 turnstiles.

> The first Access was a sophisticated model with a white case and strap, called Freeride, whose transparent dial showed the amazingly miniaturized movement. Go Big, the other launch model, had the usual colorful Swatch dial and a black strap featuring messages such as "hang-it out" and "show no money."

For Atlanta, the Photographer and Journalist Access models have already been mentioned—very much like the Freeride, but with little stylized drawings of pressmen on the strap. Access to Space has also been featured in the discussion of Specials.

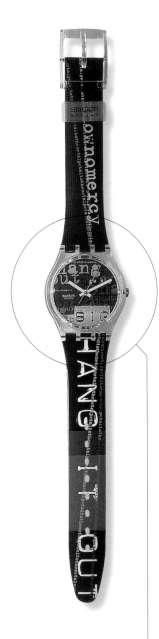

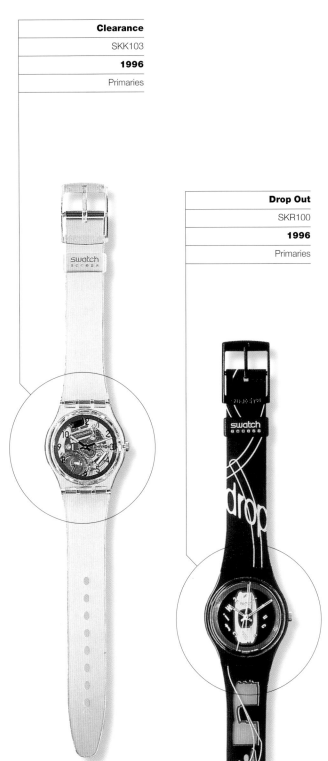

Go Big

SKK101

1996

Salzburg

SKK104

1996

Access to Salzburg

Clearance	
SKK103	
1996	
Primaries	

Drop Out	
SKR100	
1996	
Primaries	

> Salzburg was a symphony in blue with a map of the town's roadways and major intersections on both strap and dial in a mid-size stainless steel case.

The Spring/Summer collection of 1996 repeated the two original models Freeride and Go Big; for the fall three new designs appeared. Clearance was Freeride with a metal case. Drop Out was a real weirdo, with black case and strap enlivened by swirls and enlarged computer figures. What exactly was on the dial is not at all clear but it had a nice copper ring inside the bezel. By far the most attractive was Direction, a multicolored model with a strap design that followed through on the transparent dial, so that the "innards" could still be seen through the colors.

The Access collection for the spring of 1997 consisted of the same four models from Fall 1996, with the addition of Garden Turf, the Club Watch for 1997 which is featured under "Swatch Collectors" models (see p. 148).

Comin' Thru is a very jolly model designed to mix and match with colorful ski gear. Double Loop is a smart black watch with a velcro-fastened textile strap with "Ski-Pass" decor, ideal for wearing over Ski-gloves. Palmer is another black-cased model similarly equipped with a stars and stripes dial.

Direction

SKK102

1996

Primaries

Comin' Thru

SKK105

1997

Palmer

SHB100

1997

Olympic Collection

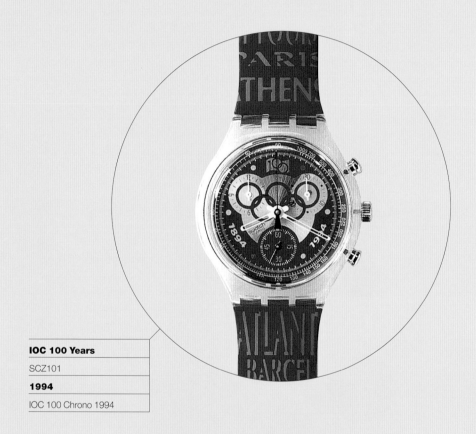

IOC 100 Years

SCZ101

1994

IOC 100 Chrono 1994

83 84 85 86 87 88 89 90 91 92 93 94 95 96 97 98

> Swatch's Annus Mirabilis was undoubtedly 1996. The appointment as Official Timekeeper to the Olympic Games at Atlanta gave the Swatch management—never slow to turn an event into a publicity triumph—so many opportunities to blow its own trumpet that it became a veritable symphony, a publicity department's dream.

As soon as the appointment became known, on November 30, 1993, Swatch proceeded to plan its campaign; it was helped by being asked in June 1994 to create a Special Swatch watch to commemorate the 100th anniversary of the International Olympic Committee; IOC 100. A Chrono was Swatch's answer, part of the proceeds of which were to be channeled into youth sports projects.

> Up to that time, Swatch had only produced a few standard models with Olympic logos on the dial. Now Swatch proudly announced its appointment as Official Timekeeper and marked the occasion with the launch of the "Swatch Historic Olympic Games Collection" (September 1994). It was to be the first of many such collections.

In June 1995 Nicolas G. Hayek presented His Excellency Juan Samaranch, the President of the International Olympic Committee, with a check for $1 million for the youth projects and at the same time unveiled the second Olympic collection "For Honor and Glory".

As part of the countdown to Atlanta, Swatch O'clock Art Towers were installed in 12 cities (see introduction) to count off the seconds remaining before the Opening Ceremony.

In November 1995 Perfect Timing, a Swatch Chronometer, was put through its paces by the Official Swiss Chronometer Testing Centre and was launched in Athens as another Olympic countdown. With 250 days to go, just one of the Swatch Automatic Chronometers will be sold somewhere in the world, every day.

Roma 1960	Tokyo 1964	Moscow 1980	Seoul 1988
PMZ101	SLZ100	LZ103	SDZ100
1994	**1994**	**1994**	**1994**
Midi Pop Swatch	MusiCall	Swatch Lady	Scuba 200

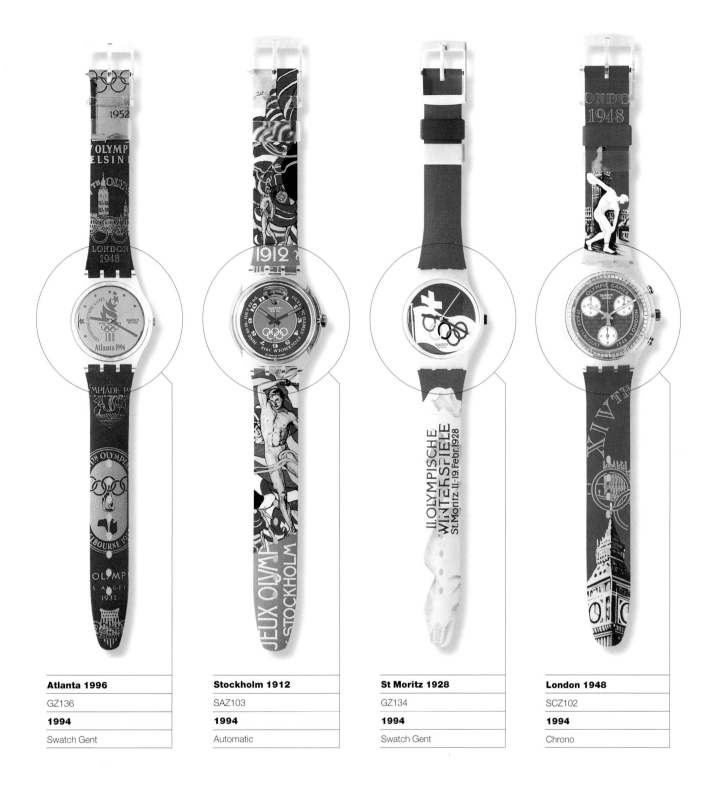

Atlanta 1996	**Stockholm 1912**	**St Moritz 1928**	**London 1948**
GZ136	SAZ103	GZ134	SCZ102
1994	**1994**	**1994**	**1994**
Swatch Gent	Automatic	Swatch Gent	Chrono

> It is 1996 and Swatch's great year begins. On March 2 Annie Leibovitz is commissioned to take portrait photographs of the ten international athletes (all Olympic winners) which will be used on the dials and straps of the Swatches in the Olympic Legends collection. (Later she is the subject of an Olympic Special herself.)

In July Swatch launched the Victory Ceremony Series of three models—a gold, silver, and bronze. The Olympic Legends collection was presented to the public. Each of twelve all-time Olympic legends were interviewed and has a Swatch Irony devoted to their passions, memories, likes and dislikes etc …The 200 millionth Swatch came off the production line in Switzerland, somewhat upstaged by the events at Atlanta.

On July 19 the Games were officially opened in Atlanta, the Olympic flame being carried a short way on its last leg by Nicolas G. Hayek himself.

Altogether Swatch produced 46 different Olympic models, 31 of which were in boxed sets—though some of them could be bought separately. All in all, it was quite an Olympian effort.

Individual models

> Perfect Timing (1995) was an automatic chronometer with an Official Timing certificate. Only 700 numbered Perfect Timing Specials were produced. The dial featured the cities and dates of previous Games in a black ring around a transparent center; the black strap was overprinted with the various disciplines from Archery to Yachting and carried the legend "Official Timekeeper to the 1996 Olympic Games."

In 1996 came the Olympic Team Swatch models which were presented to the athletes from 17 competing countries

beginning with the Chinese team. Each team's model was decorated with their national emblem and the Olympic logo.

This was complemented by the Olympic Team Swatch Silver, a model for the fans. It came with the same sort of dial as the gold, but on a silver strap. There were, again, models for each of the competing countries and by purchasing the watch, the fans were able to offer active financial support as all profits went to the Olympic Committee to help finance the cost of enabling athletes to take part at Atlanta.

Edwin Moses
SAZ106
1996
Automatic

Daley Thompson
SCZ105
1996
Chrono

Gelindo Bordin
PMZ104
1996
Pop Swatch

Saïd Aouita
SEZ107
1996
Aqua Chrono

Olympic Collections

> The Historic Olympic Games Collection (1994) comprised nine models each representing a city where the Games had been held. Starting with Atlanta, a standard Swatch, they were all highly decorated in individual styles, often with a traditional touch (like Big Ben on the London one—a Scuba) and varied from standard Swatch (St. Moritz), to Stopwatch (Los Angeles), Tokyo (a MusiCall), and Seoul, a flamboyant Scuba. They included one women's model (Moscow) and a POP Swatch (Rome).

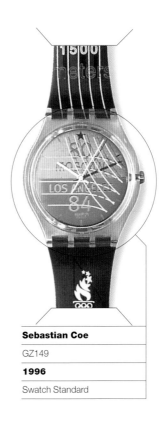

Katarina Witt	**Dan Jansen**
SLZ105	SDZ900
1996	**1996**
MusiCall	Scuba 200 Loomi

Sebastian Coe
GZ149
1996
Swatch Standard

In 1995 came For Honor and Glory which featured Atlanta (again) and eight Greek towns which had played host to the Grecian Games in the past. There were Chronos and Scubas, AquaChronos and Automatics, MusiCalls and Standard Swatch men's and women's models, all featuring some aspects of Greek decoration—columns and garlands, friezes and lettering, figures in competition and action. There was even a POP Swatch masquerading as a Grecian torch. The set was packed in a handsome orange box or they were available individually.

The third Olympic collection the Olympic Legends was a tribute to some of the individual sportsmen and women whose names have gone into the annals of Olympic history. All were gold medalists—Romanian gymnast Nadia Comaneci, German figure skating queen Katarina Witt, British decathlete Daley Thompson and his fellow countryman Sebastian Coe. Said Aouita from Morocco and Italian marathon runner Gelindo Bordin were joined by four U.S. athletes—swimmer Mark Spitz, hurdler Ed Moses, long jumper Bob Beamon, and speed skater Dan Jansen.

Collector's Models

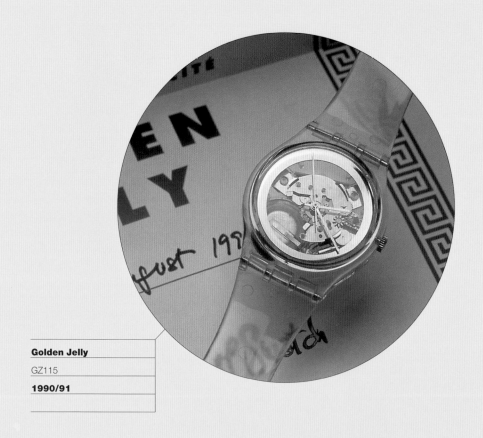

Golden Jelly

GZ115

1990/91

83 84 85 86 87 88 89 90 91 92 93 94 95 96 97 98

> Swatch Collector's models were inaugurated at the same time as the Swatch Collector's Club was formed in August 1990. A free Swatch, of a design exclusive to members of the Club, was part of the deal along with information sheets and invitations to special events.

The first of the models exclusively reserved for members of the Swatch The Club was

Golden Jelly, (1990/1991). In a transparent case and dial which revealed its movement (apparently gold-plated for the occasion), it was fitted with a transparent plastic strap through which could be seen the gold-plated spring bars which fastened it to the case and buckle. Appropriately packed in a transparent box it was all very translucent and jellyfish-like.

> The 1991/1992 model, designed by Alexander Mendini, was called Lots of Dots and was exactly that on both strap and dial, in a transparent case. Very *pointillist* and very difficult to read the time—but good fun.

Scribble was the 1992/1993 offering, its dial a jumble of scribbled figures, its transparent case fitted with a gray strap on which were more black scribbles. Fun! Due no doubt to some administrative rearrangements, Scribble remained the Collector's Swatch for 1993 as well.

For 1994 members received a Crystal Surprise—a rather psychedelic number with a bicolor strap and a purple case framing a black dial with what appears to be a crystal at the center from which spring two hands seemingly holding pennants. A limited number of these Swatches actually contained authentic diamonds.

The Club watch for 1995 was called Point of View and was designed by Karl Gerstner, a Swiss-born advertising artist who says he specializes in "graphics." His Swatch is certainly different—a dial of cool gray is overlaid by hands that are like cams, with points, indicating the hours and minutes. The seconds are ingeniously marked out by a red dot on a gray circle, and the whole is framed by a black case and strap. A highly original, pleasing modern design.

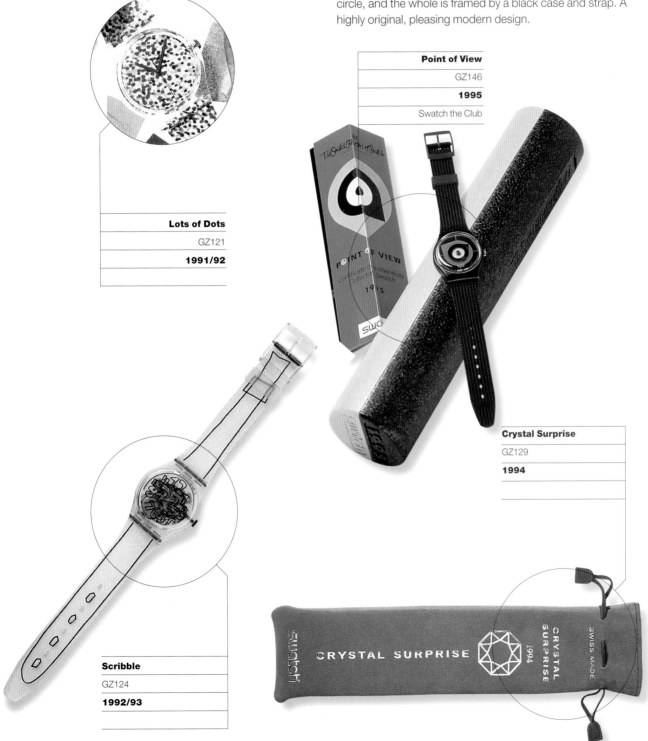

Point of View
GZ146
1995
Swatch the Club

Lots of Dots
GZ121
1991/92

Crystal Surprise
GZ129
1994

Scribble
GZ124
1992/93

> In 1996 Swatch Collectors got a bonus. The Club model(s) were Looka and Smilla. Looka is a smart watch whose dial features a cartoon face with elongated eyes which move with the time; the strap is a surrealist melange of eyes and specs and even (yes) teeth. Smilla is his girlfriend, red-headed and drop-dead gorgeous. The inventor of this dynamic duo is Stefano Pirovano, an Italian designer and illustrator from Milan. Looka was the official Club watch and the plastic body came with it. Smilla was a limited edition Club Special.

Garden Turf
Swatch the Club
1997
Swatch the Club

Looka & Smilla
GZ700/701
1996
Swatch the Club

For 1997 Club members received a pleasant surprise—The Club model was Garden Turf, a Swatch Access with the message "Join Swatch the World." Now members of Swatch the Club could enjoy, along with their other privileges, access to all the delights to which these top of the range Swatches gave access.

Garden Turf derives its name from its strap, which feels (and looks) like a piece of Astro turf designed to link thoughts of dreaming on the lawn with the policy of Swatch to respect and protect the environment. The dial of GardenTurf is decorated with ants and the movement can be seen through it. This year the Club Swatch is linked to another Swatch creation—a garden gnome, a jolly character with a white beard in a red hat who is to become the symbol of Swatch the Club throughout the year.

IV

Other Swatch Products

> One of the messages spelled out by Swatch was that its creation came about as a result of a change of attitude in a conventional and well-established industry. It is an example of what can be achieved by looking at a familiar object with a fresh vision and an open mind; it helps to have enthusiasm and inexhaustible energy—to say nothing of patience.

So after Swatch had been successfully launched, the management turned its attention and experience to other products and other industries to see what effect a fresh look might have on them. The following pages show what happened when Swatch looked at telecommunications and eyeglasses and even the automobile.

The Twintam

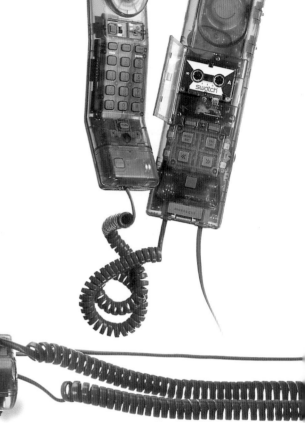

> This was a phone with a built-in answering device which was introduced to the American and Italian markets in 1992. In appearance very like the Twinphone, the initial collection was a modest three models in black, white, and blue, which were accompanied by a pocket dialer. Callers were asked to leave a message and a number and the owner called back as soon as possible. The dialer was used to retrieve messages from wherever you were—a phone booth, somewhere on the road, wherever . . . Two more colorful models joined the collection in 1993 and 1994 saw a reissue of the whole collection, possibly with additions since although the names—Green Planet, Honey Moon, etc . . . remained the same, the code numbers changed. No new models were issued in 1995.

The Twinphone

> Swatch made its first move into telecommunications with the Twinphone, a dual hand-set with a 20 name memory mute key and redial facility, all at a very competitive price. First launched in the United States in 1988 it was introduced subsequently to Switzerland and Italy, then the United Kingdom in 1991, and Germany (1992).

Twinphones, like Swatches, come in a variety of colors from plain white or black to dual tone and eventually to highly decorative multi-colored versions. Like Swatches, too, they had exotic names such as Pick Me Up, Candy, or Kyoto. There was even one called Pink Jelly. There was just the one shape

and they were launched in collections—nine in 1988/89, four more in 1990, eight more in 1991—and a Christmas Twinphone Special called Merry Silver. Only one fresh model appeared in 1992.

In 1993 each of the standard designs had a Deluxe version and by now translucent bodywork added an ephemeral air to the still unchanging shape. Including the standard versions, 20 new models were added, rejoicing in such evocative names as Tequila Sunrise and Echo of the Night.

1994/95 saw a reissue of seven of these flamboyant Twinphones, with five new and different models, such as Pastel Touch and Green Emotion. And after that there was silence.

The Cellular

> The Swatch Cellular launched in 1993 was, as might be expected, quite different from any other portable phone—brightly colored, ecofriendly (its nontoxic battery contained no heavy metal), light, and practicable. It had a 50-name memory and the first collection consisted of four colorful models each of which had different mechanics for the four countries to which it was first introduced—Switzerland, Sweden, Italy, and the United Kingdom. The same four models were reissued for 1994/1995 with no perceivable difference in design. They made keeping in touch fun and they had names to match, the best of which was Prêt-à-Porter.

The Cellular, like the Twinphone and Twintam disappeared from the 1995 catalog, Swatch's commitment to Telecom being supported entirely by Swatch the Beep (see p.117), but in 1996 came another newcomer.

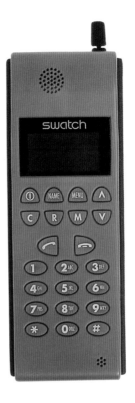
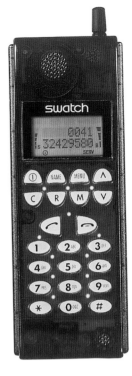

Swatch Cordless

> True to form, the Swatch Cordless phone was unlike any other on the market. It came in three parts: (1) the portable handset which could function up to 900 feet in the open and up to 150 feet inside buildings; (2) the charger on which the handset can rest when not being carried; (3) the base station which is connected to the telephone network.

The charger can be set up wherever the phone is likely to be used most—no matter where one decides to put (or hide) it. Additional handsets and chargers are available as accessories. One base station can support up to six individual handsets—an ideal set up for small offices. And the system can be extended by registering the handsets on up to four base stations. This enables free internal calls to be made even when another external call is active at the same time.

The Swatch Cordless was launched in Hanover, Germany in September 1996. By October its market had been widened to include Switzerland, Italy, and Austria. 6,000 cordless were sold within three days of the launch.

The System, called DECT (Digital Cordless European Telecommunication) is claimed to be in the top flight of cordless communications, free from the hissing so frequently associated with cordless telephones. Among its other advantages DECT technology offers first-class digital speech quality and security against unauthorized listening in the radio spectrum and GAP allows compatibility with similarly equipped systems.

There is currently just the one design in three colors (named, as usual in inimitable Swatch style) Jumpin' Dolphin in black, Orange Utan, and Blue Whale whose colors are self-evident.

It provides 6.5 hours of talk time with 60 hours of standby. Other features include automatic redialing of last three numbers called; ten-number speed-dial memory; six different ringer tones, with adjustable volume; adjustable handset volume and microphone mute function; paging function—hand-sets can be located from the base station; a system code and handset PIN (personal identification number) give protection against unauthorized use.

The system is designed to be installed by the owner without assistance. It is usable as soon as the base station is connected, the equipment having been pre-set in the factory to eliminate the need for any further adjustments. It requires about 16 hours of continuous charging when first installed and repeated charging for smaller periods during the first week of operation. After that, the system should deliver its 6.5 hours of continuous calling and up to 60 hours on standby. It takes approximately 4–5 hours to charge the handset after is initial installation period. The keypad of the handset its protected against being operated inadvertently—for example through being carried in a pocket—by the special ON/OFF/Protect key.

Up to ten frequently used numbers can be stored in the Speed Dial System, each of which can have 22 places. The numbers can be changed quickly and can be protected against accidental erasure.

SwatchEyes

> In keeping with Swatch's fascination with fashion late 1992 saw the launch of a range of interchangeable clip-on sunglasses, offering UV anti-glare protection, the result of a licensing arrangement with the German and Swiss based Sunglasses Specialist Ferdinand Menrad.

Early models were fairly restrained but the shape became more flamboyant as the Swatch Team's designers took hold of the idea. SwatchEyes, like the watches, were christened with the team's usual flair for the unusual—Toy for Joy and Rollercoaster being two of the originals.

The second edition came in a greater variety of shapes although the colors seemed a shade more restrained. The third collection—in 1993—showed rather bolder designs and some really weird elongated shapes, though more conventional ones were also included—all, of course, on the same principle of a basic shape with interchangeable clips. For Christmas, in the Swatch tradition, there came a Special—a pair of white lornettes with gilt trim, called Sans Souci. Only Swatch would dare to do it.

In 1994 Swatch Eyes announced a greater degree of protection with the Titanolux collection which had HCC (High Color Contrast), lenses which are said to give 100 percent protection against UV radiation and a sharper, distortion-free image. The side pieces were of titanium, which allowed them to mold snugly to the head.

There were six different shapes in the Swatch Eyes Clip Line, with names like Sun Lemonade, Krakomania, Jungle Fever, and Rockabilly. The Titano Lux line had three variations represented by Tropical Heat, Indian Summer, and Yellow Sun.

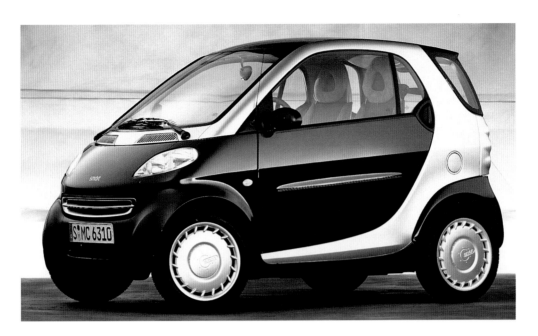

Swatch Smart Car and Swatch-Mobile

> One of the most ambitious of all Swatch's revolutionary projects is surely the Swatch Car. The Swatch watch itself was revolutionary enough, but SMH at least started with a long tradition and a lot of experience in watch production from its various constituent companies. But a car?

It all started on July 4, 1991, when SMH and Volkswagen representatives met in Berlin and announced that they had agreed to set up a joint venture with its headquarters in Biel in Switzerland to develop "an efficient and environmentally friendly compact car for the cities and their citizens of tomorrow."

What happened to that agreement is not recorded but three years later on March 14, 1994 SMH and Mercedes Benz signed a similarly based agreement in Stuttgart, Germany, to found MCC (Micro Compact Car).

On May 17, 1995, a prototype of the Smart, as it was now called, was presented to the world's press at Sarreguemines-Hambach in northeast France. It was introduced as an SMH-Mercedes joint venture which grew out of a common vision of the future of personal mobility within the framework of ecological responsibility to the community. It was summed up in the phrase "If we want to go on living as we have done up to now, we will have to adjust."

In October that same year, the cornerstone of the building in Hambach where the Smart is to be assembled was laid by Nicolas G. Hayek and less than a year later he opened the Production Preparation Center to representatives of the International press corps, who were given an exposition of the current state of developments.

Hambach—which although in France is also partly German (and now partly Swiss!)—is the largest building site in Europe. It occupies a 170 acre plot just 12 miles from Saarbrüchen. The buildings which were inaugurated are part of a European enterprise that includes MCC AG—owned 51 percent by Mercedes-Benz and 49 percent SMH—which is the commercial hub and nerve center of the company and is situated in Biel, Switzerland; the others are MCC GmbH, the technical center, located in Stuttgart, Germany, and MCC France which is responsible for erecting the buildings.

The production of Smart and Swatch-Mobile (an electronically driven version) by the joint venture is expected to provide work for over 10,000 people by the end of the century with possibly another 6,000–8,000 jobs indirectly created.

Production at Hambach is a new departure in marketing techniques. Important sub-contractors have their own manufacturing units on site, linked directly to the assembly areas, thus cutting costs and enabling production to be adapted to "just in time" delivery. By this means a final assembly time of approximately 4.5 hours—the shortest in Europe—will be attained. Actual capacity is 200,000 vehicles planned to be reached by the year 2001.

In September 1996 in Paris, Smart was voted the biggest design hit of the year and awarded the 1996 Grand Prix of Design.

During 1997 a prototype of the Smart Car will be put on show in Amsterdam in February, Barcelona in May, and the United States in June.

> Smart will be available in the Spring of 1998 in Germany, France, Italy, Spain, Switzerland, Austria, Luxembourg, Belgium, and the Netherlands at a price of approximately DM16,000 to DM20,000 ($8,000–$14,000). It will be sold exclusively through a specially created sales network of 100 outlets in 86 metropolitan areas in Europe, all of which will be similar in appearance to reinforce the corporate brand image.

Smart is a compact two-seater whose standard features will include antilock braking system (ABS), airbag for driver and passenger, electronic immobilisor, automated "tap system" six-speed transmission, electric windows, infra-red locking system, glass roof and turbocharger. Its dimensions are: length 7½ feet; width 4 feet; height 5 feet; wheelbase 5½ feet. Its luggage compartment will hold approximately 150 liters, rising to 550 liters if the passenger seat is folded down.

Its kerb weight is approximately 1,600 pounds with a payload of approximately 500 pounds. Its maximum speeds is limited to 80mph and its acceleration is given as 0-60 km/h in 6-7 secs.

Early in its development, Chancellor Helmut Kohl, on a private visit to Nicolas G. Hayek, tried out Smart for size and proved this compact two-seater had plenty of room, even for one of Europe's larger statesmen.

It is estimated that this remarkable vehicle—quite unlike any other small car—will deliver 60 miles to a gallon of petrol. In 1999 a turbo-charged diesel version, giving over 80 miles per gallon, is planned, as well as a convertible model. By the end of 1999 the Swatch-Mobile will also be on the market.

The Swatch-Mobile will be driven by an Electro Special System that SMH technicians have been working on since 1990. It is an environmentally friendly motor, controlled by a sophisticated electronic system that has been extensively tested by Mercedes engineers in Stuttgart and MCC personnel in Biel.

Motor manufacturers have been trying to produce an electric motor for a car for many years, spurred on by the ever-increasing concern over the pollution of the atmosphere by petrol and diesel fumes which, in some cities (Tokyo, for example) has almost reached lethal proportions.

But they have always met with frustrating difficulties relating to the cost and the size of the electronic control system. SMH claims to have overcome these problems and the new three-sided light car (it weighs in at around 1,430 pounds) would appear to be the environmentally friendly solution that was being so assiduously sought after.

The SMH Electric Special system will be fitted into the Smart at the Hambach plant, which will be the cradle of the SMH/Mercedes enterprise for the twenty-first century.

Tests have shown that Smart is the safest vehicle in its class offering safety standards comparable to a mid-range limousine. It has a passenger cell of steel incorporating a crash management system; the other materials from which Smart is made are to a large extent pure plastics and in part from renewable raw materials; in fact Smart will be 95 percent recyclable! Every effort has been made to eliminate hazardous materials and the whole concept is one of a responsible attitude to the environment; factory emissions and residues are rigorously monitored and controlled and the complex itself, which has been compared to a laboratory, has been built with the latest ecological know-how.

And in keeping with the company's philosophy of constant change, interior and exterior customizing packages will be available for Smart so that owners can change the upholstery on the seats, fit new door panels, or a different dashboard or even a completely new outside shell if they wish—all promised to be at affordable prices.

If Smart catches on—and there seems no reason to doubt that it will—future plans include a form of leasing/pooling package, in which owners can have access to other kinds of vehicle when necessary (a station wagon for vacations or a van for transporting bulky materials on weekends). There will also be an accessory that will enable Smart customers to have electronic access to communications and mobility services.

V

Swatch Activities

> Promoting Swatch in all manner of events has always been an integral part of the Swatch marketing policy. From its earliest days it sponsored sport—often of the fringe variety like Freestyle skiing in Colorado (1984), the Snowboarding World Championships, starting in the United States in 1986, a kite contest in Haarlem (Netherlands), and balloon spectaculars in Japan and Australia. Skateboards and BMX bike contests followed in 1988 and in the first

"Race against Time" in 1990 Stephanie Schaffter paraglided, ski'd, and raced across the Alps.

1991 saw Swatch sponsoring a Windsurfing Speed Championship in France, then Swatch started to sponsor beach volleyball which in 1995 went on circuit to Corsica, Italy, Switzerland, Greece, and France, culminating in the European championship in Norway in 1996, the victors going on to Atlanta where the sport enjoyed its debut as an Olympic discipline.

Swatch Activities

> **Swatch also promoted "Boardacross," a hybrid version of snowboarding which combines racing with freestyle acrobatics and which has now received official recognition. By September 1996 Swatch had become the main sponsor of the World Boardacross Tour of 1996/1997.**

The next year Swatch inaugurated a Roller and Inline contest in Lausanne which attracted world-class skaters.

Swatch has maintained a connection with music from the silken sound of the 40 saxophones of Urban Sax (April 1984), the Thompson Twin Concert Tour (1985), the Pierre Boulez Concert Tour of the United States in 1986, the Arabian rock group Amazulu in the United Arab Emirates in 1988 to "Swatch and Europe in Concert" at the Palais de l'UNESCO in Paris in 1993 when Nicolas G. Hayek and Jean Michel Jarre announced the joint project entitled "Swatch & Europe in Concert" leading to a spectacular tour of Europe, premiered in Mont St Michel, France.

In 1995 the English percussion group Stomp gave an exclusive concert for Swatch in Munich.

Art is another area that has always enjoyed Swatch patronage. Apart from the fantastic Swatch Art models themselves—launched at an art show in the Centre Pompidou in Paris in March 1985—Swatch has organized several "Street Painting" performances, the first of which took place in London's Covent Garden; among the others was one in Basel, Switzerland, and another at the Quai St Bernard in Paris in June 1986.

Always interested in innovation, Swatch sponsored a solar-powered car—the Spirit of Biel-Bienne—which in the second world contest in 1990 led the field from Darwin right up to the finish line at Adelaide at the end of the 3,005 kilometers at an average speed of 65kph (39mph). In 1991 the Spirit of Biel-Bienne II won the solar and electric 500 at Phoenix Arizona and in 1992 it finished second in a similar competition in Noto, Japan; in November 1993, a revamped "Spiti of Biel-Bienne III" returned to Darwin's legendary Stuart Highway for the third world Solar Challenge and in 1994 it set up a new world speed record for solar-powered vehicles of 82.59kph (51.44mph) in Almeria in Spain.

In March 1984 a 530-foot high Giant Swatch weighing 13 tons was erected at the headquarters of Frankfurt's Commerzbank, meriting an entry in the *Guinness Book of Records* while another lent distinction to the Swiss Pavilion at Expo 86 at Vancouver, Canada. In 1987 a POP Swatch Clock Tower was installed in Tokyo. As part of the publicity to mark Swatch's appointment as Official Timekeeper to the Games, Swatch o'Clock Art Clock towers were installed in Athens, Barcelona, Berlin, Hong Kong, Lausanne, London, Los Angeles, Paris, Rome, Tokyo, Sydney, and Beijing. Each tower was designed by an indigenous artist, and were there to tick away the seconds remaining to the Opening Ceremony.

Apart from the donations made to youth projects across the world through the sale of certain models such as the UN-inspired UNLimited and Earthmover, Swatch has always been ready to support worthy causes at events such as the Life Ball at Vienna City Hall in May 1996 for the benefit of Austria's Aids Support. The wearer of the most imaginative gown won a trip to the Olympics in Atlanta courtesy of Swatch. Later that year Swatch joined forces with UNESCO on RTL to help "Children in Need." Auctions held every hour helped to raise substantial amounts of money for a number of UNESCO projects.

Swatch has always been closely connected to Fashion (Swatch *is* fashion, some would say). In September 1993, Swatch was present at the biggest U.S. fashion event and presented the "Passport 93 set"—two watches created by the celebrated fashion designer Jean-Charles de Castebagel which also incidentally supported Elizabeth Taylor's Aids Foundation.

In March 1996 Swatch ventured into a fashion show in Tokyo's famous "Liquid Room" to launch its Spring/Summer collection with the aid of some of Japan's best known DJs. And in June of the same year, Swatch was the main sponsor of the Prix Bolero in Zurich, for the presentation of an award to Swiss newcomers to fashion design. In October 1996 Swatch used a "ready to wear" show at the Carrousel du Louvre to present the prototype of its Smart Car to an international fashion industry and audience.

Not all of Swatch's activities were purely for publicity although some of them were accorded world reportage. In March 1992

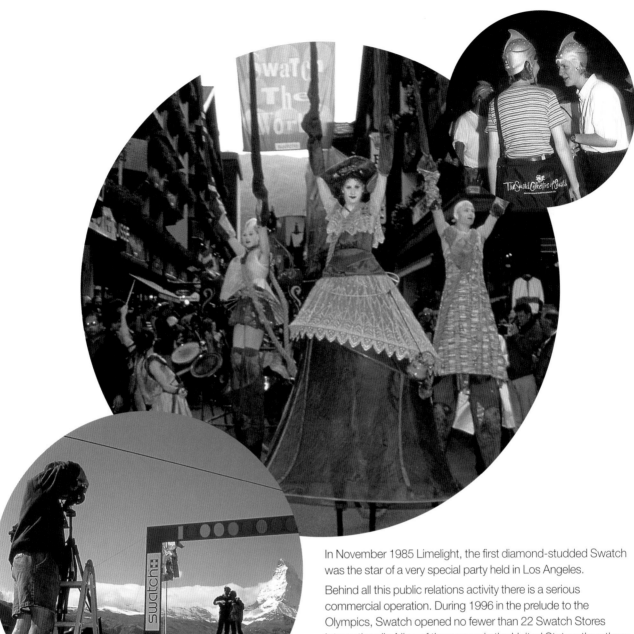

In November 1985 Limelight, the first diamond-studded Swatch was the star of a very special party held in Los Angeles.

Behind all this public relations activity there is a serious commercial operation. During 1996 in the prelude to the Olympics, Swatch opened no fewer than 22 Swatch Stores internationally. Nine of them were in the United States: the others in Austria, Belgium, England, France, Holland, Italy, Spain, and Switzerland.

In December 1996 Swatch announced it was going to open a flagship store in New York. Called the Swatch Timeship, it would occupy 5,000 square feet of space on three floors at 5 East 57th Street, between 5th Avenue and Madison. Other prestigious stores on the same block are Tiffany's, Chanel, Hermès, Levi's, Nike, and Warner Brothers.

Its designer says it will combine visual creativity with mechanical precision—primary elements in the success of Swatch itself—in a spectacular store full of original and innovative display and customer service ideas.

A giant watch over 12 feet in diameter will dominate the store front on 57th street, and the façade will be clad in bright blue textured material. There will be a Club chamber inside dedicated to members of Swatch the Club.

By the end of 1996, Swatch was into retailing in the United States in a big way.

Nicolas G. Hayek gave his views on Industry's environmental responsibilities in the General Assembly Hall of the United Nations in New York and followed this in March 1995 with another address to the United Nations when he presented the Swatch UNLimited commissioned by the UN to mark its 50th anniversary.

Finally, there are the Swatch parties. The first one of note took place on September 24, 1988 to mark five years of Swatch production and the five millionth Swatch.

In September 1992, against the backdrop of the massive Matterhorn, Swatch celebrated the 100th million Swatch with three days of multicultural festivity.

Appendix

Books about Swatch

> **Collectors need to have a handy source of information on which to base their decisions to buy or sell, or to document their collections.**

The following information is taken from an article by Rita Shenton who runs a specialist horological bookselling business, in *International Wrist Watch*:

Swatch after Swatch appeared in the UK as interest peaked (1991) and sold for around £28 ($42). There is the history of the watch itself, but far more emphasis is placed on these watches as an actual art form, drawing attention to their "language" and "communication"—a fascinating aspect of another collecting dimension. Definitely a book for anyone who has the more factual variety already housed on their library shelves.

Published by Antiquorum about ten years after the launch of the first Swatch models, copies of *Swatchissimo* appeared in 1991. A large format book with more than 500 pages and beautifully illustrated, it provided concise details on each of the production models, POP specials, hybrids, and so on, following an 83-page history of the creation of the Swatch watch. Starting with the invention of the movement by Elmar Mock and Jacques Muller, it covers the colorful designs and sensual shapes by Schmid and Muller, how the idea for the name Swatch was conceived by Franz Sprecher and the work of Franco Bosisio, Chief Executive of the Design Lab in Milan. Written by Roland Carrera, a Swiss journalist and historian, the text is in French, Italian, and English. When published the price was around £60 ($90), and copies are still available. It remains the most sumptuous of relevant publications, although others have subsequently appeared with more emphasis on values.

Bonello's *Katalog für Swatch Uhren* first appeared in 1992 as the international collector's guide. There are more than 600 color illustrations showing the watches and the packaging for Specials. The descriptive captions are in German, French, and English. Average values are given in five currencies. This useful pocket-size compendium of information retails for about £13 ($20).

WBS *Collector's Guide for Swatch Watches* came out about the same time. With a very similar contents and format, it carried a note to the effect that WBS Marketing was not associated with SMH/Swatch. One scents a conflict of interests! Again

identification of models and market values were offered to the interested reader.

Swatch Emotion dwells at length on how the various models were grouped and displayed in order to encapsulate a thematic design for the exhibition held in Turin. Visitors to the Swatch stores in London will have experienced this particular style of sales presentation. This book also traces the individual artist's thoughts behind each design through to the reality of production. There have been many other publications on the Swatch but mention must be made of *Swatch and Swatch*, once again the catalog of an exhibition—this time held in Venice. The emphasis is on the prototypes and variants from the main stream of production. Fantastic possibilities for an ardent collector!

SWATCH	UK and US PRICES	
	UK £	*US $*
1. *Swatch Original Plastic*	*25.00*	*40.00*
2. *Swatch Standard*	*29.50*	*50.00*
3. *Swatch Loomi*	*32.50*	*50.00*
4. *POP*	*29.50*	*40.00*
5. *POP Pocket*	*29.50*	*50.00*
6. *POP-Up*	*32.50*	*50.00*
7. *MusiCall*	*32.50*	*50.00/55.00*
8. *Scuba*	*32.50*	*50.00/55.00*
9. *Scuba Loomi*	*37.50*	*60.00*
10. *Solar*	*45.00*	*55.00/65.00*
11. *Automatic*	*49.50*	*70.00/80.00*
12. *Chronograph*	*49.50*	*7.00/80.00*
13. *AquaChrono/Midi*	*57.50*	*90.00/100.00*
14. *Irony Standard*	*45.00*	*55.00/65.00*
15. *Irony Scuba*	*59.50*	*80.00*
16. *Irony Chrono*	*75.00*	*125.00*
17. *Maxi Swatch*	*75.00*	*125.00*
18. *Art Special*	*49.50*	*70-80.00*
19. *Swatch Specials*	*55.00*	*90.00*
20. *Swatch Collectors*	*Free to Club members*	
21. *Swatch Access*	*45.00*	*55.00*

Footnote: these are the recommended retail prices in the UK and are subject to change.

Index

A

Acid Pop	74
After Hours	118
Aiglette	54
Aiglon	54
American Dream	128
Anlak	115
Arcimboldo	113,114
Atlanta 1996	143
Avaton	90
Avenida	112
Award	98

B

BMX	87
Baisser D'Antan	50
Barrier Reef	103
Bergstrüssli	92
Betty Lou	44
Big Red	131
Black Circles	112
Black Motion	111
Black Rudder	127
Black Widow	77
Blackboard	115
Blade Runner	46
Blanc de Blanc	74
Blue Flamingo	47
Blue Function	100
Blue Matic	110
Blue Pasta	68
Bonaparte	93
Breakdance	85
Brode D'Or	46
Borgo Nuovo	42
Boxing	68

C

C-Monsta	23,89
Calafatti	42
Canard Laqué	56
Cartographic	131
Cellular phone	151
Charms	113
Cheik Nadio	69
Chérif & Silvie Defraoui	64
Chicchirichi	48
Classic	40
Clearance	139
Coffee	79
Coffee Break	121
Color Scribbler	72
Comin' Thru	140
Compu-tech	40
Conform	58
Cool Mint	57
Cordless phone	151
Country-side	46
Crystal Surprise	18,147
Cupydus	48

D

Dahlia	47
Daly Thompson	144
Dan Jansen	145
Dancing Feathers	99
Depiste	89
Destine	72
Desert Puff	86
Deauville	42
Direction	140
Divine	104
Drop Out	139
Dudelsack	125

E

Ecentric	101
Edwin Moses	144
Eggsdream	18,19,88
Eiga-Shi	88
Element	90
11 P.M.	90
Encantador	80
Enchanting Forest	67
Essaouira	49
Europe in Concert	123

F

Feathers	81
5th Avenue	111
Film No. 4	70
Fire Signal	73
Fix n' Zip	68
Fleur d'Eté	78
Flowers	67
Fluoscope	107
Fluosite	130
For Your Heart Only	55
François 1ER	111
Franco	47
Freeride	138
Freeway	45
Frozen Tears	56
Frutti	45

G

Garden Turf	148
Gelindo Bordin	144
Ghiacciolo	134
Glance	50
Gold Breeze	53
Go Big	139
Golden Bond	44
Gossip	120
Gran Via	111
Grand Prix	98
Graphickers	67
Glowing Ice	102
Goldfish	107
Gulp!!!	48

H

Hands	71
Happy Fish	104
Happy Joe	132
Hitch Hiker	99
Hocus Pocus	93
Hollywood Dream	93
Honeytree	98

I

IOC 100Years	141
Ice Dance	54
Inky Water	131
Inspiral	120

J

James' Choice	118
Jelly Bubbles	104
Jellyfish	84,86
Jess's Rush	122
Jet Lag	98

K

Katerina Witt	145
Keret	70
Kishoo	24,78

L

Lady Limelight	92
Lady & the Mirror, The	71
Lamp	59
Last Week, Next Week	116
Latest News	120
Le Chat Botté	52
Leaf	80
Lens Heaven	68
Lifesaver, The	76
Light Tree	95
Lipstick	72
Lolita	55
London 1948	143
Looka	148
Lots of Dots	147
Lots of Suns	137
Love, Peace & Happiness	70
Luminosa	109
Lunaire	105

M

McGregor	40
McSquare	56
Magic Spell	23,94,95
Magnitude	52
Marilyn	65
Martingala	124
Matin à Tanger	75
Meeoww	75
Mengedenga	135
Mille Feuille	77

Mimmo Paladino	63
Mind the Shark	106
Mint Drops	105
Missing	115
Mogador	48
Modèle avec Personnages	62
Monster Time	54
Moscow 1980	142
Mozart	93
Mustard	59

N

Nab Light	42
Nautilus	41
Navy Berry	97
Nespos	133
Never Seen Before	60
Night Shift	122
Nightstar	79
Niklaus Troxier	63
Nugget	115

O

Ocean Storm	133
Old Bond	43
Olympia Logo	85,87
One World	79
Orb	65
Over the Wave	104

P

Palace Doors	76
Palmer	140
Passage to Brooklyn	60
Patching	76
Perlage	49
Photoshooting	50
Pierre Alechinsky	63
Pink Betty	43
Pink Pleasure	108
Pinstripe	40
Pitti	113
Planetarium	137
Pleasure Garden	74
Point of View	147
Pompadour	92
Pop Bones	69
Popocatepetl	75
Power Steel	99
Pleasure Dome	99
Poulpe	107
Protect	57

R

Rallyé	101
Rap	53
Ravenna	46
Red Banner	120
Reef	109

Refrain	125	Sign of Times	136	Taxi-Stop	43	Victorian	78

Refrain 125
Reposition 58
Ring a Bell 125
Ringo 80
Robin 44
Roboboy 72
Rocking 52
Roi Soleil 94
Roma 1960 142
Romeo & Juliet 57
Rorrim 62
Roses &... 77
Rosso su Blackout 64
Rotor 135
Rouge 77
Rough & Rugged 134
Royal Puff 86
Running Tune 125
Rush for Heaven 44
Russian Treasury 100

S
Said Aoulta 144
Sailor's Joy 105
St Moritz 1928 143
St Peter's Gate 112
Salzburg 129
Scribble 147
Sealights 134
Seatrip 133
Sebastian Coe 145
Secret Service 117
See Through 100
Seoul 1988 142
Sex-Tease 53
Shiny Start 101

Sign of Times 136
Signal Flag 97
Silver 131
Silver Moon 128
Silver Plate 55
Sir Swatch 41
Skate Bike 97
Skipper 97
Smart Car 23,153-4
Smilla 148
Sole Mio 54
Sorti Mysterieux 113
Sound Effects 80
Soupe de Poisson 76
Space Chill 128
Space Trip 130
Spartito 124
Speaker's Corner 119
Specchio 101
Speed Counters 102
Sposa 116
Steel Lite 50
Stockholm 1912 143
Stripp 108
Sun Garden 130
Sunscratch 137
Sunscreen 137
Superblu 133
Swatch-Mobile 22,153-4
SwatchEyes sunglasses 152

T
Tailleur 49
Tambour 125
Tappeto 78
Tarsia 116

Taxi-Stop 43
Tech Diving 105
Tempo Naturale 70
Temps Zero 65
Ticker Tape 43
Ticking Brain 71
Time Dimension 102
Time to Cook 126
Time to Dance 59
Time to Move 18,87
Time to Reflect 89
Tokyo 1964 142
Top Brass, The 100
Top Class 51
Tourmaline 51
Transparent 57
Travel Kit 80
Tresor Magique 112
Trifoll 74
Truck Driver 130
Turn Around 119
Tutti 44
Tweed 49
Twinphone 150
Twintam phone 150
Typesetter 47

U
Underpressure 106
UNlimited 22,88

V
Valerio Adami 63
Vasily 41
Verdu 64
Verushka 75

Victorian 78
Virtual Green 102
Virtual Orange 59
Vive la Paix 67
Voie Humaine 51

W
Walk-on 108
Walpitu 41
Wanayarva Tjukurra 69
Washed Out 108
Waterdrop 107
Waterpower 128
Waving 109
Website 58
Weightless 58
Wild Laugh 69
Windjammer 134
Windmeal 71
Windrose 39
Wired 126

X
X-tian La-X 22,94

Y
Yellow Racer 39
Yellow Ribbon 118
Yellow Star 122

Swatch the Club all over the World

Switzerland
Jakob-Stampfli Strasse 94
CH-2504 Biel
Hotline: +41 32 343 96 44
Fax: +41 32 343 90 48

Germany
Postfach 5769
D-65732 Eschborn
Hotline: +49 61 73 606 333
Fax: +49 61 73 606 113

Austria
Kuefsteingasse 15
A-1140 Wien
Hotline: +43 1 981 85 45
Fax: +43 1 981 85 49

France
65, rue des Cras
Boite postale 4007
F-25071 Besancon Cedex
Hotline: +33 1 53 81 22 06
Fax: +33 1 45 74 62 46

UK
Omega House
112 Southamptom Road
Eastleigh
SO50 5PB
England
Hotline: + 44 1 703 646 846
Fax: +44 1 703 646 888

Italy
Centro Direzionale Milanofiori
Strada 7
Palazzo R1
1-20089 Rozzano
Hotline: +39 167 834 008
Fax: +39 2 575 110 44

USA
1200 Harbor Boulevard
Weehawken
NJ 07087
Hotline: +1 201 271 47 13
Hotline: +1 800 U4 Swatch
Fax: +1 201 271 46 33

Belgium
249 Boulevard Sylvain Dupuis
1070 Bruxelles
Hotline: +32 2 558 13 99
Fax: +32 2 520 53 15

Netherlands
Postbus 1250
NL- 6201 BG Maastricht
Hotline: +31 433 25 55 55
Fax: +31 433 25 00 00

Portugal
Av. Infante D. Henrique
Lote 1679 R/cC/L/J
P-1900 Lisboa
Hotline: +351 12 07 34 42
Fax: +351 12 07 33 46

International
Jakob-Stampfli Strasse 94
CH-2504 Biel
Hotline: +41 32 343 93 83
Fax: +41 32 343 90 29

Club Hotlines
Japan: +81 3 39 80 40 07
(9.30am-6.00pm)
Japan: +81 3 59 50 42 53 *(24hr)*
Singapore: +65 2 75 63 88
Taiwan: +886 2 781 38 11
Hong Kong: 852 2 510 51 38
Greece: +30 1 77 56 902